MIKHAEL SUBOTZKY

RETINAL SHIFT

Steidl

MIKHAEL SUBOTZKY

TEXTS BY
ANTHEA BUYS
&
SEAN O'TOOLE

EDITED BY
IVAN VLADISLAVIĆ

RETINAL SHIFT

Standard Bank Young Artist Award 2012
Mikhael Subotzky

On the occasion of an exhibition at the
following venues, 2012 / 2013:

Monument Gallery and Gallery in the
Round, Grahamstown National Arts Festival

Nelson Mandela Metropolitan Art Museum,
Port Elizabeth

Tatham Art Gallery, Pietermaritzburg

IZIKO South African National Gallery,
Cape Town

Johannes Stegmann Art Gallery,
Bloemfontein

Standard Bank Gallery, Johannesburg

University of Potchefstroom Art Gallery

 GOODMAN GALLERY

First edition published in 2012

 Editor
Ivan Vladislavić

 Book Design
Michael Aberman and Emmet Byrne

 Scans
Tony Meintjes

 Separations
Steidl's digital darkroom

 Production and printing
Steidl, Göttingen

Steidl
Düstere Str. 4 / 37073 Göttingen,
Germany
Phone +49 551 49 60 60 / Fax +49 551 49
60 649
mail@steidl.de
www.steidlville.com / www.steidl.de

ISBN 978-3-86930-539-4
Printed in Germany by Steidl

Previous Standard Bank Young
Artist Winners:

1984 Peter Schütz
1985 Marion Arnold
1986 Gavin Younge
1987 William Kentridge
1988 Margaret Vorster
1989 Helen Sebidi
1990 Fée Halsted-Berning and
 Bonnie Ntshalintshali
1991 Andries Botha
1992 Tommy Motswai
1993 Pippa Skotnes
1994 Sam Nhlengethwa
1995 Jane Alexander
1996 Trevor Makhoba
1997 Lien Botha
1998 Nhlanhla Xaba
1999 (no award)
2000 Alan Alborough
2001 Walter Oltmann
2002 Brett Murray
2003 Berni Searle
2004 Kathryn Smith
2005 Wim Botha
2006 Churchill Madikida
2007 Pieter Hugo
2008 Nontsikelelo Veleko
2009 Nicholas Hlobo
2010 Michael MacGarry
2011 Nandipha Mntambo

ACKNOWLEDGEMENTS

Moses and Griffiths is presented courtesy
Standard Bank Collection
Who's Who is presented courtesy Emile Stipp Collection

The following photographers are thanked for the
use of their images:
Peter Williams, p. 63
Julia Cloete, p. 197
Kelly Rosenthal, p. 201
Patrick Waterhouse, p. 298 (first image)
'Doctor', p. 298 (second image)
Patrick Waterhouse (in collaboration
with Mikhael Subotzky), p. 420
Marc Nicolson, p. 473
I was looking back was partly inspired by W.M. Hunt's
collection and the book *The Unseen Eye*.

Technical assistance was provided by:
PVision
Magnetic Storm
True Technical
Hewlett-Packard
Framed By Orms

Thank you to:
Julia Cloete

Mandie van der Spuy, Sue Isaac, Barbara Freemantle
and Standard Bank

Ismail Mahomed, Jay Pather, Brenton Maart,
Melissa Mboweni, Tony Lankester, Nicci Spalding,
Ryan Bruton, Gilly Hemphill and everybody else at
the National Arts Festival

Liza Essers, Claire van Blerck and everybody at
Goodman Gallery

Anthea Buys, Sean O'Toole, Ivan Vladislavić,
Michael Aberman and Emmet Byrne

Caitlin Pieters, Tjorven Bruyneel, Oriole Bolus, Meghan
Judge, Thabiso Sekgala, Edith Viljoen, Samora Bikwani,
Michelle van Blerck and everybody else who has helped
in my studio

Gideon Mendel, Jim Goldberg, Alec Soth, Patrick
Waterhouse, Anya Mendel, Eve Mendel, Greg Nicolson,
Marc Nicolson, Simon Eppel, Werner Mennen, Graham
Rowe, Serame Metsing, Anna Bailey, Prospero Bailey,
Candice Breitz, William Kentridge, Emile Stipp, David Ross,
David Opperman, Tony Groenewald, Nicolas Garrett, Mike
Ormrod, Tony Meintjes, Anton Coetzee, Moeneeb Dalwai,
Layla Swart, Hina Saiyada, Jonathan Roquemore, Laurence
Hamburger, Jonny Steinberg, Minette Vari, David Goldblatt,
Linda Givon, Artur Walther, Martin Parr, Gwydion Beynon,
Lisa Cloete, Nico Cloete, Christopher Klatell, Roxana
Marcoci, Chris Boot, Hélène de Franchis, Bernard Fischer,
Gerhard Steidl and the staff of Steidl, Studio La Città and
Magnum Photos

Various parts of the work on this exhibition were produced
with the support of the W. Eugene Smith Memorial Fund, the
Goethe Institute in Johannesburg, and the Goodman Gallery

MOSES AND GRIFFITHS CREDITS

Featuring
Moses Monde Lamani and Griffiths 'Boy' Sokuyeka

Executive Producers
Mikhael Subotzky, Liza Essers, Laurence Hamburger

Produced by
Laurence Hamburger, Tess Tambourlas-Van Zyl
(Nobodies Business / GOOD COP)

Directors of Photography
Antonio Forjaz / Mikhael Subotzky

Editor
Matthew Swanepoel (Priest)

Sound recordist
Tony Honeybun

Grip
Ken Hodgson

Final sound
Dave Harris (Freq'ncy)

Production Manager
Zandile Tisani

Colourist
Craig Parker (Seven Four Four Digital)

Camera Assistant
Paul Painting

Production Assistants
Mpho Masango, Caitlin Pieters, Tjorven Bruyneel

Thanks to
Bongani Mgijima, Nozipho Madinda, December Sedina,
Louisa Clayton, Cheryl Fischer, Sisanda Mankayi, Mark
Percival, Ismail Mahomed, Tony Lankester, Nicci Spalding,
Ryan Bruton, Saleem Badat, Steve Fourie, Brent Meistre,
Dominic Thorburn, Ruth Simbao, Jeff Peires, Nomaphelo
Lungile, Ross Shackleton, Ashley Stander, Mbaza Klaas,
Therese Boulle, Glenn Goosen, Michelle Barrow, Cal
Kingwill, Bella's Guesthouse

SELF-PORTRAIT

Front and back covers

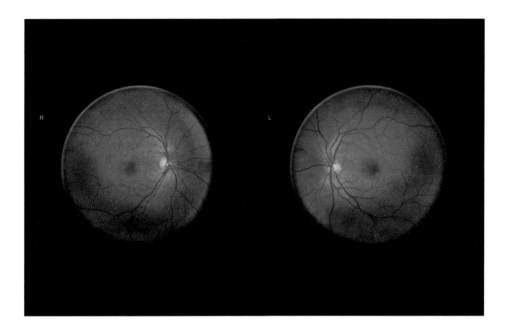

2012
Two colour prints mounted to Dibond and toughened glass.
80 x 100cm each.

High-resolution images of my left and right retinas are placed
side by side. I was intrigued by my encounter with the optom-
etrist. At the moment when my retinas, my essential organs of
seeing, were photographed, I was blinded by the apparatus that
made the images.

(WITH ASSISTANCE
OF OPTOMETRIST)

WHO'S

p. 1
(runs throughout)

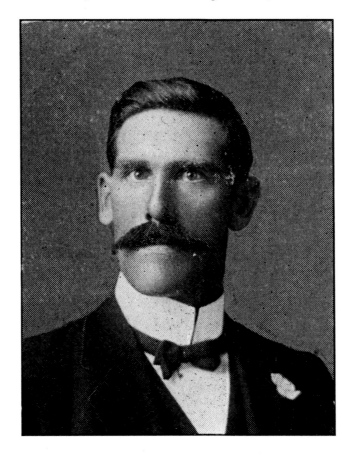

2012
11 slideshows on vertically oriented 55"
HD screens linked to BrightSign
sync boxes.

To make this work, I scanned every passport-
sized portrait from 11 books in the serial
publication *Who's Who of Southern Africa*.
Each screen presents a slideshow of all the
images contained in one year's edition. The
years selected are 1911, 1921, 1931, 1941,
1951, 1961, 1971, 1981, 1991, 2001, 2011.
The portraits are decontextualized from the
other information in the books that assigns
their importance, such as names, titles,
achievements and hobbies. The slideshows
thus become an endless parade of importance
as personified in over 30 000 portraits from
books of the last century. The very last
screen shows images from 2011, when the
printed publication was replaced by an on-
line site with the same name.

WHO

I WAS

p. 46
(runs throughout)

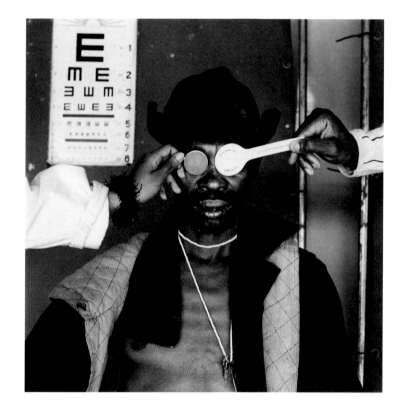

2012
100 colour prints of varying sizes mounted on
Dibond and toughened glass (installation
20 x 2.9 m). Several of the glass mounts have
been smashed.

This is an installation of 100 photographs mined
from the last ten years of my archive. In prepar-
ing the work, I went through every photograph I
had ever taken, and chose those where the process
of looking, or being looked back at, was resonant.

LOOKING BACK

MOSES AND

p. 86–165

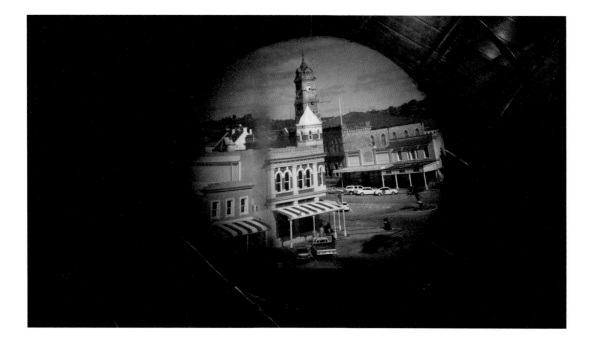

2012
Four-channel projection on four HD video projectors and four 2.67 x 1.5 m
Perspex screens (duration 18.5 minutes).

Moses and Griffiths is a filmic portrait of two buildings, and two men, in
the small South African town of Grahamstown. Moses Lamani gives tours of
Grahamstown through the Observatory Museum's nineteenth-century camera
obscura. Griffiths Sokuyeka gives similar tours of the 1820 Settlers Monu-
ment, a Louis Kahn inspired 1970s monument to English language and culture
in South Africa.

Initially, I filmed the official tours, which both men give with remark-
able consistency. These tours offer a narrow account of local history,
focusing on the English settlers who left their mark on Grahamstown after
the influx of 1820. I then asked each man to give a personalized tour, to
talk about his own history in the town and in the building where he works.

These four tours, official and personal for each man, are presented on
four screens, which are hung on the four walls of a room. The four narra-
tives happen simultaneously, but the voices on each screen pause to allow
other voices to speak, and so create a new conversation among them.

GRIFFITHS

CC

p. 218-269

Assault GBH & Robbery	Business Burglary & Theft	Theft from Vegetable Shop	Malicious Damage to Property & Theft
Theft of TV Set	Theft of Cable	Robbery of Motorists (Smash & Grab)	Murder by Students
Robbery & Assault GBH	Theft of Manhole Cover	Possession of Stolen Property	Attempted Theft of Manhole Cover

2011
Single-channel video using found CCTV footage on Blue-ray player
and 32" HD screen (duration 15.39 minutes).

The source footage for this work is from central Johannesburg and was acquired from the police. Their CCTV programme is highly successful in terms of arrests and crime statistics, and yet central Johannesburg is still seen as a no-go zone by many.
 The footage was given to me by the police in short clips and is unedited. My only intervention was to place them in 12 boxes on a single screen, and to time them in relation to one another to emphasize a point: that moment when the arrested criminals are forced to look back into the scopic eye that has helped to apprehend them.

TV

DON'T EVEN

p. 324–347

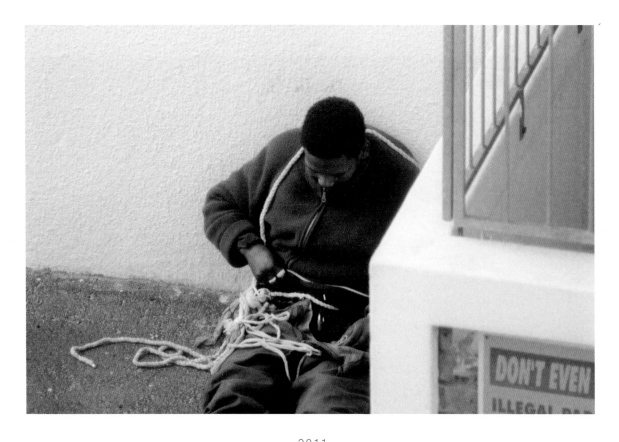

2011
Single-channel video using stop-motion footage on Blue-ray player and 32" HD
screen (duration 7.48 minutes).

This single-channel film is made up of still photographs shot from the window
of my apartment in downtown Cape Town in 2004. I would hold down the shutter
button as long as the camera would allow, and the sequences of images were put
together to form a crude stop-motion film.

 Don't even think of it shows various scenes that caught my attention. Most
notably, a homeless man starts masturbating. A man without a private space to
house this most private of acts. A little while later, another group of home-
less men sit down nearby to eat some scavenged food. A woman in the apartment
above calls a private security guard, an agent of the 'Inner-City Improvement
District', who chases them away. She provides the guard with a bucket of soapy
water to wash away their mess. For good measure, she pours a few more buckets
over the spot from her balcony.

THINK OF IT

EYEING

p. 398–407

...one's sense of being looked at from the past (or from a future past), by the eyes of a photographic subject, is misleading.

ANTHEA BUYS

OTHERS

A GROUP

p. 444–453

...*Retinal Shift* foregrounds the complicated and often interconnected nature of this relationship between expression and description.

SEAN O'TOOLE

PORTRAIT

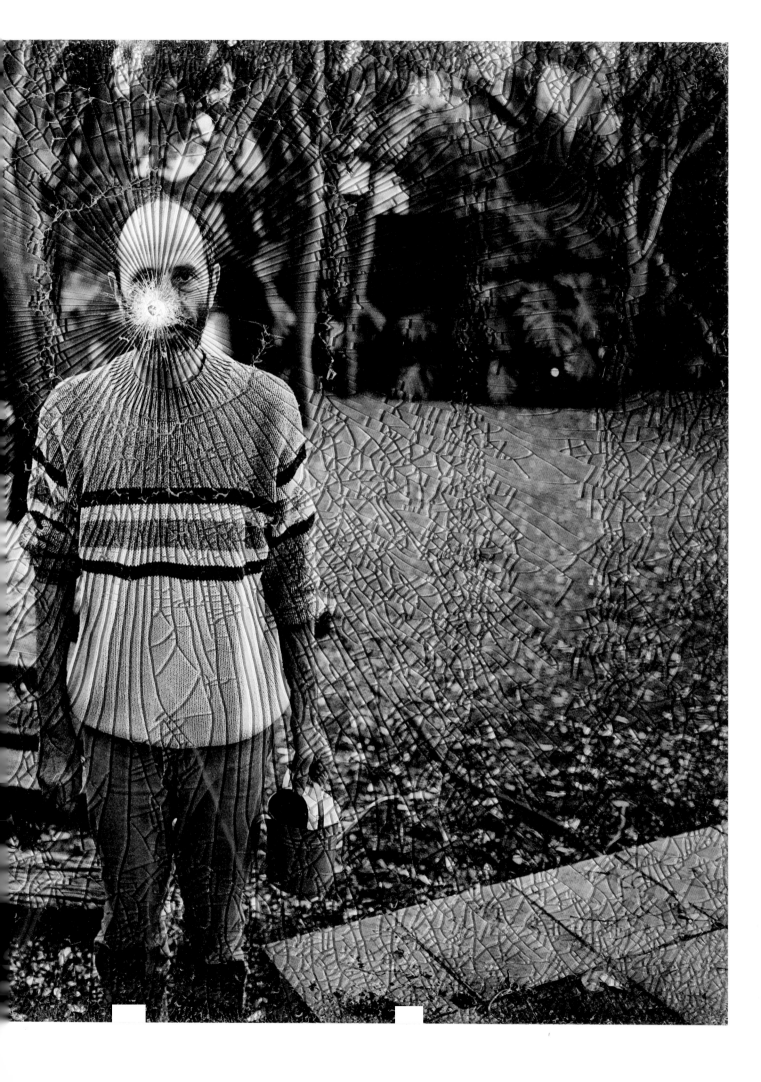

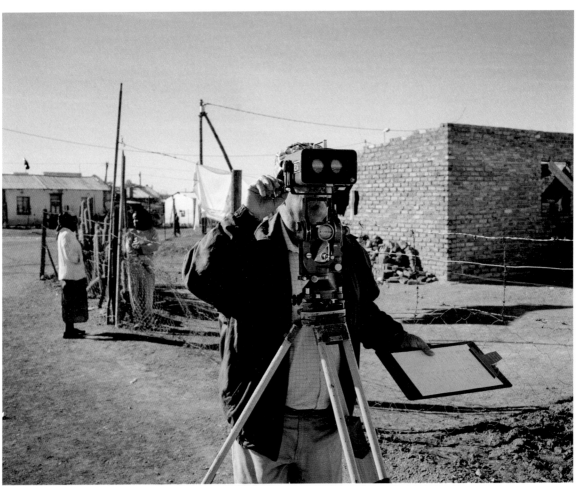

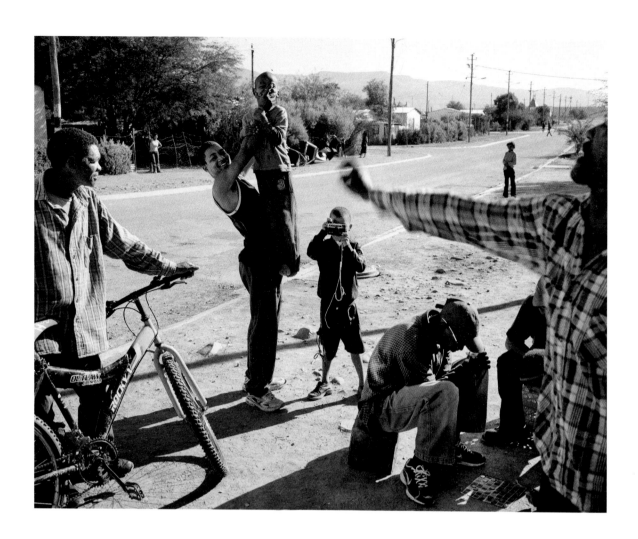

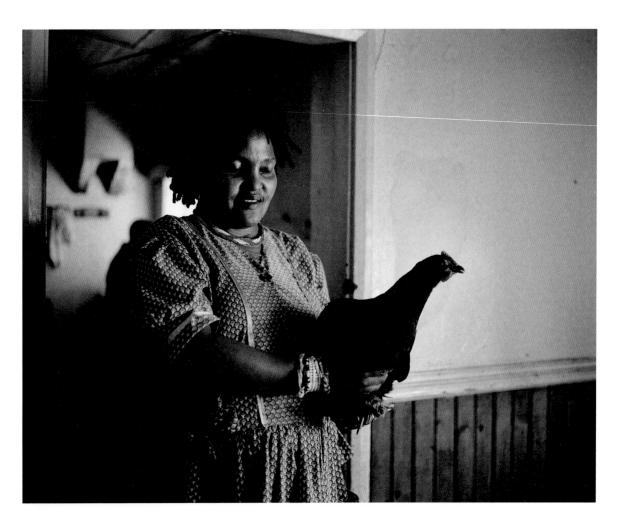

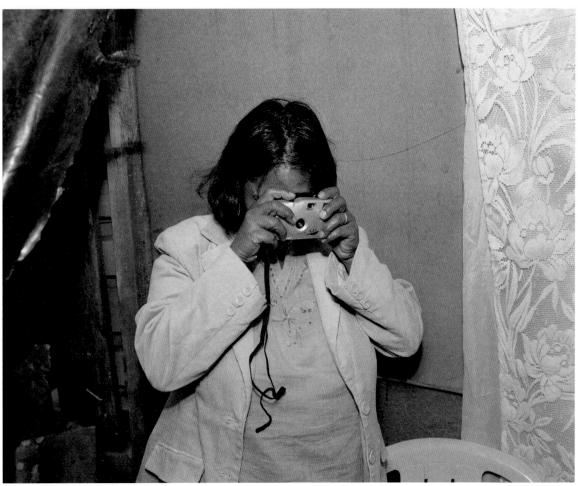

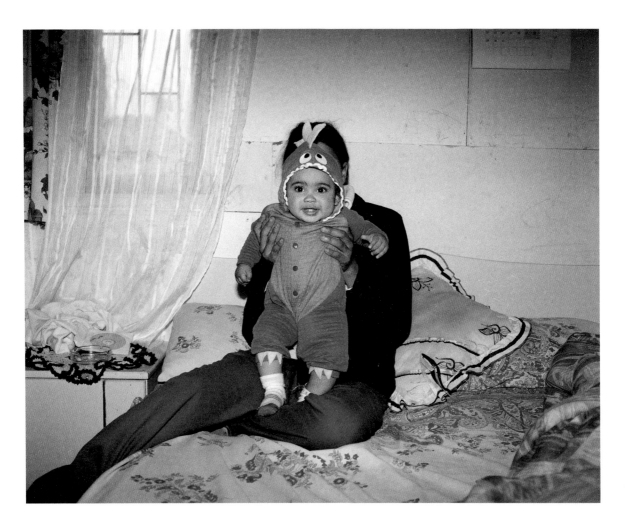

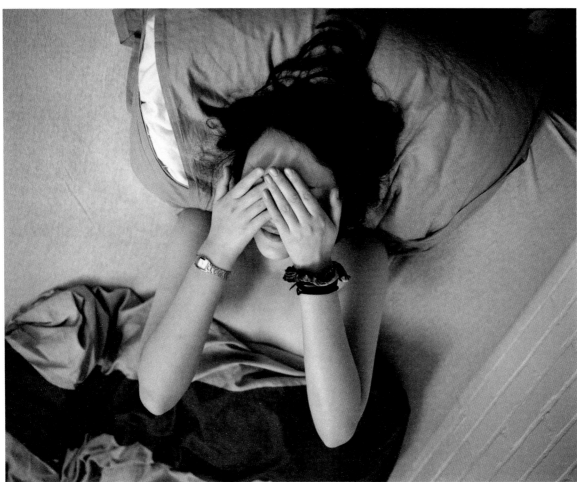

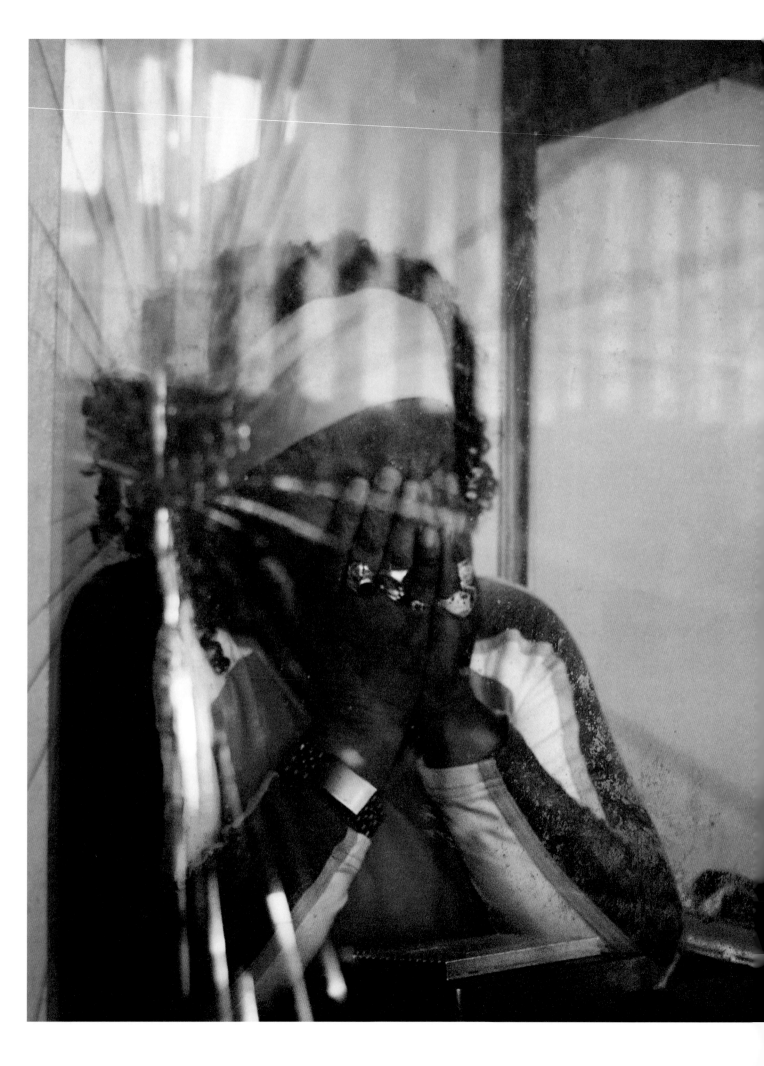

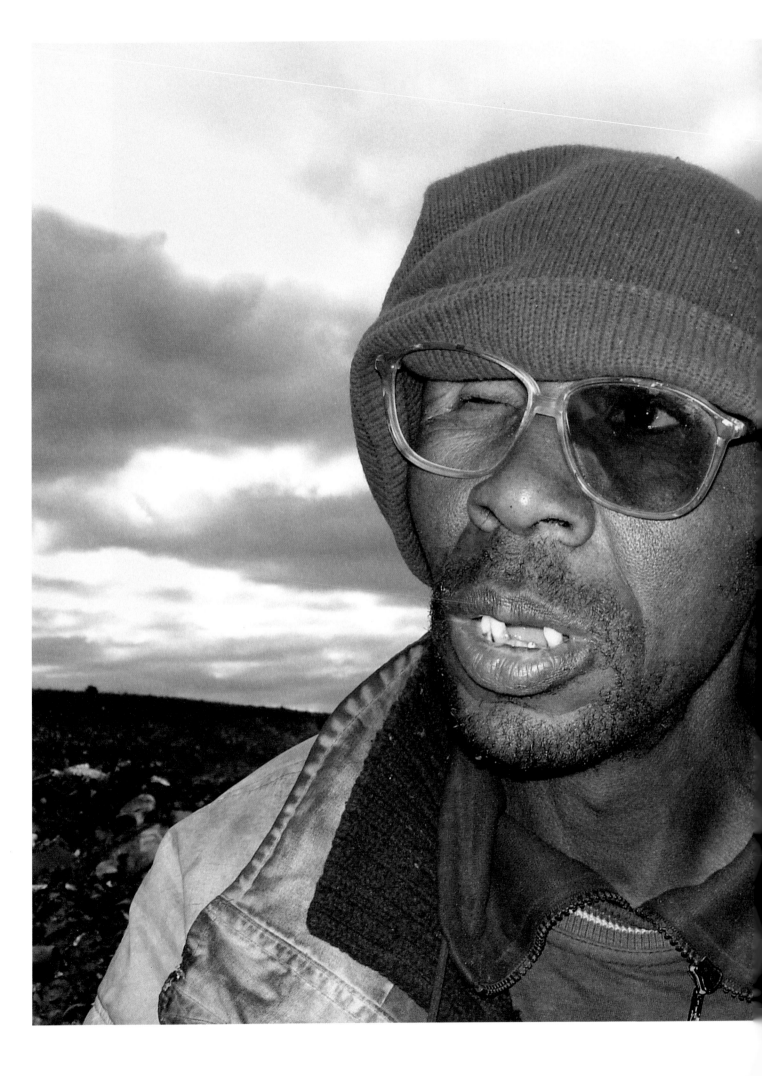

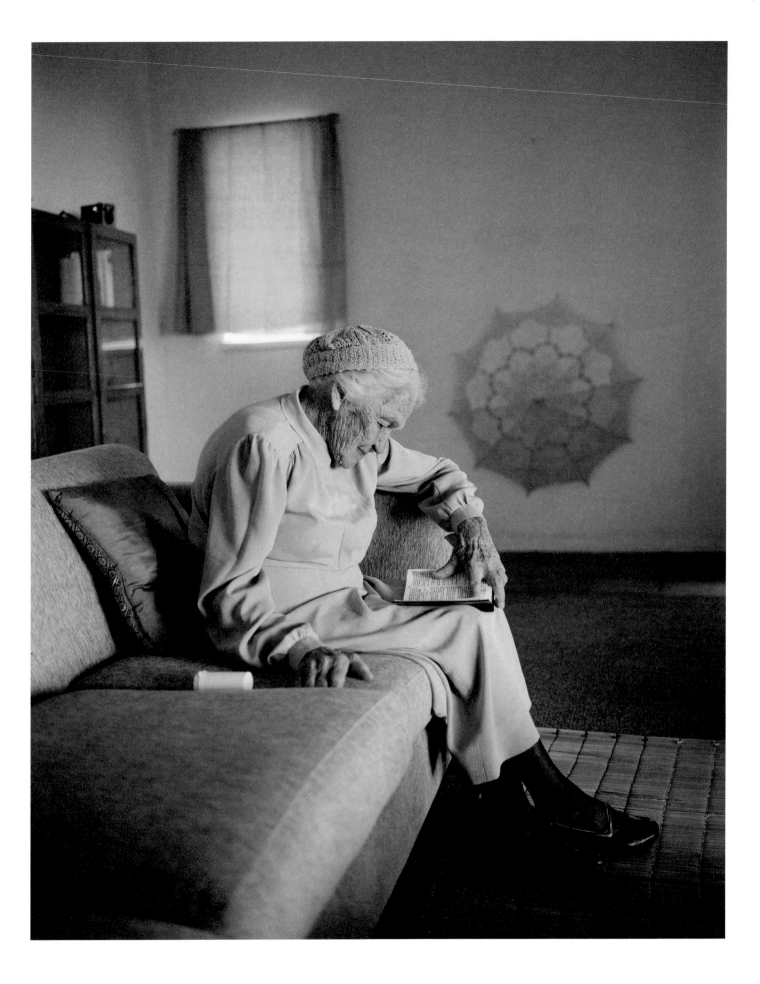

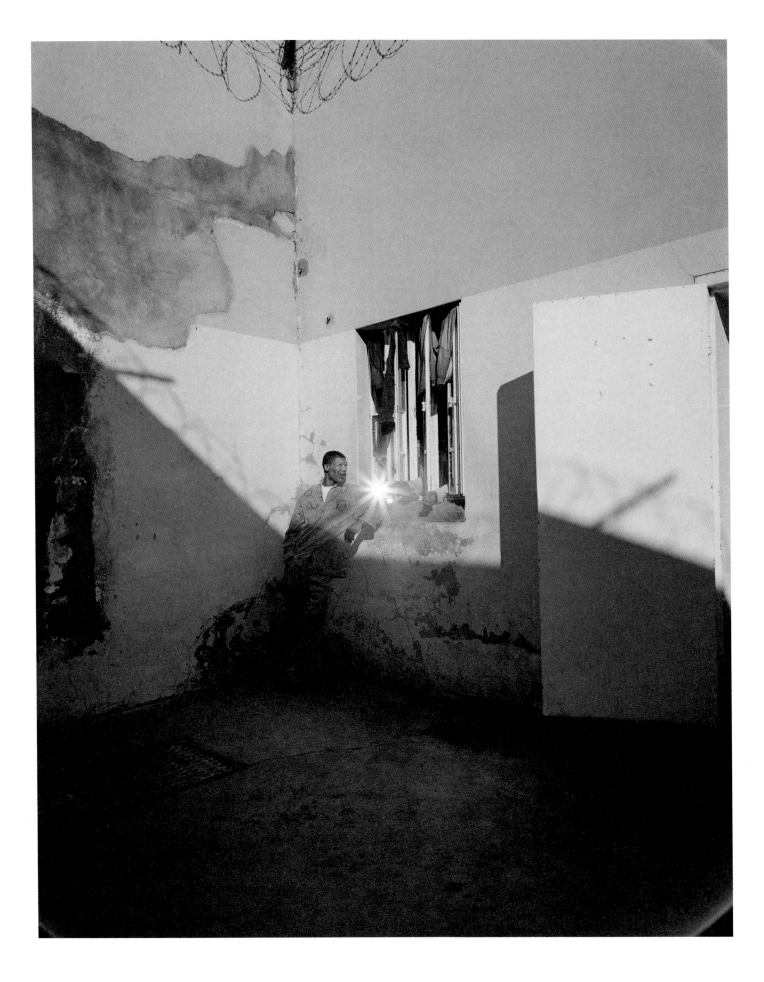

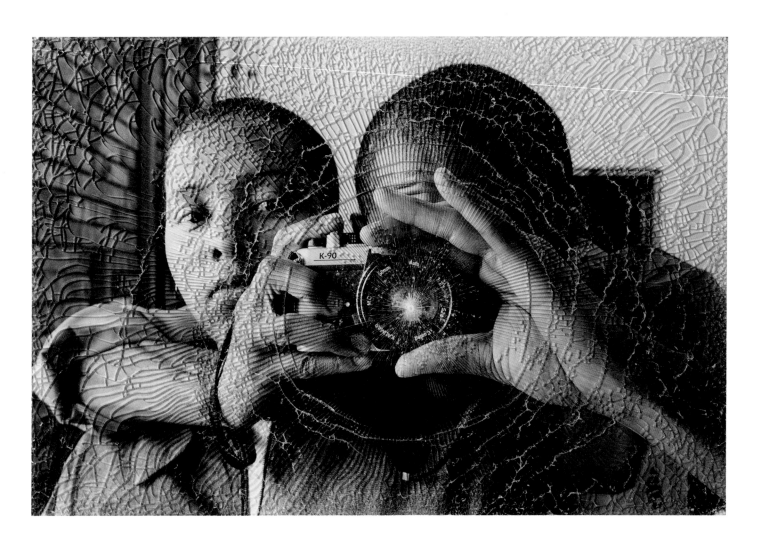

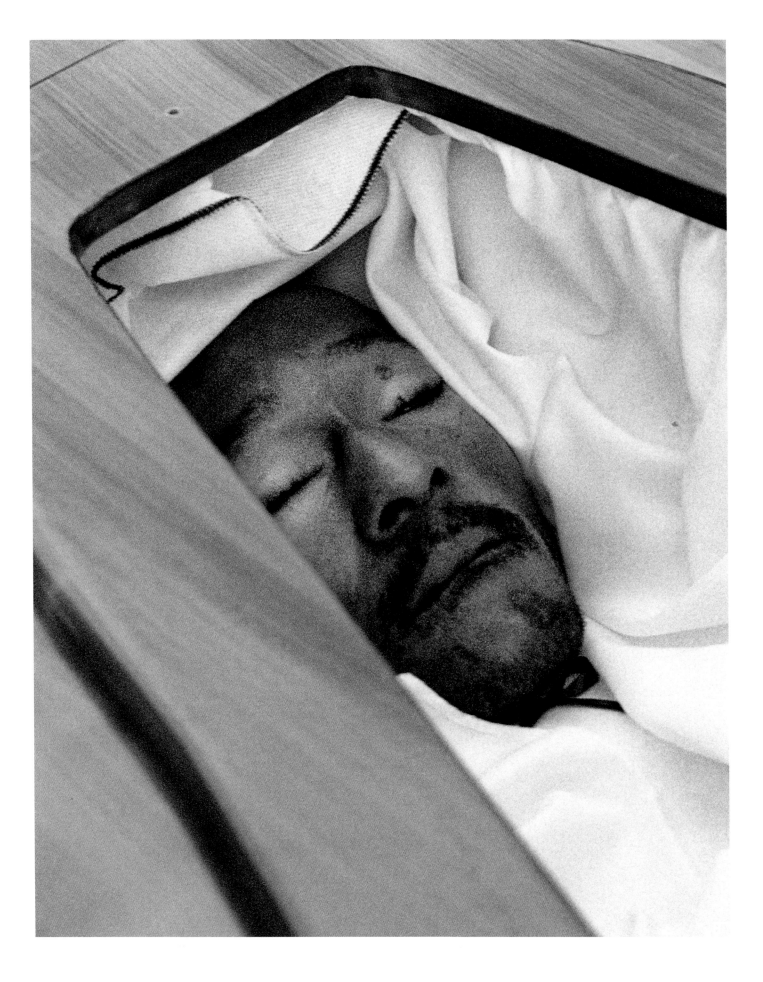

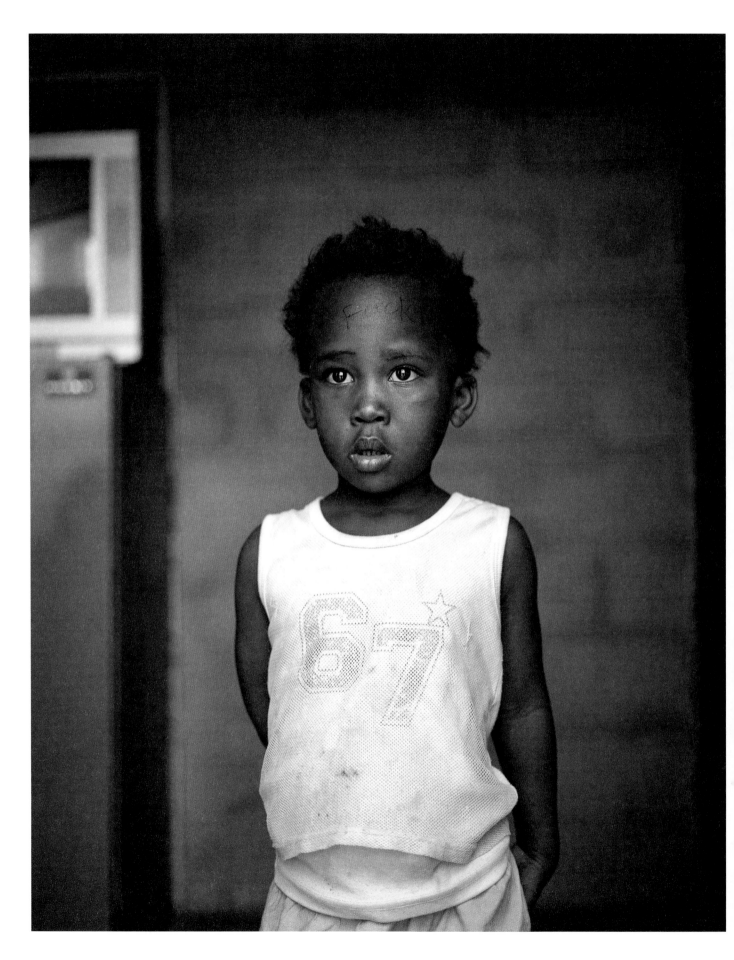

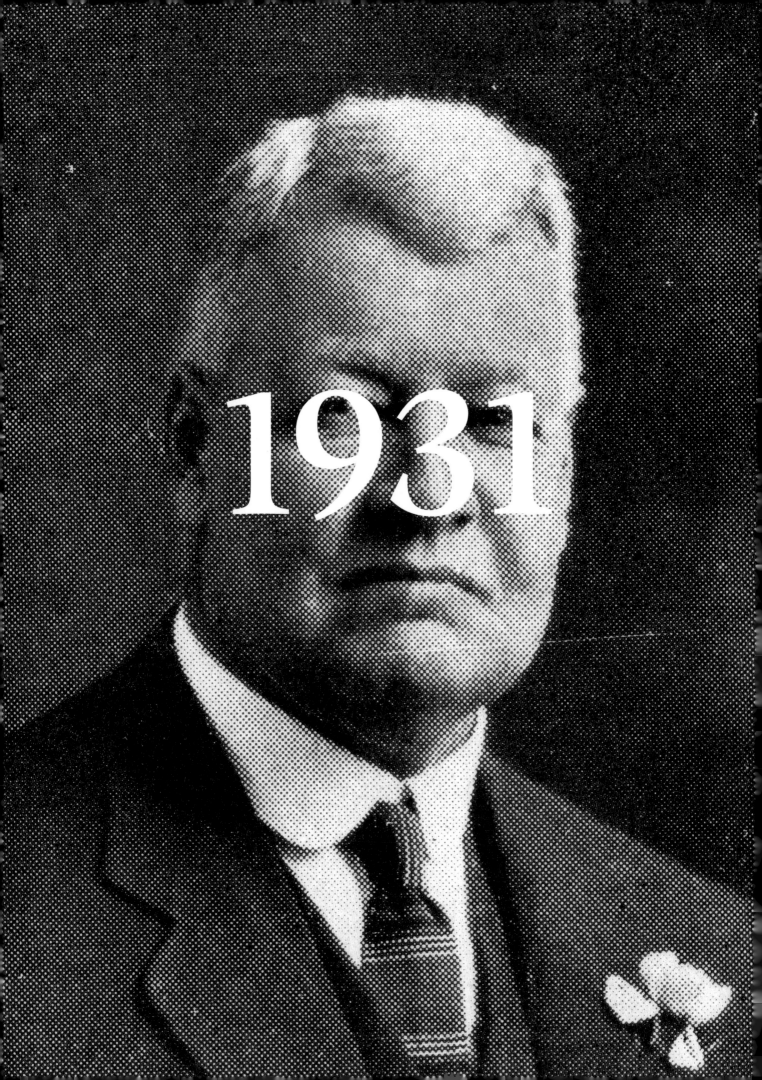

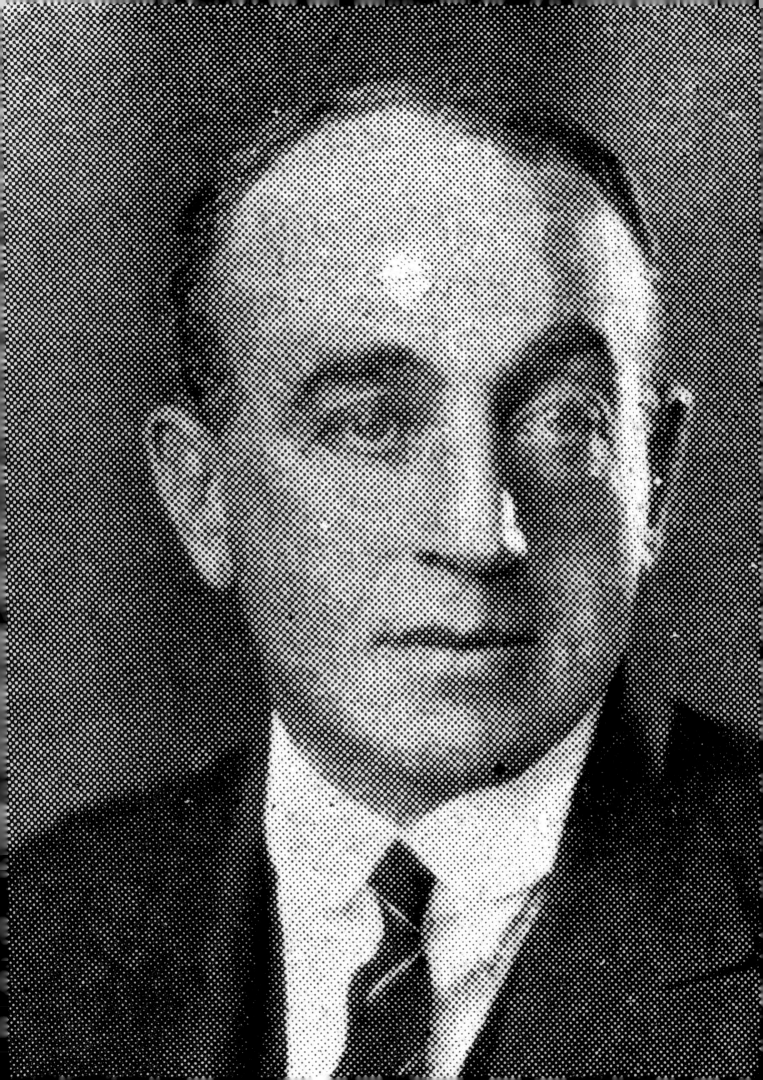

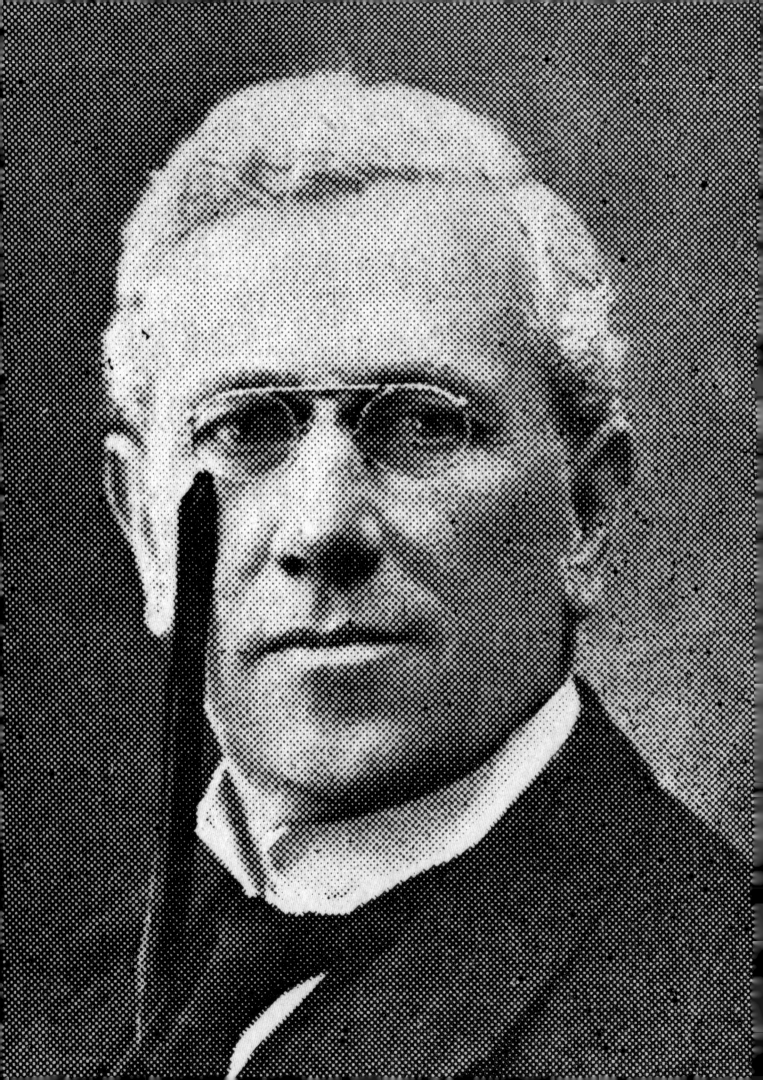

MOSES

TRANSCRIPTS OF HIS
OFFICIAL AND PERSONAL
TOURS OF THE
GRAHAMSTOWN OBSERVATORY
CAMERA OBSCURA

LAMANI

Firstly, let me just say good morning to everybody. My name is Moses Lamani, and this is the Grahamstown Observatory Camera Obscura, of which this was brought in 1882 – now it's the year 2012. So it is about 120–127 years old standing here.

> Okay right, firstly my name is Moses Monde Lamani, and this is the Grahamstown Observatory Camera Obscura. I was born and bred here in Grahamstown, *ndingumQadi mna umXhosa, umThembu, uNcingo, uNgubelawu, uQadi.* I am giving you my genealogy, my origins. Then I was born in 1956 on the 25th of October.

And what is right above us on the roof is a turret. That turret has got a mirror and a double convex lens inside. So that's the mirror, it takes the image from outside to the lens, and the lens takes the image to this table here. Actually, what we're just seeing here is what is happening right now outside, because that rotates 180 to 360 degrees, then you will see the whole of Grahamstown on top of this table.

This is only one in the southern hemisphere of its kind, Victorian one, but there are two that are recently built; the one is in Pretoria, and the other one is in Cape Town, also called the Observatory in the Science Museum there.

As it were, this was used by Mr Galpin and Dr Atherstone in those good old days, ancient times, because Grahamstown was a very, very small town. There were no cars, no telephones, no big buildings, even no televisions like nowadays. But, since they were inventors, they were just using this in such a way that they could find one another's whereabouts in town. Sort of communication. Say one was in town, then the other one would just come up here and pull up these ropes so that they could see him. As soon as they found him, they could send these messengers to go and call him, then they could do what they wanted to do.

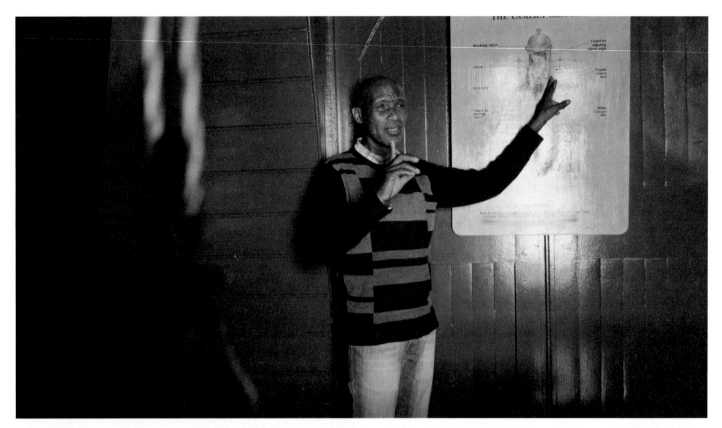

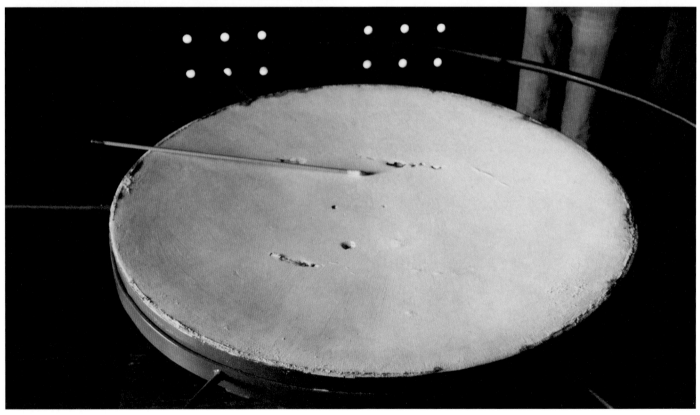

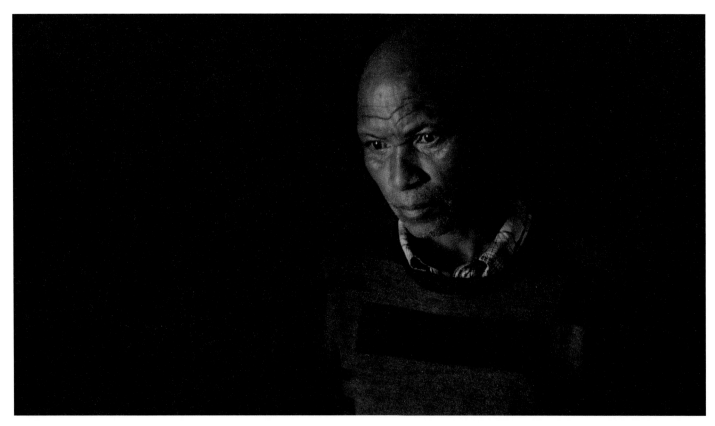

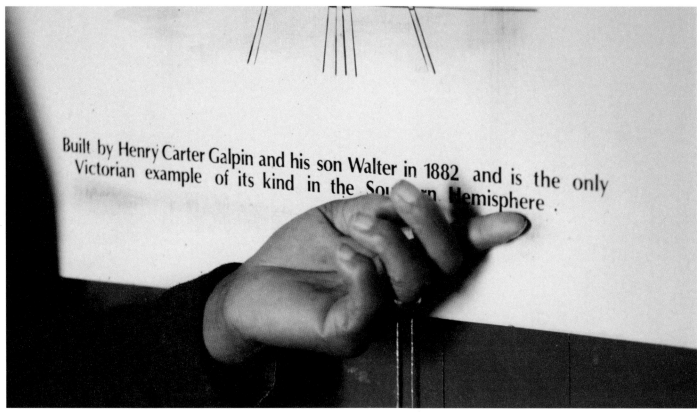

Built by Henry Carter Galpin and his son Walter in 1882 and is the only Victorian example of its kind in the Southern Hemisphere.

All of my life I spent here in Grahamstown, but only two years I went out of schooling in Grahamstown, to Ciskei for about two years. Then that's where now I was detained and tortured. After that I came back to Grahamstown again, that's where now I came back to be working in Grahamstown.

Those days, if one was there to watch it, they only used to charge him or her a shilling. And really, what was just taking place outside, is what we are just seeing right now on top of this table. Otherwise what has been restored, that is the mirror, the lens, and this table, then, the whole concept is original. And as we see the lines on this floor and these four doors, they are also using this telescope inside here to watch some stars at night, and the telescope is in one of the rooms downstairs. Because Mr Galpin, the owner of the house, was a watchmaker, a jeweller, a land surveyor also, and a astronomer.

Then, this rope on my left-hand side is for the mirror, tilting up and down, this one on my right-hand side is for the rotation of the turret, right round. And I suggest that as the picture moves, you just move along to your side so that you can see the picture directly, not upside down, but slowly.

So what we are just to follow first is the very main street of Grahamstown.

So this is our starting point, that's the very street we are in, Bathurst Street.

This is the cathedral tower there, St Michael's and St George's.

This is now cathedral towers, St Michael's and St George's, that's where my wife used to go church. The reason why it is called now St Michael's and St George's, the pastors there, there are two. The one just wanted to be higher than the other, the other one wanted also to be higher. So they said no, they must just say two names - St Michael's and St George's.

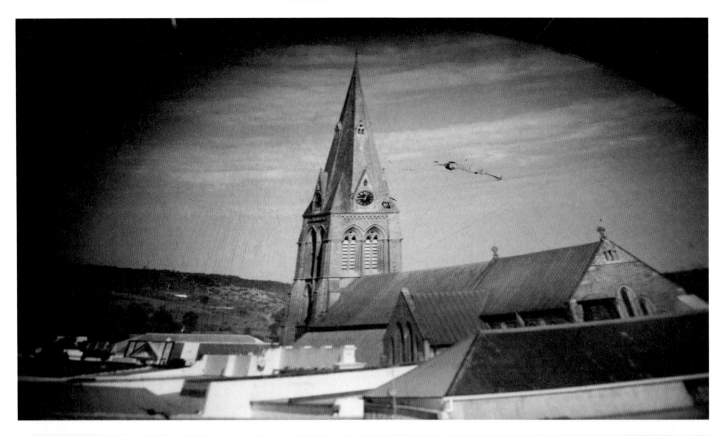

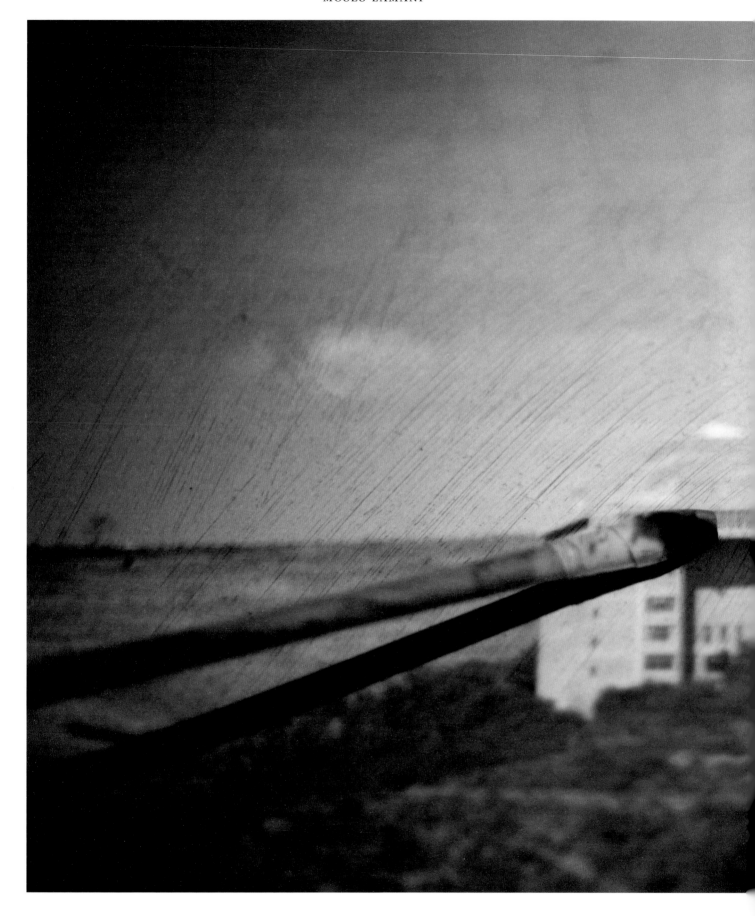

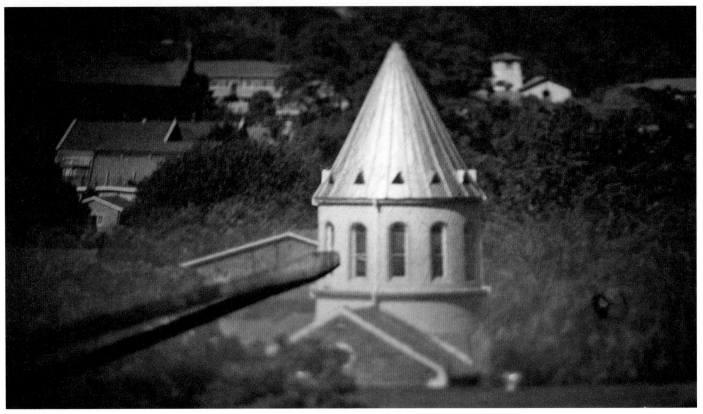

That is now the coffee bar just in front of us across the street, Copper Kettle.

That's the Rhodes University on top there. Next to Rhodes you see the Albany and 1820 Settlers Museums. That's where our headquarters are, we're a part of that.

> This is now the Rhodes University down there. Next to Rhodes, this is the Albany and 1820 Settlers Museums, that's where I started working. My first job there, I was a gardener and a cleaner. But when I told them I was a historian, they sent me here to the Observatory Museum, to work in the camera obscura.

And this is the 1820 Settlers Monument on top there, a conference centre. Next to it, that's another museum there, Fort Selwyn Gunfire Hill.

> This is now the 1820 Settlers Monument, a conference centre. That's where we used to go, during Festival time; with my wife - at the time she was my girlfriend - we used to go there for Festival activities.

Then down here that's the VG Girls, Victoria Girls' High School.

> And this is the VG for Girls, Victoria Girls' High School.

This was the old synagogue church tower there. Whereas they are just using this as the legal offices now.

> And this was the old synagogue church tower there, but now they are just using that as their legal offices. Now there are no more Jews in Grahamstown.

That is now the P.J. Olivier up there, Afrikaans High School. That's now the Dutch Reformed Church, NG Kerk.

> This is now the Dutch Reformed Church, NG Kerk. That is where they got the clock, the clock mechanism for this clock here,

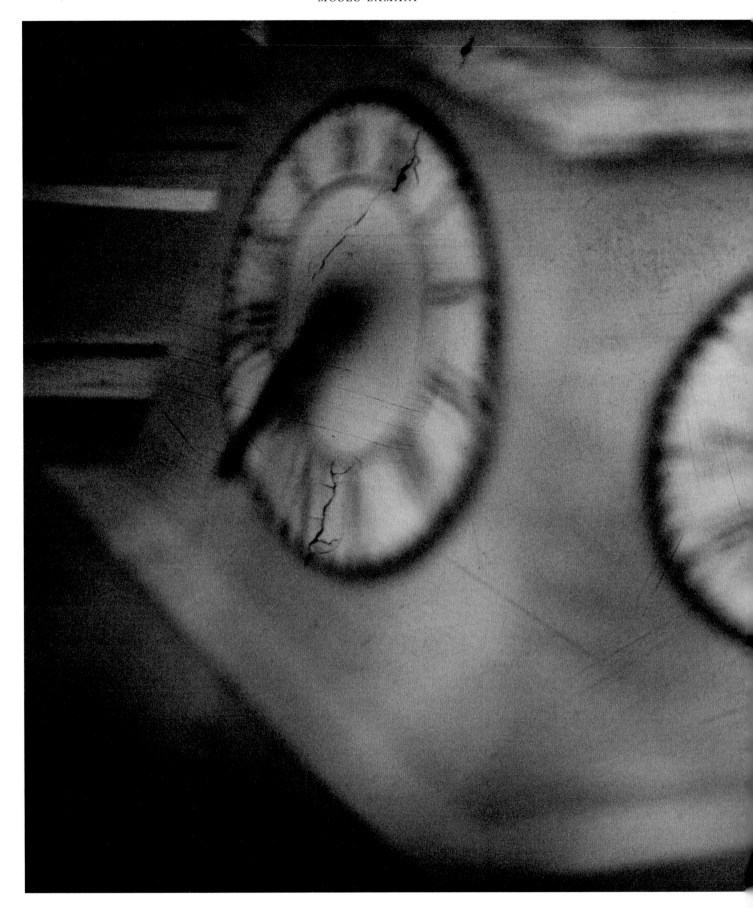

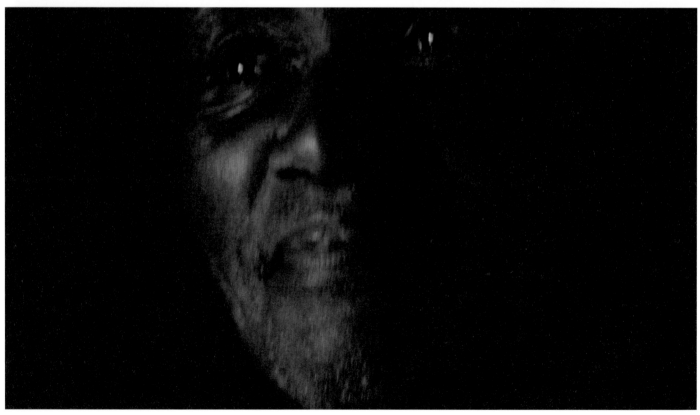

at Observatory Museum. In Xhosa, we call it the place of
the chicken, as there is a sign of a chicken on top of the
weathervane. That's the emblem of that church tower.

This is our clock tower here, the one with the pendulum in one of the rooms downstairs.

This is our clock tower here, the one with the pendulum down-
stairs. This one doesn't work now anymore. The time that I
started working here, we used to wind this clock three times
a week, but now it doesn't work anymore. And the winder is
still in one of the rooms downstairs.

This was the Odeon Cinema there in Bathurst Street, the movie place. But now it's no longer a cinema, just an ordinary shop.

And also, this was the Odeon Cinema. In those days we used to
go there for the bioscope, with my girlfriend before she was
my wife.

Here is the Mike's Motors garage, BP garage, in Beaufort Street. That is the Beaufort Street there to Port Elizabeth.

Then, this is now Mike's Motors garage, BP garage, in Beau-
fort Street. My girlfriend used to talk to her brother to
take us to the bioscope down there in the Odeon Cinema. He
used to fill the petrol in that garage.

This was the Cathcart Arms Hotel over there. An oldest hotel in Grahamstown, even in the country, that was established in 1825.

This was the Cathcart Arms Hotel over there, that was estab-
lished in 1825. That's where my uncle used to be a barman
there, in those days. In Xhosa we call it the place of the
cat, the Cathcart Arms Hotel.

Next to it there is the Ossher Brothers' shop. And this is the Temlett House, that house was built by the 1820 settlers, and

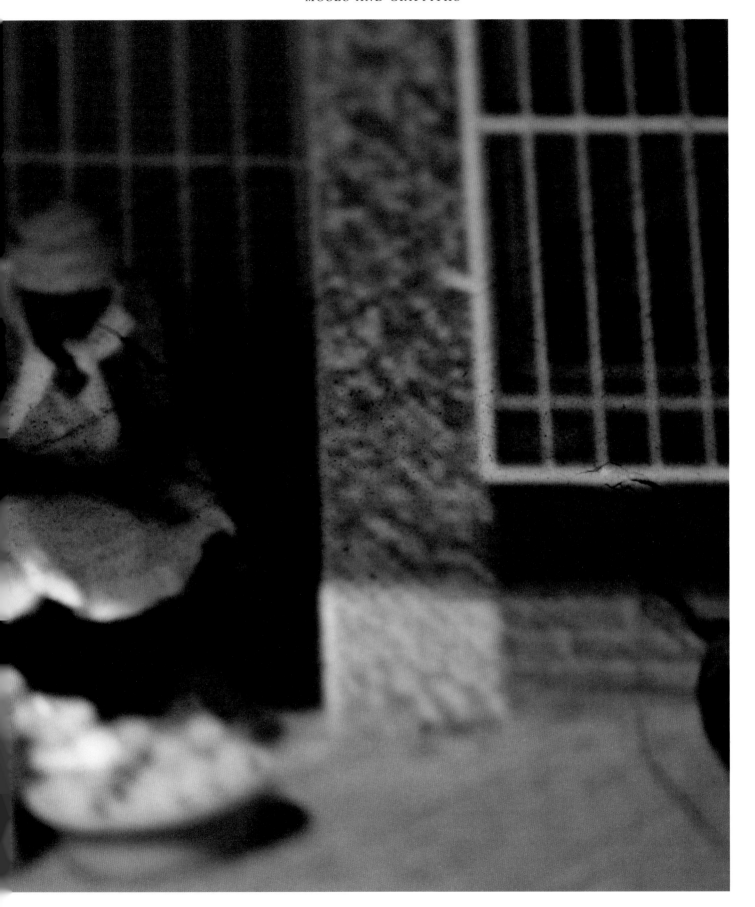

it was the boarding house for the Rhodes students. But a few months or a year, two-three-four years ago, it just got fire inside. They are busy renovating it now to be the SACC, South African Council of Churches.

> That is the Ossher Brothers' shop, that's now selling Xhosa traditional clothes and whatsoever. When a boy is going to initiation school, that is where you can buy the initiate's blanket, eating utensils and other necessities.

That is now the new shopping complex over there, Shoprite Checkers are there now. Before, there was an old market square, marketplace.

> This is the new shopping complex over there, but before, that was a marketplace, a market square. That's where my girl-friend's mother used to buy and sell fruit and veg, in those days, and then we used to go there, being sent by them to buy fruit and veg for them.

Next to Shoprite Checkers, that's the new police station, and these red roofs over there, that's the Fort England Mental Hospital.

> Then red roofs over there, that's now the Fort England, the mental hospital. That's where my wife's sisters used to work. And also we used to go and visit there. I still remember, even my brother, uRichard Fonsile Lamani, who is now in Cradock. He is mentally retarded and was kept there at Fort England. But what I am hearing is just that he is recovering now.

Further down there, that's where the new taxi rank is.

> Further down there, that's where the new taxi rank is. But before that, that was only an open space, that's where they used to play putt-putt in that space.

This is the old road from East London to Port Elizabeth, Raglan Road, East London Road.

That's the new bypass that is being in use, the new road, N2 from East London to Port Elizabeth.

That's the Raglan Road, from East London to Ciskei. That's the road to Ciskei, where I was schooling, that's where I was tortured and detained there, for politics, in nineteen eighty…eighty-three, eighty - four-somewhere there. In Raglan Road during times of riots in 1980s, we black people, we used to throw stones at the cars passing by under this street.

Then that's the new bypass, now that is recently built, because that time we were throwing stones to the cars from Raglan Road. They built this N2…it is now the other way to King William's Town, East London, and also Ciskei.

These are the new houses that are recently built, RDP housing, municipality housing. Further down, that is now Fingo Village, and Fingo Village is the one that was donated by Queen Victoria to the Fingos, hence it was called Fingo Village, F-I-N-G-O.

That's now Fingo Village down there. Then that piece of land was donated by Queen Victoria to the Fingos, because Fingos are those that used to help English people during the times of war. And Fingos are those that used to cut the first part of their finger here, to identify themselves from other tribes.

Further down, that's now Nyaluza High School, that's where I was in school for the rest of my life, with my wife. She was my girlfriend before, but we were schooling together there. Then there is a T-junction down there, that's where we used to go on foot to our school, Nyaluza High.

That's now Makana's Kop over here. Makana was a chief or a leader of amaXhosa, and he was attacking Grahamstown in these brave days during the battle of Grahamstown in 1819, eighteen one nine, and was just up there on that hill with his warriors, that's why it was called after his name, Makana, M-A-K-A-N-A.

That is now Makana's Kop over there. Makana was a chief and he was the one who betrayed the Xhosa people…he mis-led a lot of black people during the time of wars. English

people, they used to be at Fort England, using some guns
from there. Being a witchdoctor, Makana said to the black
people that water will just come out from the guns. But
there came bullets, not water. A lot of people were killed
there, six hundred - thousand people.

Then down here, these are the new houses next to the station built in an old settler style – that is the Stockenstrom village. And Stockenstrom was the Governor of Grahamstown in those days.
 That is now the traffic circle on High Street. This is the railway station over there.

That's now the traffic circuit in High Street. The reason why
that was made to be a traffic circle is because that was the
main street of Grahamstown and that's now the intersection of
the streets. If you want to go to the coloured area, you go
that way; if you want to go up High Street, you go this way.
 And this is the railway station over there. Those days,
it was great for us whenever some of our family goes out to
PE or Alicedale or Port Alfred, using the train, we used to
go there and say goodbye to them.

Above that is just another black township, that's the Joza and Tantyi locations.

Then this is our black townships here, that's Joza and Tantyi
locations. Then our side … where we are staying … is just
here, that's Tantyi location.
 Again, this is our Methodist Church in our locations,
that's where you usually go every Sunday. Then my mother and
my father were married there.

Then right on top there on this little hill, that's the Sugarloaf Hill, in Somerset, that's around the coloured area. The reason why it was called 'Sugarloaf' is because, those days, if soldiers were just running away from the punishment from the army camp, they used to hide themselves under that hill, and would be begging some sugar and bread from people passing by, those days.

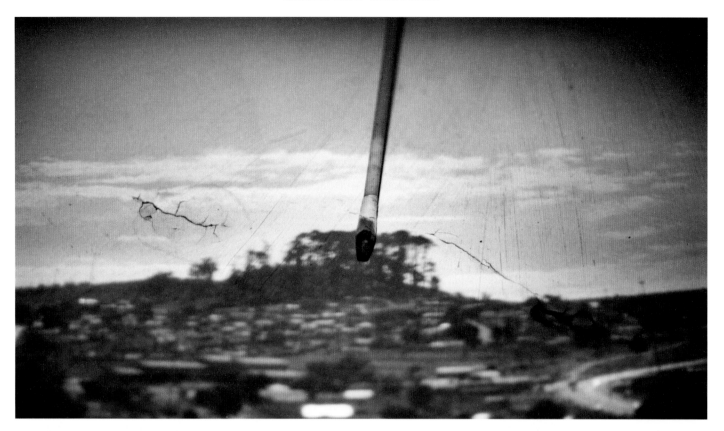

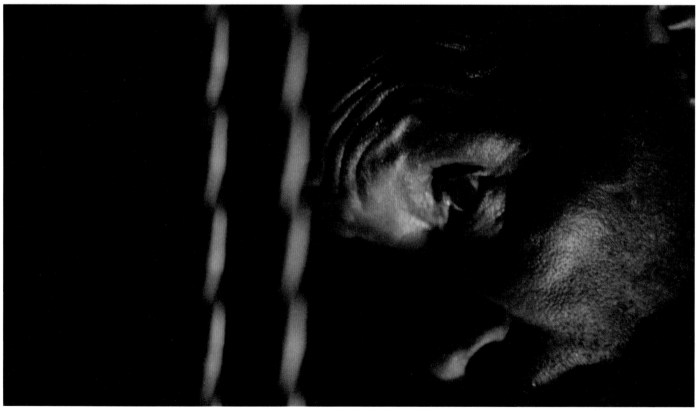

Below it, that's the Kingswood College, technikon college.

> And this is now the Sugarloaf Hill in Somerset, that's along the coloured area. That little mountain was called Sugarloaf because of hardship or maybe poverty or hungriness. Then those days, during some times of Guy Fawkes, we were just fighting with coloureds. We couldn't go up to this hill in those days, because we were fighting, because of the crackers.

Further down there, that's now the Shaw Hall in High Street. That was the second house of parliament in those days.

This was the Grand Hotel before, but now that's the res for the students.

> Then this is, this was the Grand Hotel before. This was where my mother was working, and was cleaning and cooking there. Sometimes she was bringing us some leftover food from those dishes. That was great for us, those days.

And this is the backyard of the Frontier Hotel next door.

And then right on top there behind those trees, that's where the military base is, army base. Below it, that's the new Graeme College, that's the boys' school.

> Then right on top there, that's where the military base is. It is where my father used to work. He worked very hard without complaining, sweeping and cleaning the soldiers' rooms, climbing the stairs and cleaning everything, the bungalows, my father did.

That's again the backyard of the Frontier Hotel next door, a braaing place.

> This is now the Tyre Services Wesson's, but before that it was Cleaning Tyre Services, that's where I started work, before I came here.

That's now the Methodist Church in High Street, Commemoration

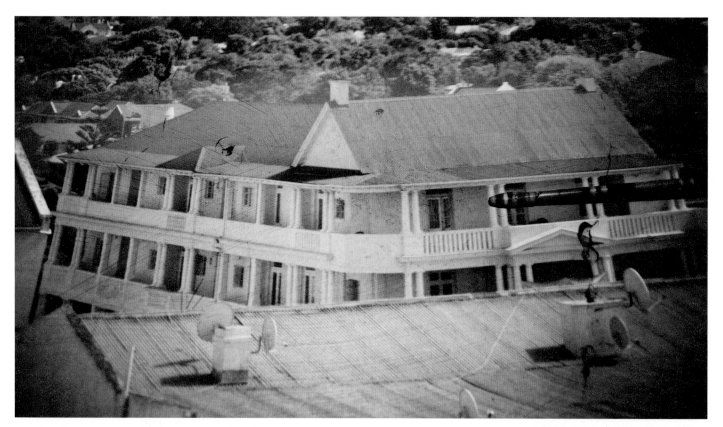

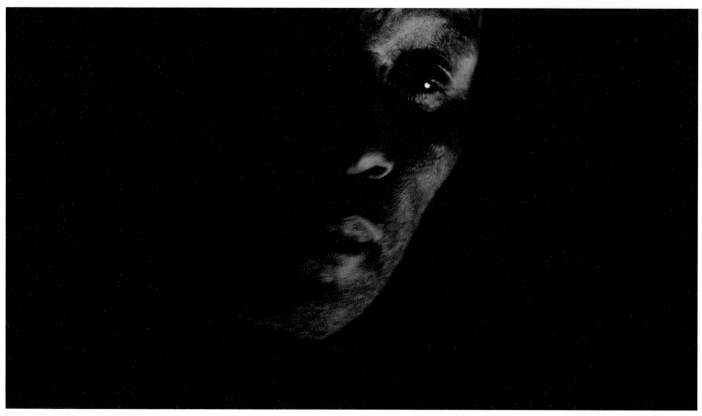

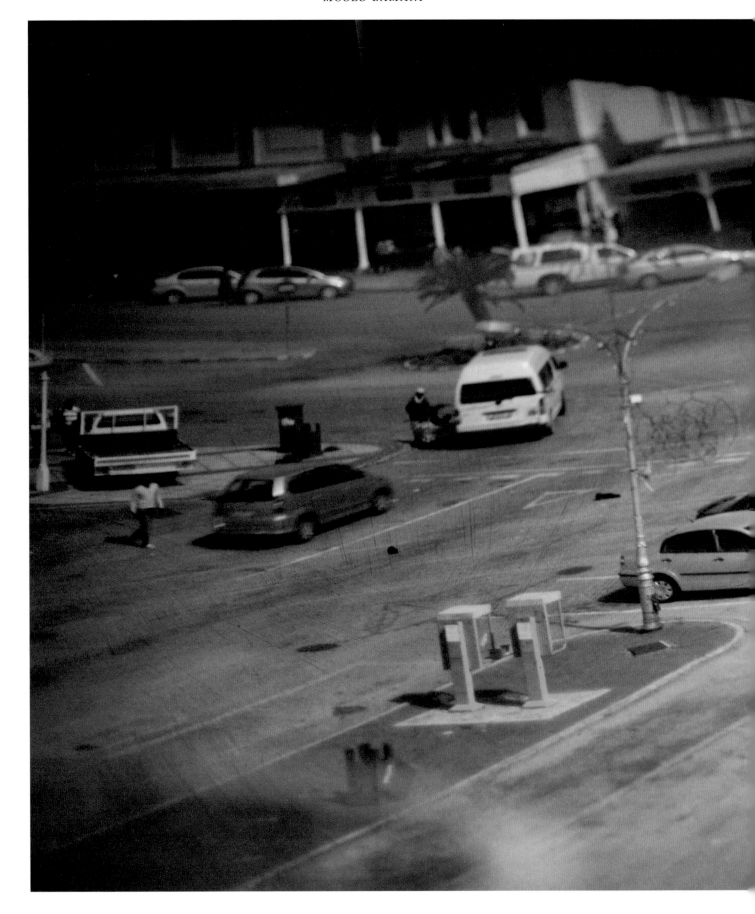

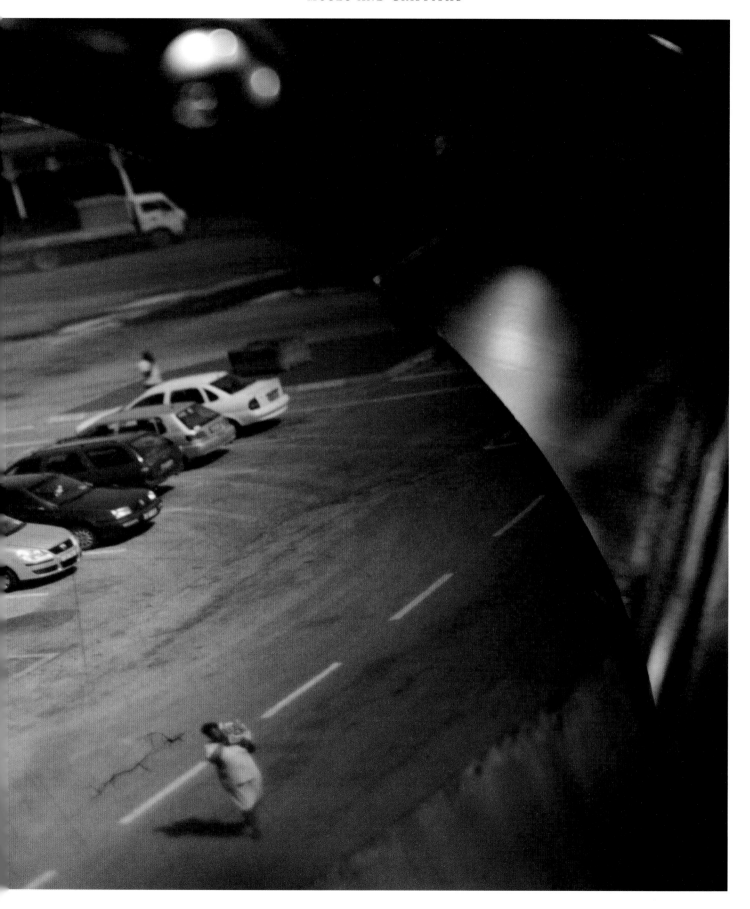

Church, that was established in 1852.

That is also another Methodist Church here in town, but we all mixed now, if you don't want to go to the church in the location, you can come there now.

Then right on top there, that's where the Settlers Hospital is.

Then right on top, that's now the Settlers Hospital. That's where my last sister was born there, Rosemary Lamani. But now is passed away.

And this is the Birch's shop over here, clothing shop.

And that's the Birch's shop over here, clothing shop. That's where our fathers used to buy us clothing, schooling clothes.

That is an angel statue in High Street, Anglo-Boer War statue, 1899–1902.

That is an angel statue in High Street, Anglo-Boer War statue, 1899-1902. This statue was made for peace in between English and Afrikaans people. They were fighting to take over Grahamstown, but English people won the war.

Then, we are just back to our starting point again. So that all makes 360 degrees right around, and that is the end of our tour.

Then, we're just back to the starting point again. So that all makes 360 degrees right around, and that is the end of our tour.

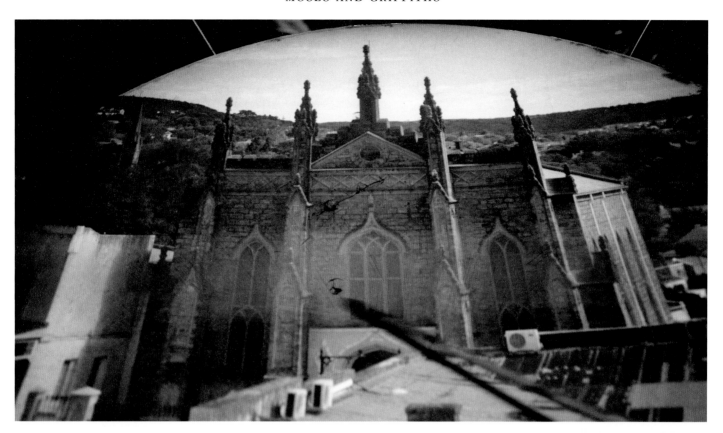

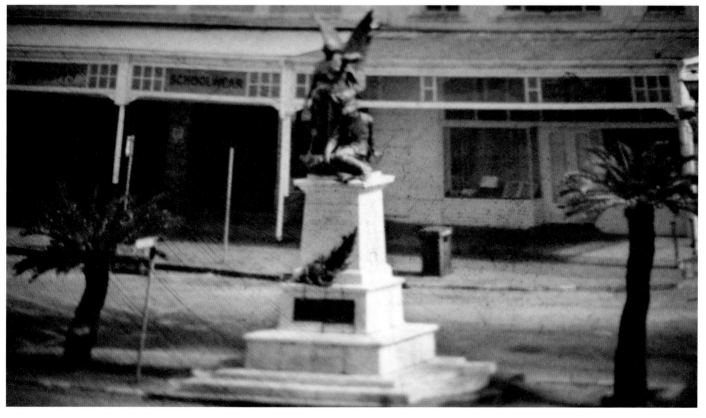

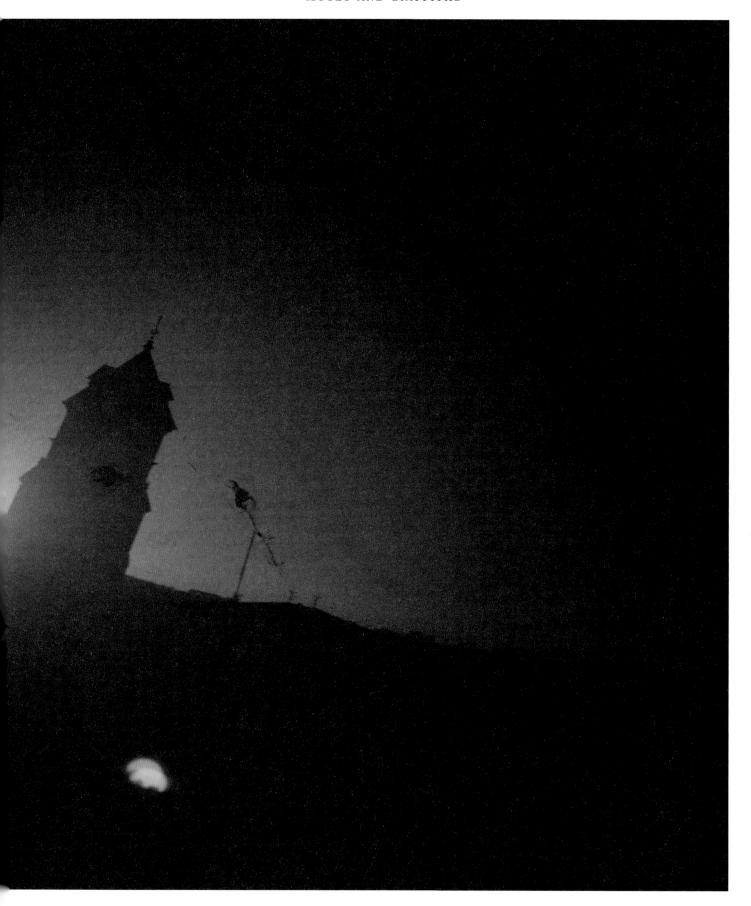

GRIFFITHS

TRANSCRIPTS OF HIS
OFFICIAL AND PERSONAL
TOURS OF THE
1820 SETTLERS MONUMENT

SOKUYEKA

Let me just take this opportunity, this afternoon. Let me welcome you, let me *welcome you* at the 1820 Settlers Monument. My name is Griffiths Sokuyeka. I've been working for the Foundation since nineteen hundred and ninety-two.

Let me again take this opportunity to welcome you here in the 1820 Settlers Monument. I myself, Griffiths 'Boy' Sokuyeka, was born here in Grahamstown. But my family, they came all the way from Bathurst.

Let us start our tour up here in the Yellowwood Terrace. From this Monument, you can see the whole of Grahamstown. Grahamstown, as I've indicated, it's an educational centre. We can also boast about our churches. We've got schools, and it's a historic place. It was founded in eighteen hundred and twelve. Then, it was just a military outpost, this place.

Why I've chosen to be here at Yellowwood Terrace? When I was employed, here, by the Grahamstown Foundation, this is the floor that I was working on. My first job was to sweep this place. I like this Yellowwood Terrace, because you can see now the whole view of Grahamstown.

But today, it's better known now as an educational centre! You know we've got Rhodes University, 'where leaders learn'. But the population of Grahamstown has grown up, daily basis. Because the people are coming all the way from around this area, they are looking for the jobs.

Also, this place reminds me about how the people were located during the apartheid era. You can see the black townships, you can see the coloured townships, you can see the English… you know, all those things. That's why I've chosen this place, you see, that's why!

This building, it commemorates now the British immigrants, who came over the years, and also they settled in this country. There

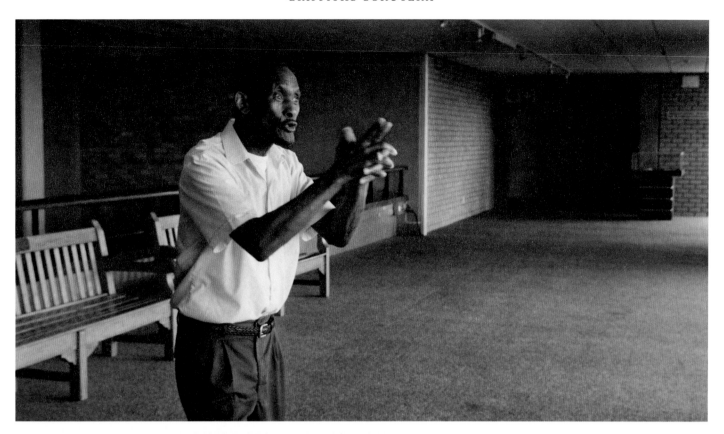

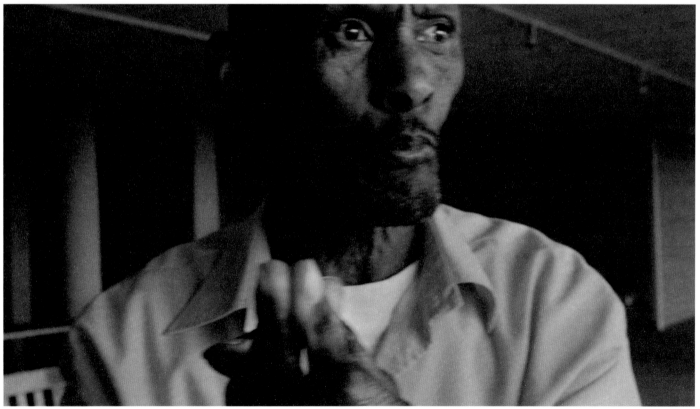

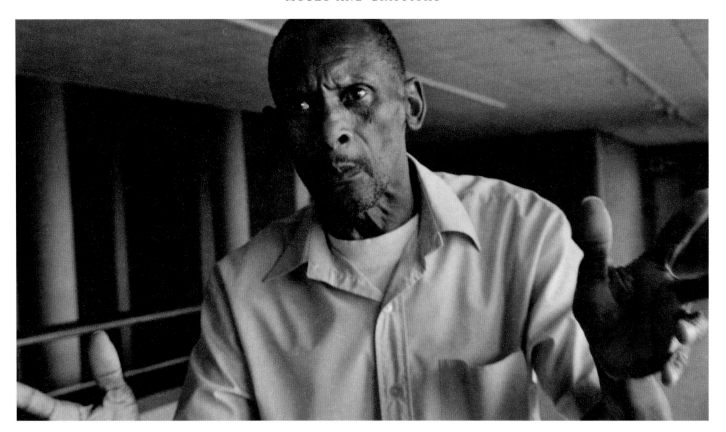

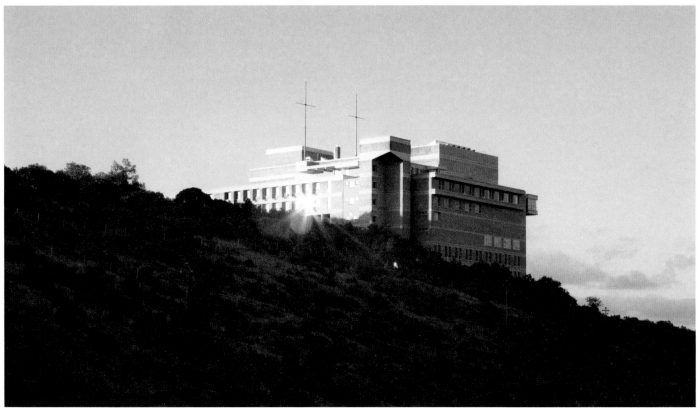

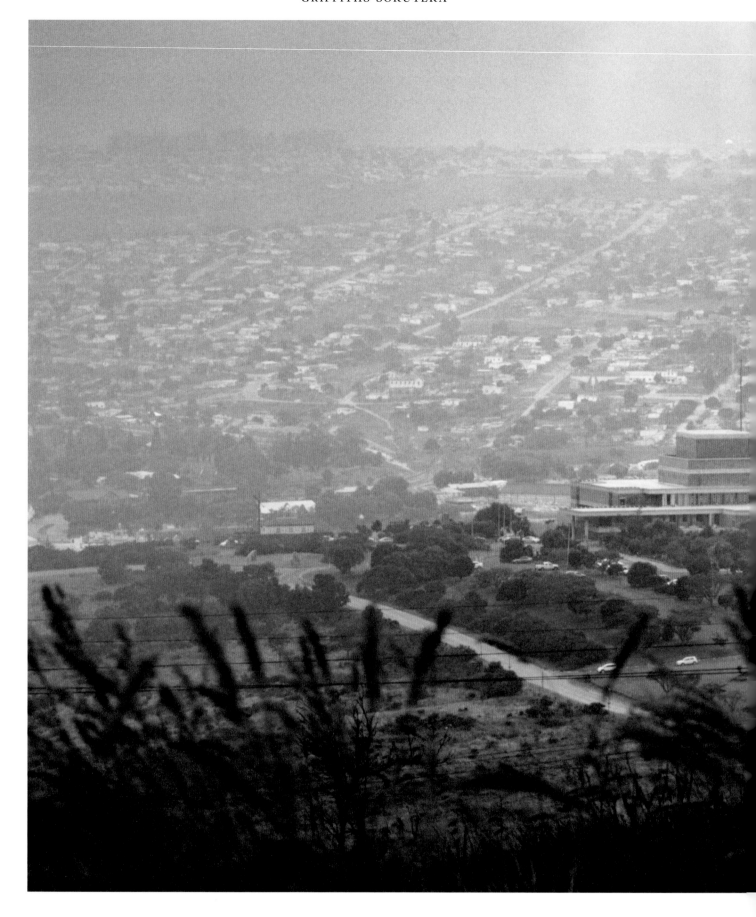

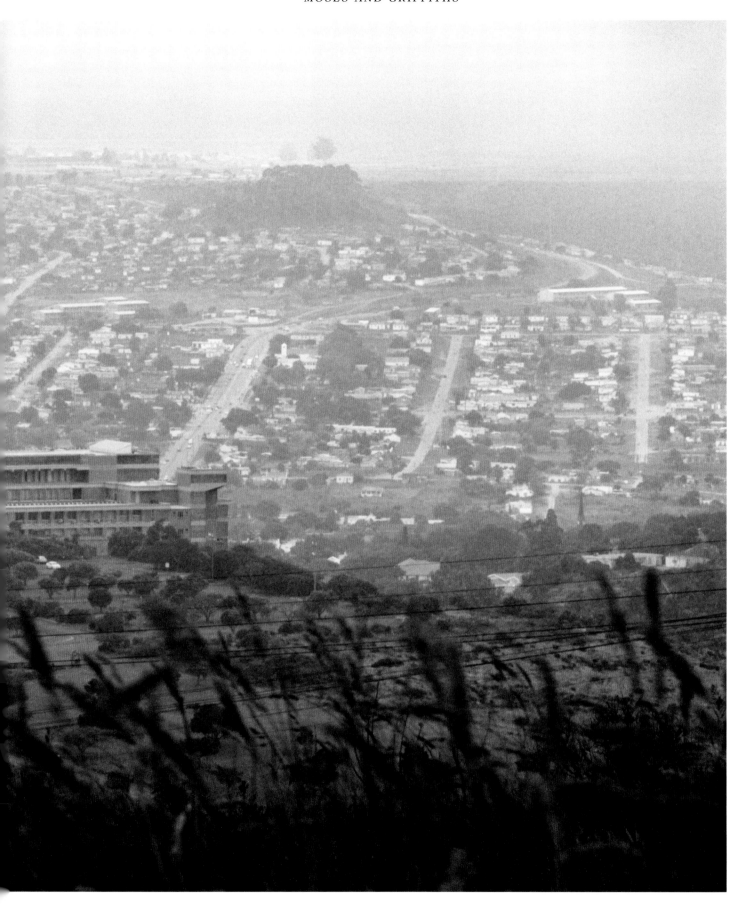

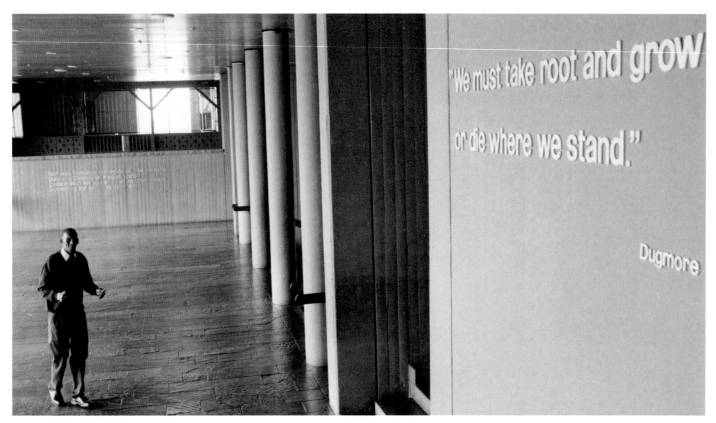

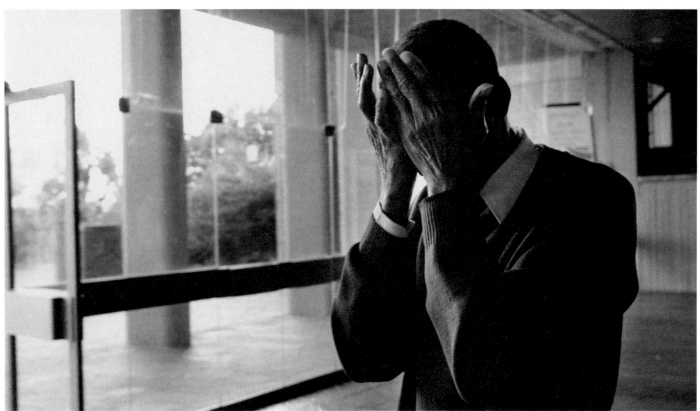

were many types of immigrants. There were missionaries, administrators, soldiers, who came to serve and also to settle in this country.

> Now, before my family come here in Grahamstown from Bathurst, they have to apply at Native Affairs. They must apply a permit. And then when they settled here in Grahamstown, they have to look for a work. Unfortunately, they didn't get any jobs here.

Now, there are other parties, which came after the discovery of the gold and also the diamonds. So those parties come all the way from Britain.

> But when they came here, with that little bit of shilling, they bought a little land here. And then they built a shack there, where my whole family now stays, in this one shack. But I was born here in Grahamstown. I'm a bona fide Grahamstown.

The last party which came in here, that was from Scotland, which was led by Thomas Pringle. Thomas Pringle was a great man. Because he was a Secretary of the Anti-Slavery Society. And also, he fought for the freedom of speech and the freedom of expression as well.

> In fact, I didn't even know my mother! She left me as a little tiny baby. A tiny baby! And they call me 'boy' - 'That tiny boy.' But I can tell you the truth: when I grew up, I grew up with my *makhulu*, old mother. She taught us discipline. As you can see, I'm a disciplined guy today, not like these young guys.

So the people from Britain, they appeal now, they want to apply to come and settle in this country. Unfortunately, only about five thousand of those people were allowed to come and settle in this country. About ninety thousand applications couldn't come. And unfortunately when they arrived in this country, there were some

wars now. There were some confrontations, where these settlers met those people, like Khoikhoi...all those people. Because of the land, and their cattling, there were those confrontations. We call it the Frontier Wars. The last one I remember was on eighteen hundred and ninety. That's the last one. So they've got troubles, you know, people stealing their cattle, all that stuff.

> We grew up on a difficult situation, man. Very, very difficult situation. Everybody in that shack, they are cooking here. We wash inside here. We are sitting here. One room. We are about six of us. We didn't have beds during that time. We have to lie down there on the ground. Only old people can sleep on the bed. And by seven o'clock, everybody must be sleeping.

Let's come to this building now. As I've indicated, this is the 1820 Settlers Monument, which commemorated the British immigrants who came over the years and settled in this country, right?

> So, I went to school at Sub A. You know, during that period, we usually write on the slate. You know slate? We don't have books during that period. But before you go to school, there was a measurement with the government that they apply. And if you don't meet those requirements, they said, 'Go back, you must go and eat some more beans, and then you can grow up.' You must eat some more stiff pap, and then you can grow up, and then you come back here next year. But what about that whole year? Meaning that they were just exploiting us. While their children, they are going to school, daily basis, because there was no measurements for them.

And then again, as we know, in nineteen hundred and forty-eight, there were those elections here. Now, there was English-speaking, there was Afrikaans-speaking in this country. Before that nineteen hundred and forty-eight, this country was governed by the English-speaking, okay? After those elections, this country was governed now by the Afrikaans people, right? Now what happens, the English-speaking people in this country, they've got fears! They've got fears that their heritages and their statues

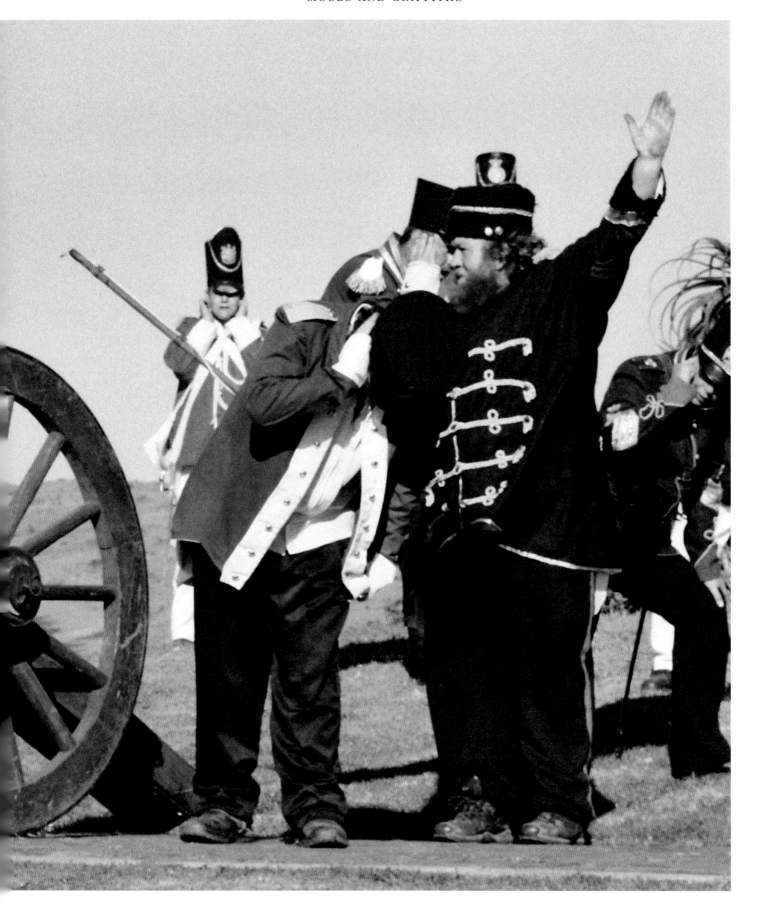

are not going to be recognized by their new government. Hence they said, 'Okay, let's build now this house.'

I went to school at Moyake, I went to Andrew Moyake High School. I passed my Standard Nine there. And I went to college, it's in an old rural area…Transkei. I go there for motor mechanic. Because during that period you know, the white people…in fact, I mustn't say 'the white people' - I must say 'the government' of that period, let me put it that way. I mustn't do that…I must say 'the government', those people who were in government of this country. They said, 'Okay, you must go and learn in the Bantu states.'

And there were quite a number of questions, which were raised by people. Why is it chosen to build this monument in this site, why? So the people they just go to the community, they say, 'Listen man, we want to build a monument here in Grahamstown.' You see, they are selling that concept to the people. So when they went outside to the community, the community said, 'Okay, that's a good idea, let's build the monument here.'

So I went there and then I learned there for three solid years, and then I came back. And when I came back, I couldn't get work. I can't rely on my sisters and other people, I'll have to do something for myself. So I went to town, looking for work. Fortunately I got a job, as a petrol attendant. Early sixties - no, early seventies. During that period when there was that…that toyi-toyi, you know, the world wasn't stable at all. Because people they went to riots, they want to change things. Nineteen hundred and seventy-six, there was that…massacre. I was working as a petrol attendant during that period. But after that, I thought, 'No! This is not my right place, this one. This is not my right career, this one. I can't waste my time here.' And I was always saying to my mother, 'Ah, I don't like to work on that garage man. Ja, you know those people there at the garage, they always call me *kaffir*, all those things, I don't like those things. Call me *native*, 'Come here native, come and pump my tyres', all that stuff. I was really bored with that, I couldn't take it any longer.

The other reason why they build this house is because Grahamstown lies on the Garden Route. Quite a number of cars pass that route. So now with these statistics from the Department of Transport, they said, 'Okay, there is a need,' build this monument so that they can attract the tourists as well.

> I was just fortunate, because there is a guy who was the supervisor here at the Grahamstown Foundation during that period. His name was Ben Madolwana. He had a relationship with my family as well. And my mother told him, 'Listen here, man. I've got my son here. He's looking for a job, you know. A decent job.' Then this guy told me, 'Okay, I will try. I'll tell you when something comes up here.' Fortunately, there was a vacancy. So actually, when they employed me here, I was a sweeper, let me put it that way to you. Now, that was a cleaner, you see. That's the first opportunity. Now the doors are a little bit open, we are getting there now!

Now, before the monument was built, they said, 'Before we build this monument, let's build a stone outside there.' Now that stone, that's a blessing stone. That stone was unveiled in nineteen hundred and sixty-two by the first State President of South Africa, that was C.R. Swart. So he opened that stone over there in dedication of the settlers' achievements. What they've done for this country.

> Fortunately, I got that job. The very first day I've taken all the tourists from Britain on a tour. That tour of mine was successful. And Ben Madolwana came to listen. And he asked me, 'Where did you get all those things?' I told him, 'Listen here, I'm a guy who always researches, I don't sleep, I don't play around. I go to the libraries, I call the libraries down there, I always ask *why*?' In fact, I told them, 'Listen here, I'm a curious guy, I was really curious because you've got a big huge building, why do you build this building? What was the reason? What was the objective?' All questions must be answered.

They started building in nineteen hundred and sixty-eight,

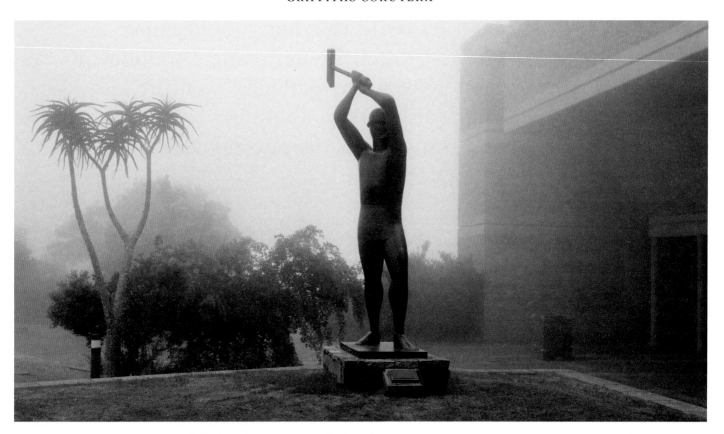

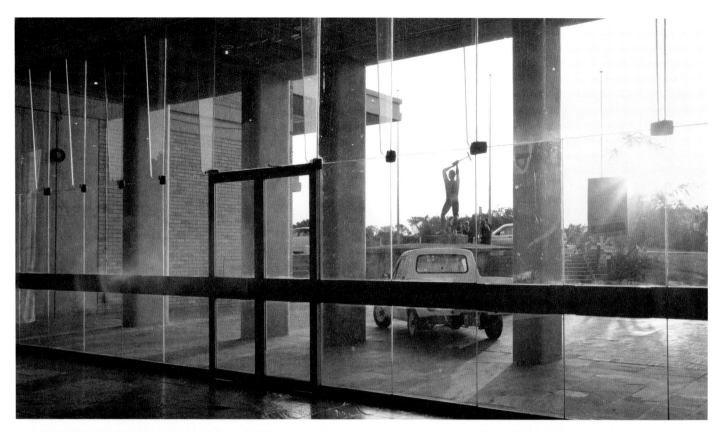

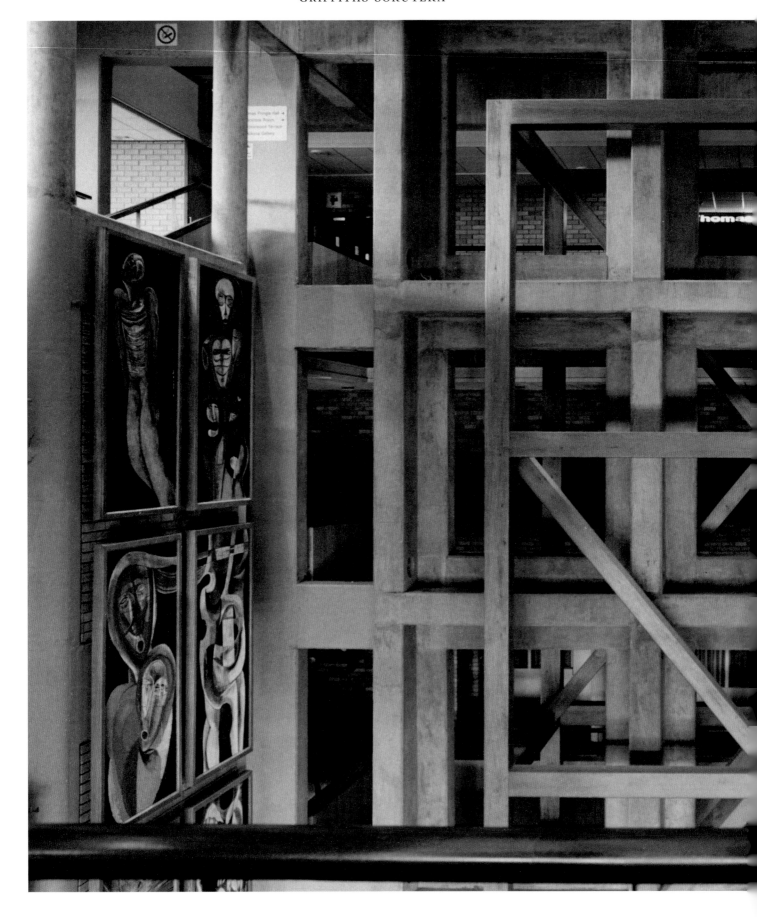

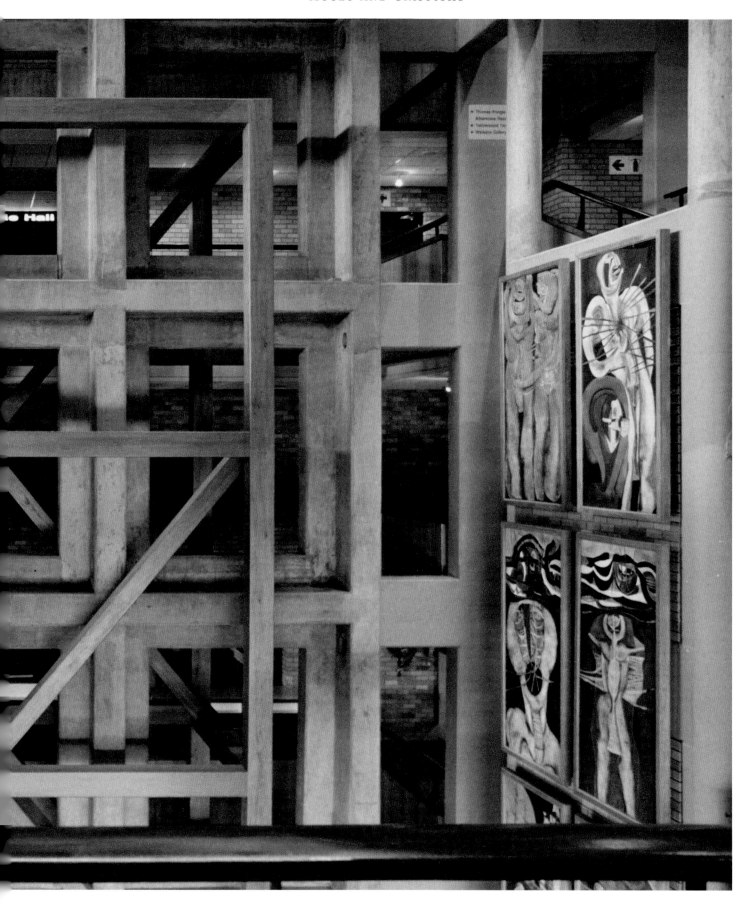

all right. It fulfilled now that imaginative concept of a living monument. Promoting the freedom of speech, social interaction, and also the use of English language in this country. That was their main objective: to promote that English.

> Ben Madolwana retired from this building. He was my mentor here. After retirement, unfortunately, he died. He left me behind. He said, 'Listen, Griffiths, my boy. Never ever disappoint me there. Never ever. I trust you, my boy.' That's what I'm doing right now. I filled those boots, size ten boots. That's why I'm here. On the first of April, I'll be twenty years working here. I'm going to get my honour for twenty years. For loyalty. Loyalty and discipline.

Let's go down these stairs.

This is our focal point. Also, this is the heart of the monument. And also, this is a symbolic area, let me put it that way to you... it's a symbolic area.

> If you go straight up this road there, I was born at number one Victoria Road in the location there. Just right there, you can see it nicely from up here. That's where I was born.

Now, right at the bottom here, that's a fountain. They call it the Milestone Fountain. It suggests the needs of the people – what we need, and what we produce. For instance, we need water, we need bread, we need tea, all those things. That's suggested.

> There was that Group Areas Act during those times. Group Areas Act. So we were allocated there. That's where I was born. And when I was about eighteen to nineteen years, they said I must go and apply for a *domboek*.

Now, just around the fountain you see there's a quotation there. 'That all might have life and have it more abundantly.' Now that quotation is from St John's, chapter 10, verse 10. It expresses the need now, of the Foundation itself.

Yes, *domboek*. You have to carry it out all the time. When you go to town, whenever you go here, you have to carry that *domboek*. If you don't carry that *domboek*, you are going to the prison.

Now during that period, when they build their houses, they use that timber, that yellowwood. Now that yellowwood structure, as it stands there, it represents the Union Jack, with the cross of Christ. And then, you can see there's concrete in between. Meaning that the Britons, the South Africans, they were trying to match and also to bind their culture as well. Do you get my point? And you can see this building is concrete all over the place. Meaning that there are more challenges. Daily basis, when you wake up, you know that 'I've got a new challenge'. That symbolizes that.

So those were the things that were happening to us. You see those things, they were just hurting, hurting, hurting, you know? But today, we got a better world now… Ja.

Let's go upstairs to those murals now.

Now those are the 'Settler Murals', right – 'Settler Murals'. They were commissioned by the Grahamstown Foundation and they were designed by Cecil Skotnes, and then they were executed during the National Arts Festival by year nineteen hundred and eighty-six.

Now, unfortunately, we can't see that, because of the mist here. There's some trees over there. We call those trees 'Makana trees'.

Those Settler Murals over there, they represent the journeys of the 1820 settlers, their challenges, and what they faced.

Now, we call it in Xhosa, *endaweni yezono*. *Endaweni yezono*. That place was very, very important during those times.

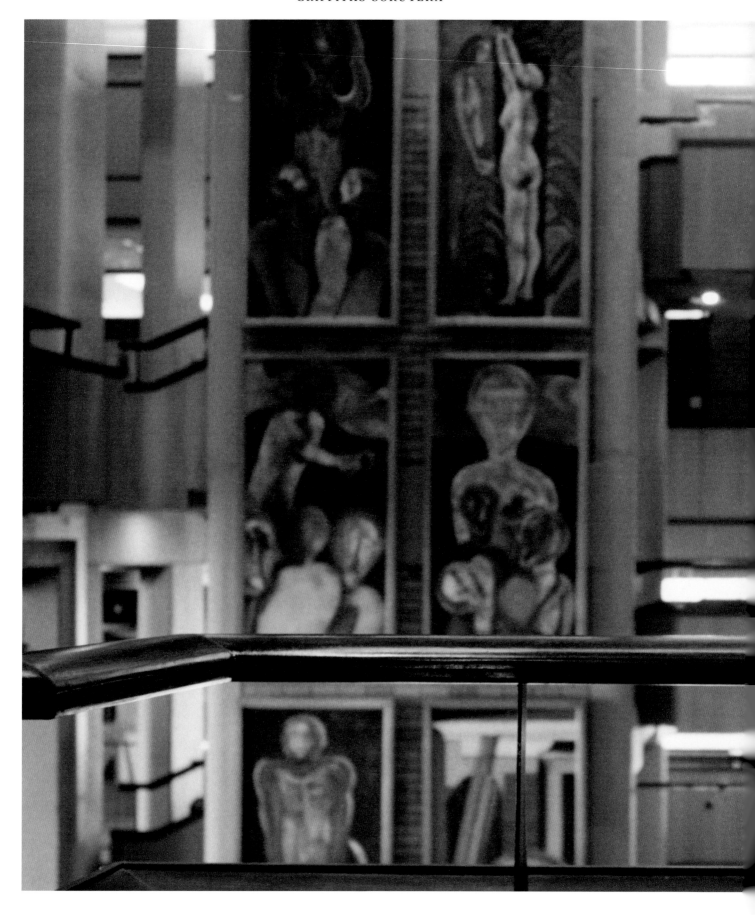

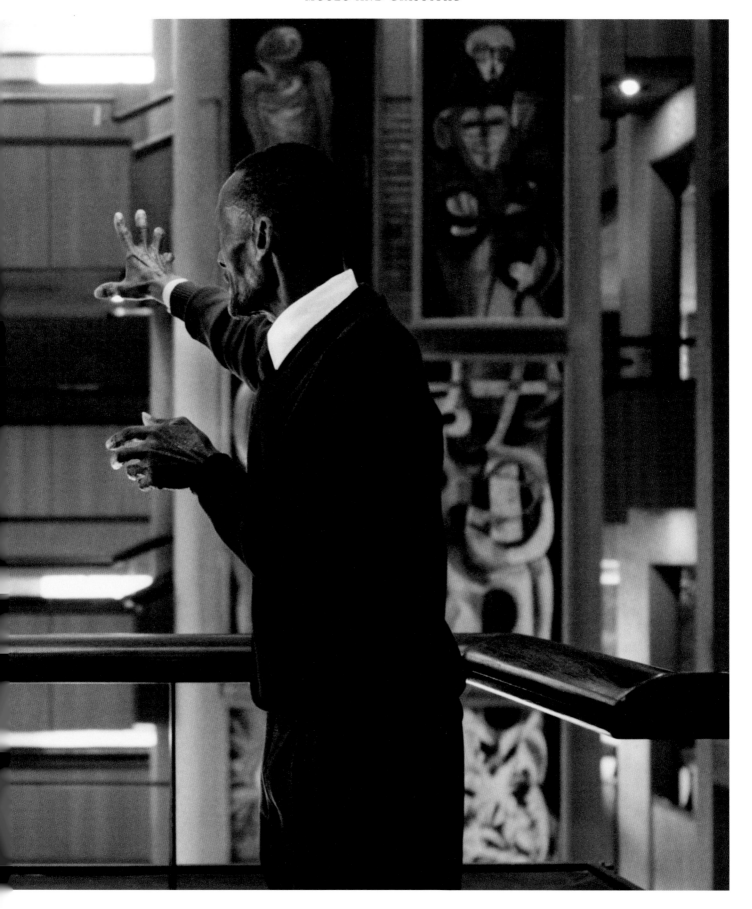

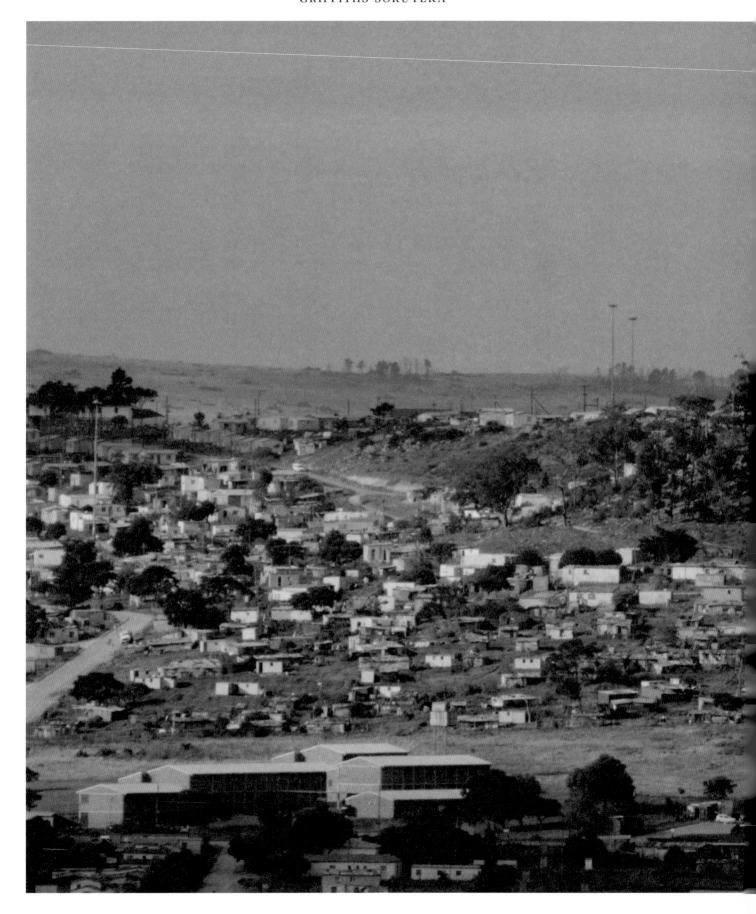

Because why? If you've done something wrong, it's a place whereby everybody goes up there to confess. For example, you've just killed somebody. You go up there with ministers and you confess there. 'Yes, I've killed Griffiths "Boy" Sokuyeka. But I come here to confess now.' You can ask everybody who was born in Grahamstown during that period, I'm not joking. That's the truth.

Now, right at the top there that's Bondage, and the other one, that's Cruelty. And then right at the centre there, that is Starvation, and also that is Exile. Now, during that time, those people at Britain, they were actually depressed after those Napoleonic Wars. They didn't get food, they were starving. They were depressed. Now, they say, 'Let's go to the other places,' like South Africa. 'Let's go to South Africa, and get some green pastures, there.'

When there's a drought outside here, there's no rain, there's nothing, nothing. We just go up there to that hill. Everybody's carrying one stone. We just go up there. We sing. Church songs. We just put all those stones down there, and then we pray. When you go home, the rain is falling, *waaah!* Can you believe me? You ask Moses about that, he'll tell you what I'm saying is true.

That was a very important place to us. We usually go there and also clean it. That's a spirit place, a place for our ancestors.

At the top there, those were the spirits of their own. And then on the other side, those were the ancestors. When they came here on this land, they said, 'Our spirits, our ancestors, they're going to be here now.'

Now, right at the centre there, when they landed now in this country, let me put it that way to you, they came up with a new people they never ever seen before. They see those people, like Khoikhoi people, Xhosa people, they never seen before! I don't want to use this word, there's a new word that I don't want to use...'Coloured' people, let me put it that way. But they put it the

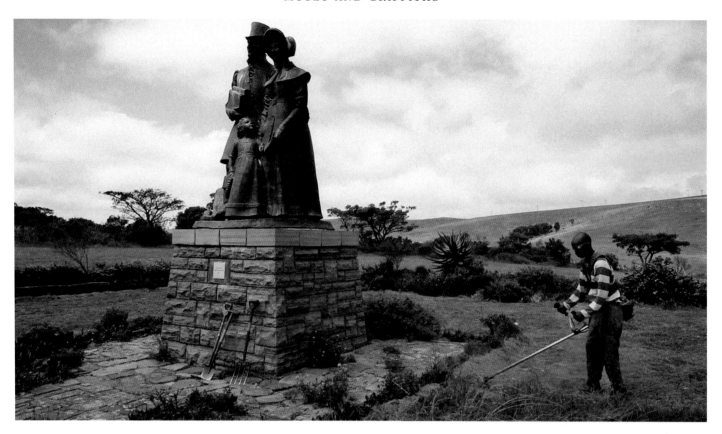

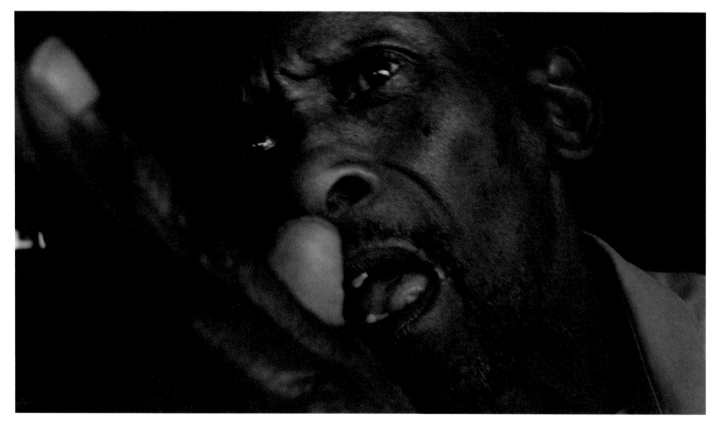

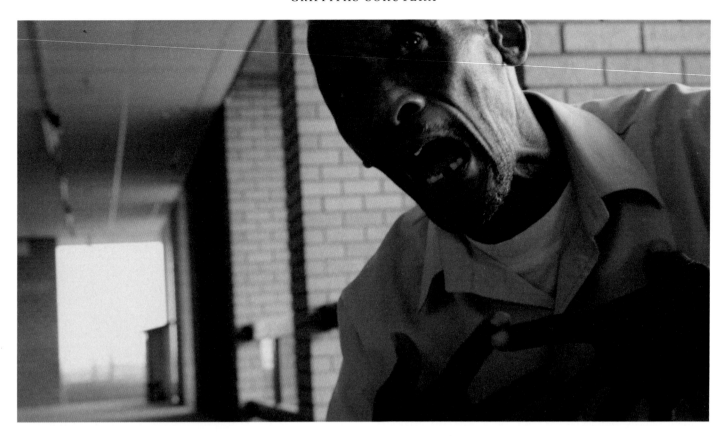

other way, you get me, that word. But I don't want to put it that way. It's the new South Africa now, okay.

> But things have changed dramatically today. Dramatically. After this new dispensation, things have just… I don't know. I still remember one day, there was a minister who came all the way from the other location and he passed the Makana trees. When he passed there, they just assassinated that guy. Stone dead. A minister. The kids these days, they are using those drugs. Stone dead. So, it's not a holy place now, that one. I'll put it this way, it's a devil place. And I'm not changing what I'm saying, that's it. That is bottom line. Because today, the people they don't have respect.

Those people now, they are prehistorics, they were cattling. And then the British people, the immigrants – let me put it that way, that's a better word – the immigrants who came over from Britain, they brought themselves those horses over there.

> And today, *ubuntu*, *ubuntu*, *ubuntu* is gone. That is respect, loyalty and discipline. All those things, they have just been taken from our nation. It's very bad. Very bad for the new generation.

Now, right at the bottom here, those were the confrontations, because of the land and also of the cattling. So those Frontier Wars, they started from the Sixth up to the Ninth, nine Frontier Wars. The last one, the ninth one, was in eighteen hundred and seventy-seven. So when they settled there, they settled on a troubled Cape Colony, let me put it that way to you, 'troubled Cape Colony'.

> I don't even walk in the evening there. You can't. It's a bad place. I would rather live with the animals in these days. With my dogs, cats. That's it.

Now, we have talked about Panel A and Panel B; those are the beginners, and the others were the frontiers. Now, we are going

towards a new society. So, after those confrontations, they sit down and they discuss, 'Okay, enough is enough now. Let's go for a common mother's land.' And then on the other side there, our labour. 'Let's produce now *isiqhamo*.' Those were the gathering of the fruits. With their labour, they should produce fruits, *isiqhamo*.

> And I must indicate to you that when I grew up, I was a tiny guy, you know. I played rugby as well. I always love rugby. I always watch it when the schoolchildren in town play rugby, like St Andrew's College, Kingswood College.

And then right at the bottom here, they fought again, for the right of freedom. And also, they fought again for the right of staying. As you know, people were located during that period. So, they fought for those things: freedom of speech, freedom of location. If you look there, you will find out that there is a location for Xhosa people, there is a location for the coloured people, there is a location for the white people, you see. So people were located. That was the right of assembly. They fought for the right of assembly. And also, they fought for the right of justice as well.

> When you watch rugby, you cannot go beyond that fence. Only white people were allowed to sit on those nice stands there. So all blacks, we're just watching the rugby there. And we like it. Sometimes after rugby, all those boys would be like, 'Hey, you kaffirs, go home, man, go home, kaffirs. Hey, you natives, it's too late now. You'll have to run, go home.'

Right at the bottom there, with the discovery of the gold, and the diamonds. Now, we need labour for those things.

> Do you know that here in Grahamstown, by nine o'clock there was a bell here at the cathedral. That bell was meaning that the natives who come and spend time in town, they'll have to go back to the location. They don't need any native here anymore. Only those ladies who are working for those bosses.

Now, on the bottom one there, those were the architects. We need people now, skilled people now, for building the bridges, building the houses.

> If they find you looking around in the town in the evening, the policemen are going to take you and put you behind bars. They don't compromise, they say, 'Ah, oh, no, this is a baboon, man. Three months.' They call us all sorts of…you know. I must indicate that. That's how I grew up.

Now after all these wars, and blah blah, all these things, now the people want to express themselves, they want to fill themselves. They say, 'Let's build the theatres! Let's go for the art now!' That's poetry and theatre there. At the centre there, you can see those people are singing there! Songs and music, people are dancing, going for operas, people watching all the drama. That's great!

> You know exactly the feeling, at about half past eight, when you must go back to the location. You must leave all the things that you are going to do here in town, just go to the location. Sometimes the people, they come up in the afternoon for church services. At cathedral of St George. But they don't want us to go to that church too.

The panel right at the bottom there, those were the greatest gifted languages. Now, when you talk about languages, we are talking about the mother's tongue. I'm a Xhosa, I am speaking Xhosa. I am fluent in Xhosa. That's my mother's tongue!

> There was that apartheid. That was that discrimination, you see? They said no, we blacks must go to the blacks, whites to the whites. So those are the things which we experienced during that period. But anyway, I'm here now today.

Now, the last panel there, the very last one, those are creative spirits. You can see now the birds are flying. There's a peace

now, after all those frontier wars, blah blah, there's a peace. You can see the birds are flying over there, *prrr*, *prrr*, birds are flying! Peace is maintained now, peace is maintained after all those things.

Are you happy with that? When I talk about those ones, I can feel it here. I can feel it. I can feel it. Because I like those panels. They are just uplifting me, all the time.

> You take whatever you need there on your camera. You can go anywhere with those, I am not worried about it. The truth is the truth, that's it, finished and *klaar*, that's the bottom line. I don't beat behind the bushes, I just go straight. That's how my mother taught me.

Let's go now to the other side.

We usually use this room for those exhibitions. And also for photographings, they put up over there. And also for the exams. We've got conferences also...those are the breakaway venues, you see. Now, this is Thomas Pringle Hall, this one. They use this one for the weddings as well. People just come up and do their own things.

Are you happy? Okay! Great! We can go now to the auditorium.

> So here are the pictures of that fire. The one that started in the auditorium in nineteen hundred and ninety-four.

Let's start with these pictures now of the auditorium. You can see over here how this place was damaged after the fire. The fire of nineteen hundred and ninety-four. Before, the seating was orange. And then you can see after the fire, it's a new one which is blue. Most impressive, that new blue one over there.

> But when this place was starting with fire, I was on duty, I was on duty! Two of us were looking after this building. And it happens about 2 a.m. in the morning. We thought there's a leak of water somewhere, we can hear something. But we can feel it! Smoke, man! So the fire started right inside there in

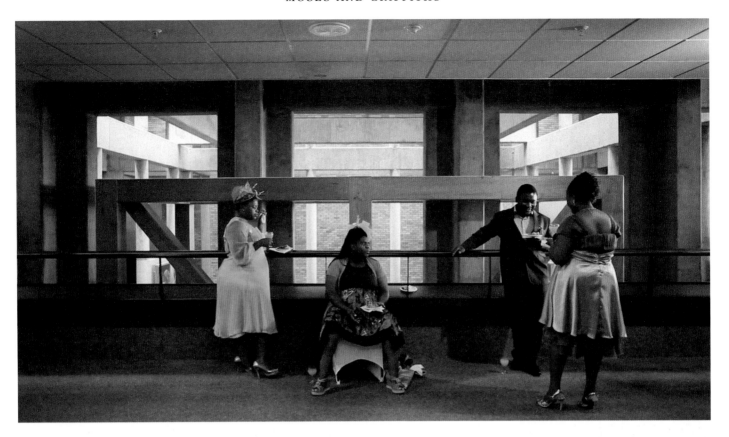

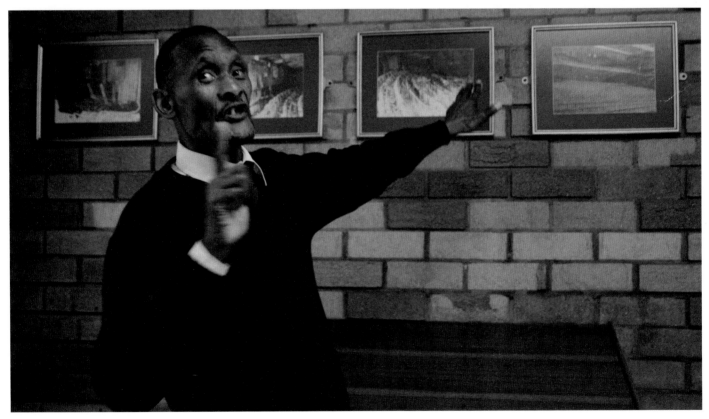

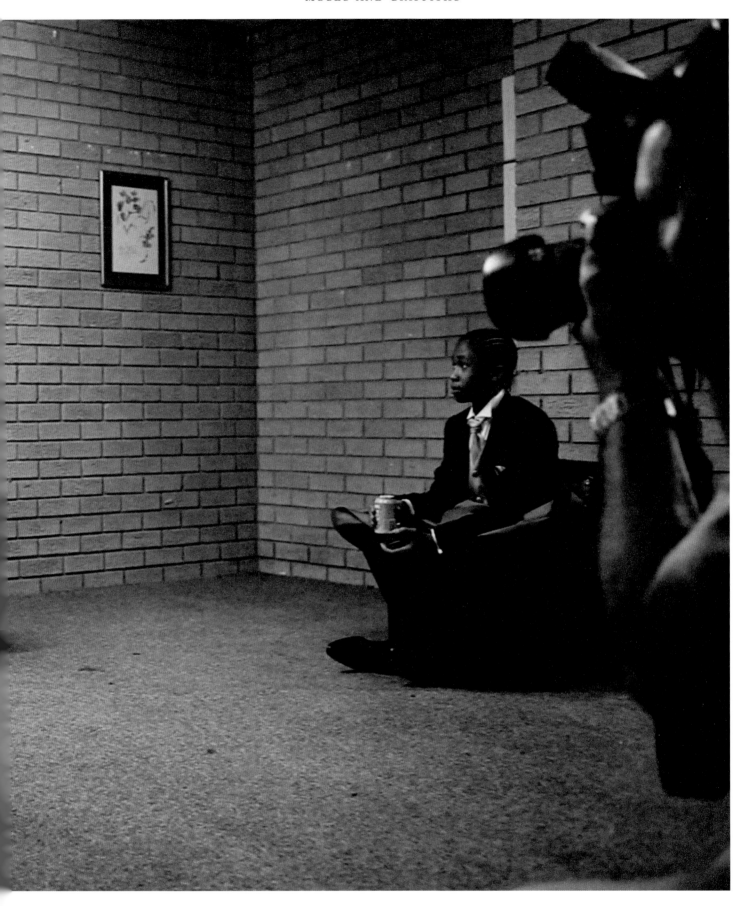

the auditorium, and it was just *whoosh!* And that evening, it was cold and it was windy. And we had to rush and go to the phone. Then we just dialled for the ambulance, I mean for the fire brigade, to come up here. The minute that I put down the phone, everything just went out, *pshew!* Just like that. We had to run out to save our lives.

So, as I've said it started nineteen hundred and ninety-four, and then it cost plus-minus thirty million rand to renovate the whole of this place after the fire. It's a miracle that they found this money to renovate this place. In time for our new dispensation here in South Africa. A miracle.

But unfortunately, that management, that first management over here, they were really arrogant, I must be honest to you. Because thinking that…we set up the fire with this house - Ja!-we have to go to…to the police. They take us down to the police, man! We have to…they want statements from us. I've told them what happens!

They were just up and down, up and down, daily basis! You can't even eat. When you start eating somebody's calling you: 'You must go and account there what happens, blah blah blah.' When you come to the work, your heart is very sore, my friend. You don't feel like coming to work, no, no. You feel like saying, 'I don't feel like coming because I know I'm a culprit here in this building.'

Now, this is our auditorium. It's where the fire started. Right in this auditorium. But today, this is one of the most impressive theatres in the African continent. The seating now is nine hundred and forty-eight. Now, we've got the better lighting as well. At the front there, we've got the orchestral pit. When they're going to play orchestrals, they just come up that way. So that is the stage. We've got a huge stage, and also we've got a side stage as well. And right on the walls there, we've got also the acoustics as well. Very, very good acoustics we have.

Thinking that this fire was politically motivated, they said, 'Okay, these blacks, these blacks' - I repeat - 'these blacks,

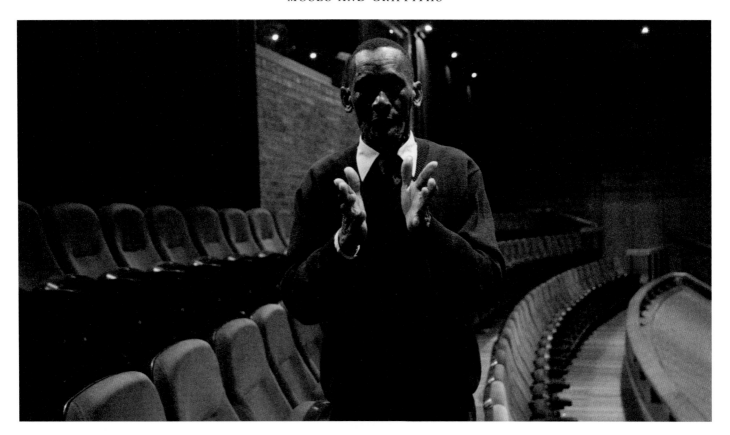

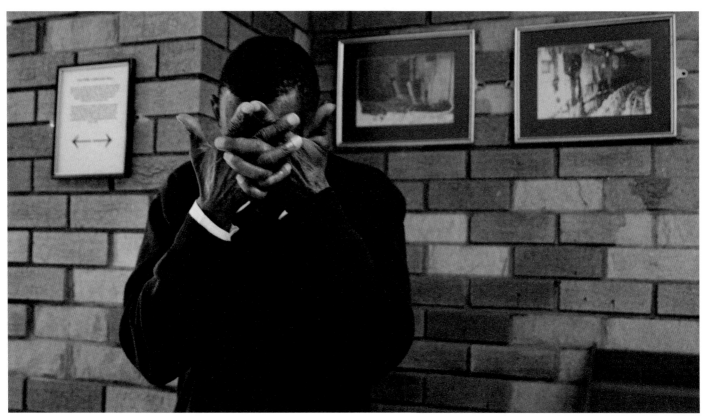

they are responsible for this. They know exactly what happened here.' That happened almost two solid months. And I thought, 'No, no, no, I must resign here. I can't take it any longer.' I've spoken to my family, and they say, 'No, don't resign…go for it.'

At the end of the day, they found what was the cause of the fire. There were the mouses in this building, whereby they ate all those electrical cables. And then they…they caused that conflict. And then, we were just…

This auditorium, they utilize now for different activities. Rhodes University, 'where leaders learn', they utilize this place for their graduation ceremonies. The schools of Grahamstown, they come up here for their prize-giving ceremonies. And also, this place is utilized during National Arts Festival.

This building, it was twenty years old when the fire started. Unfortunately, when they built this house, they never put those sprinklers in. That's why they couldn't extinguish that fire right at the beginning, because there were no sprinklers. But today, you've got those sprinklers as well. 'Once bitten, twice shy.' Isn't it?

That was nineteen hundred and ninety-four. The thirteenth of August. I will never ever forget that day. Until I die. It's always in my mind here. But today, I've still got a query. That management, they were arrogant, they never ever apologised to us. I've still got that in my heart. Still here. They owe us an apology, what they've done, because treatment was not so good. But because I love my work, because I love the Foundation, I love this building, because I know this building…our schools, you know, especially black schools, they benefit from this building. That's why I love it. That's why I keep on saying, 'Okay, I will work for the Foundation.'

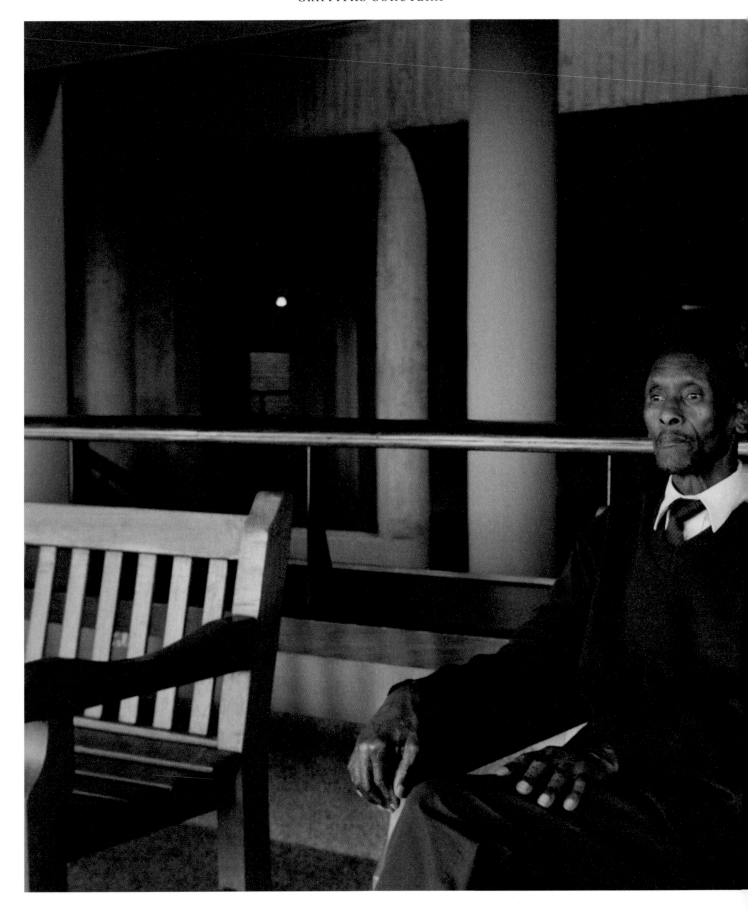

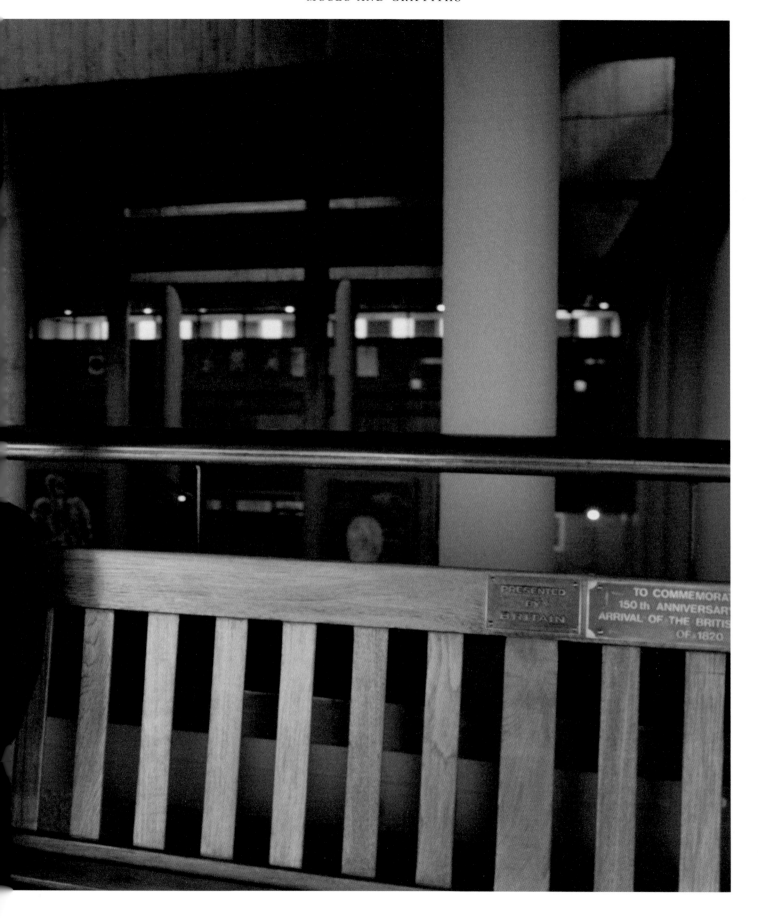

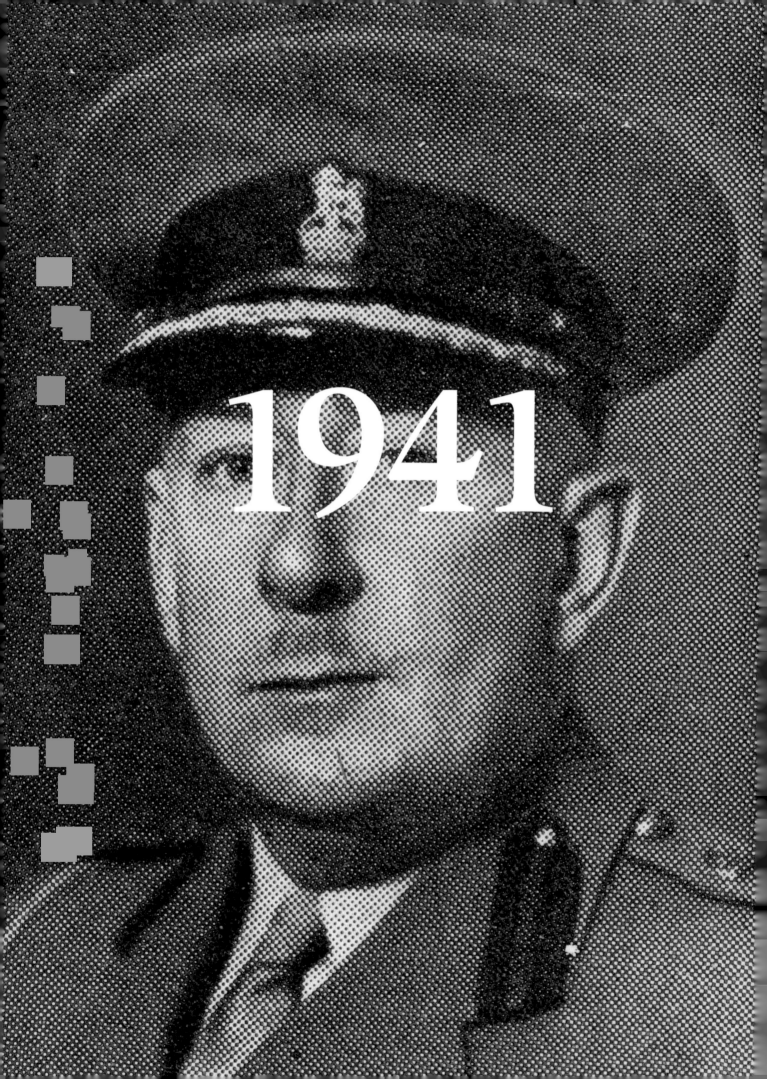

1941

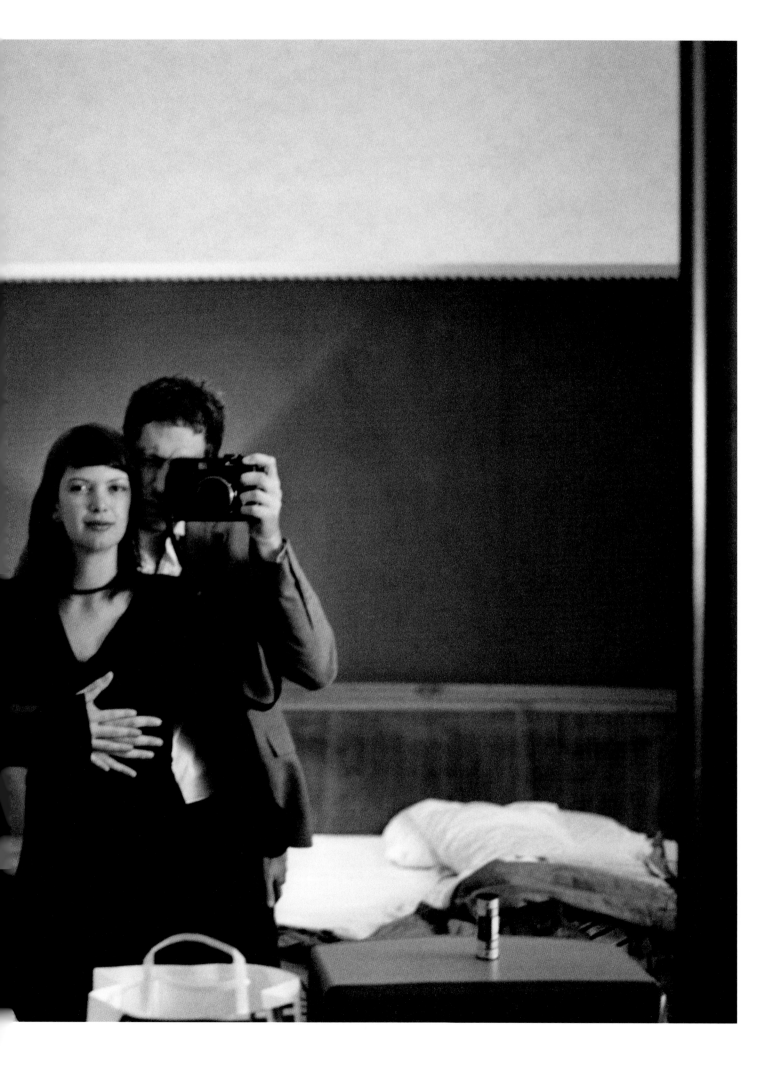

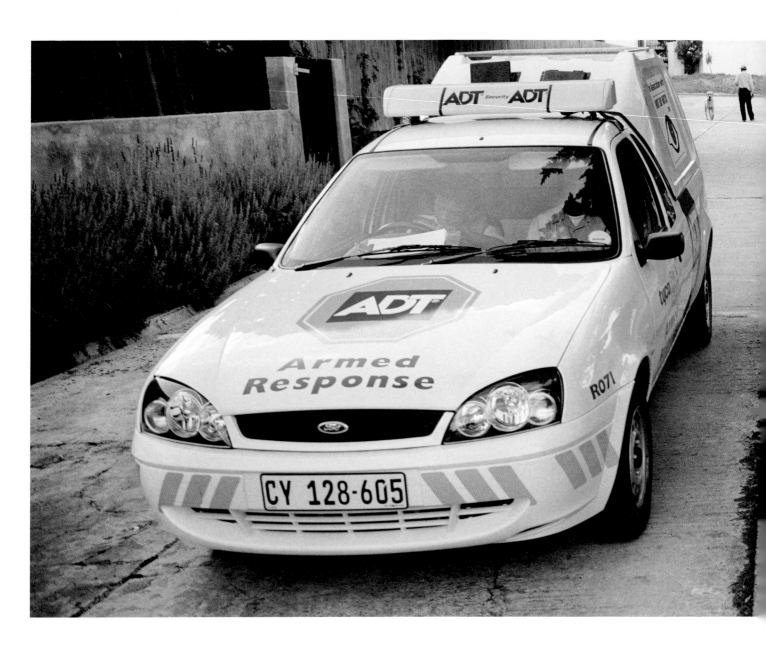

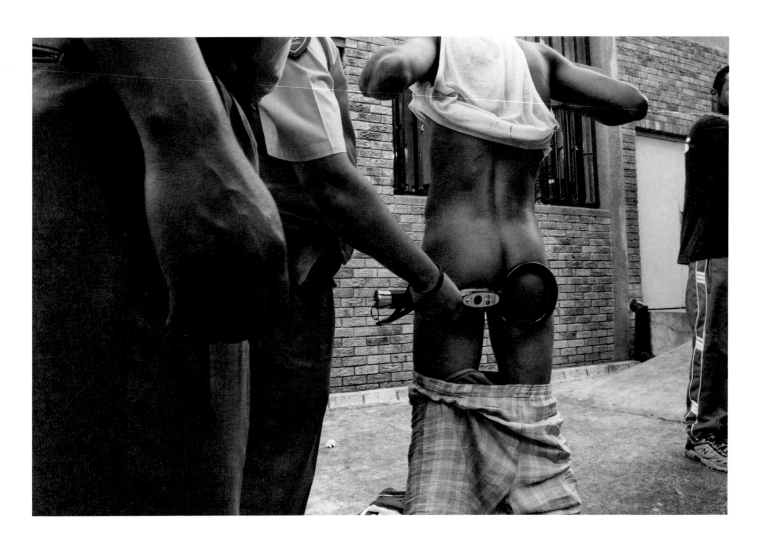

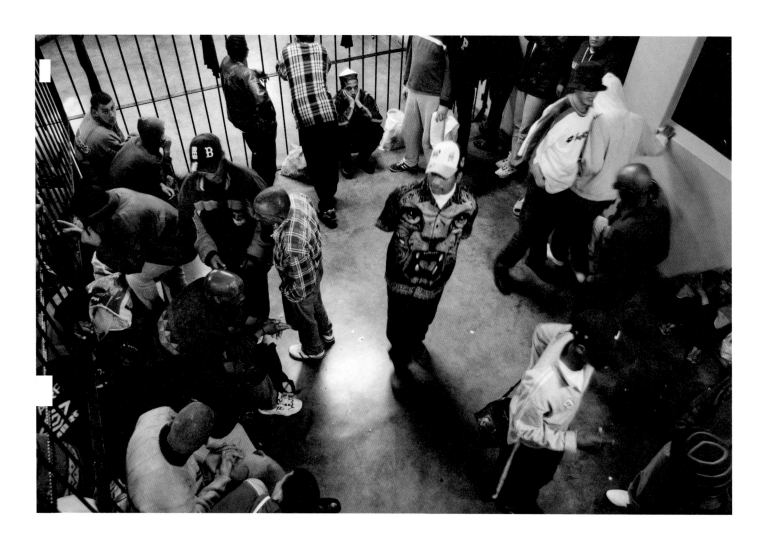

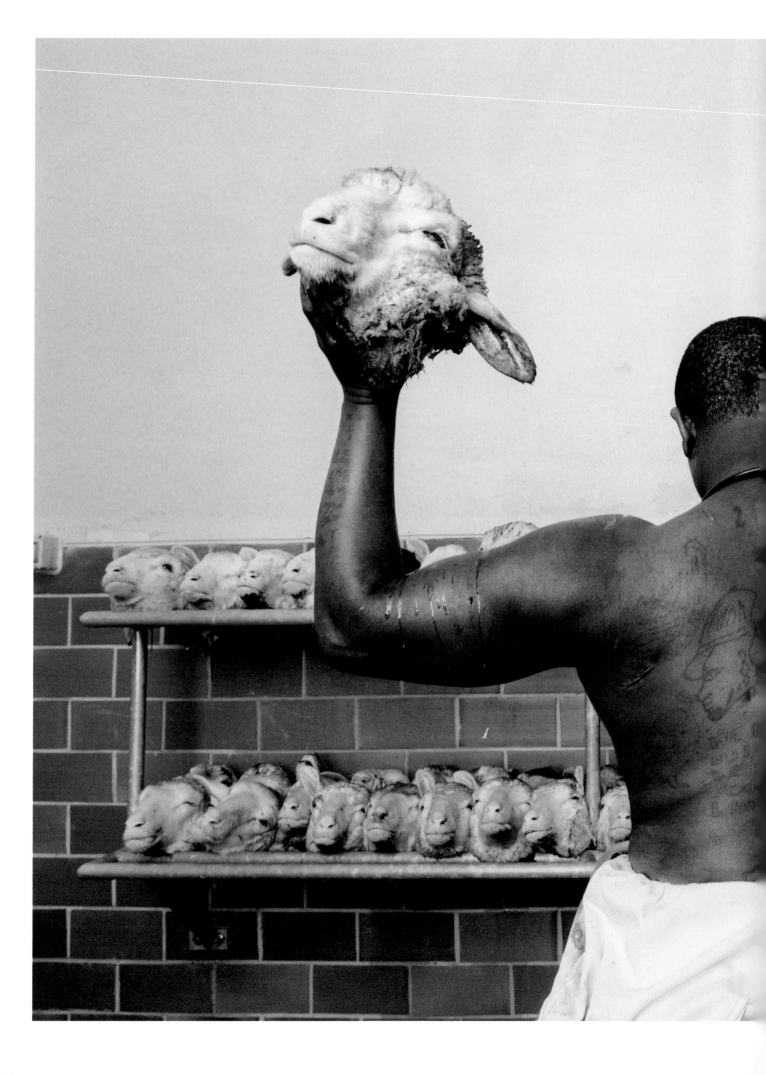

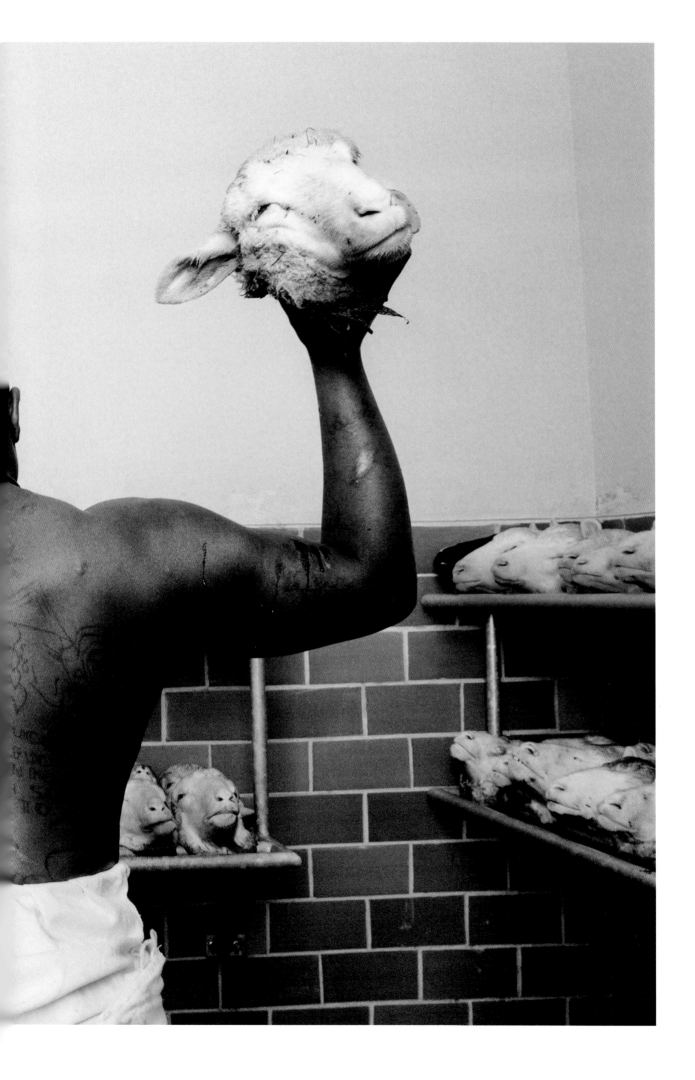

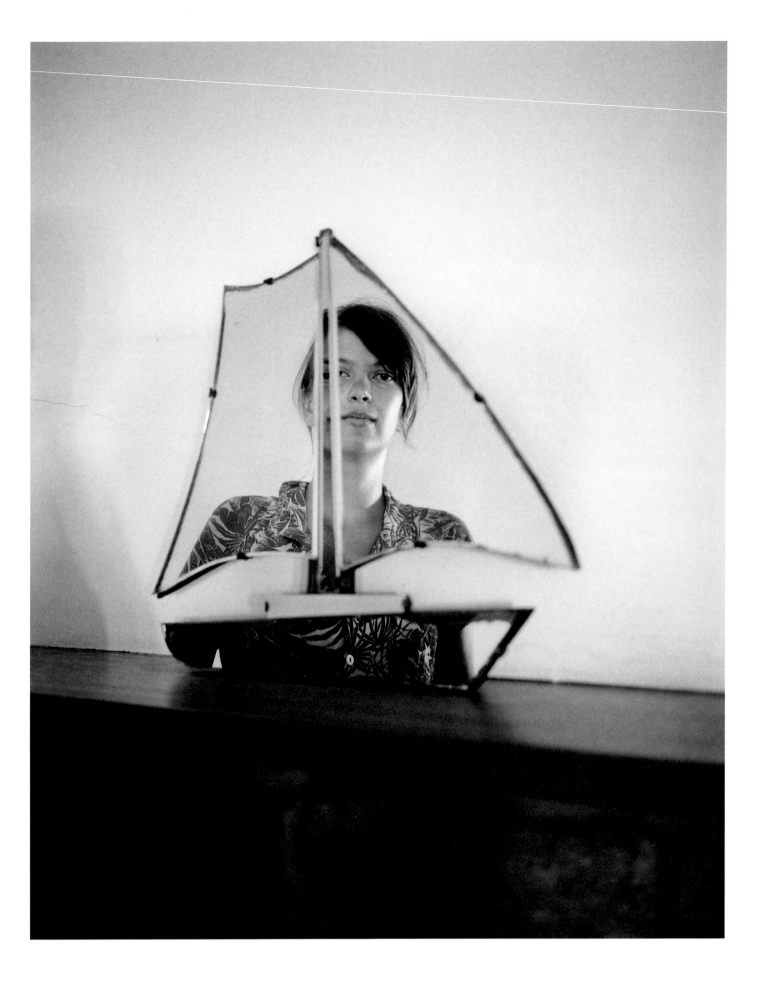

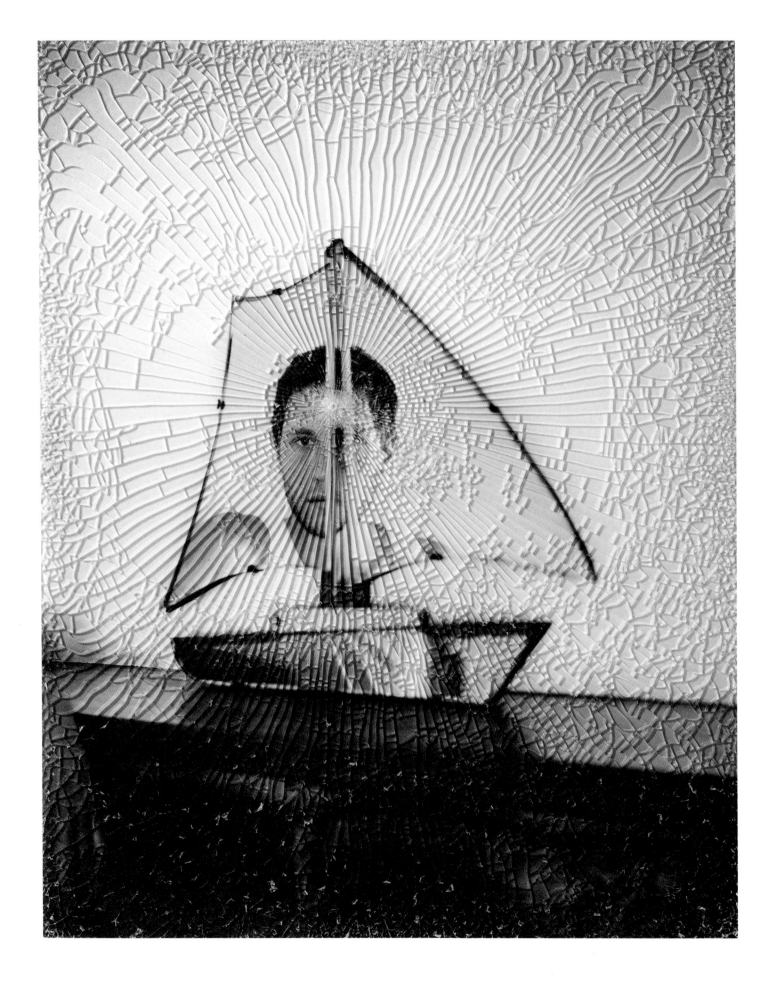

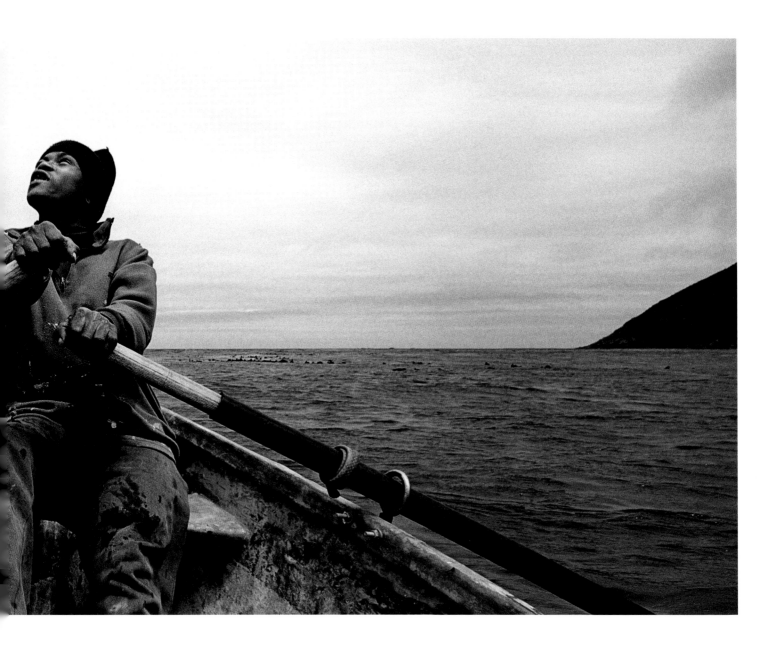

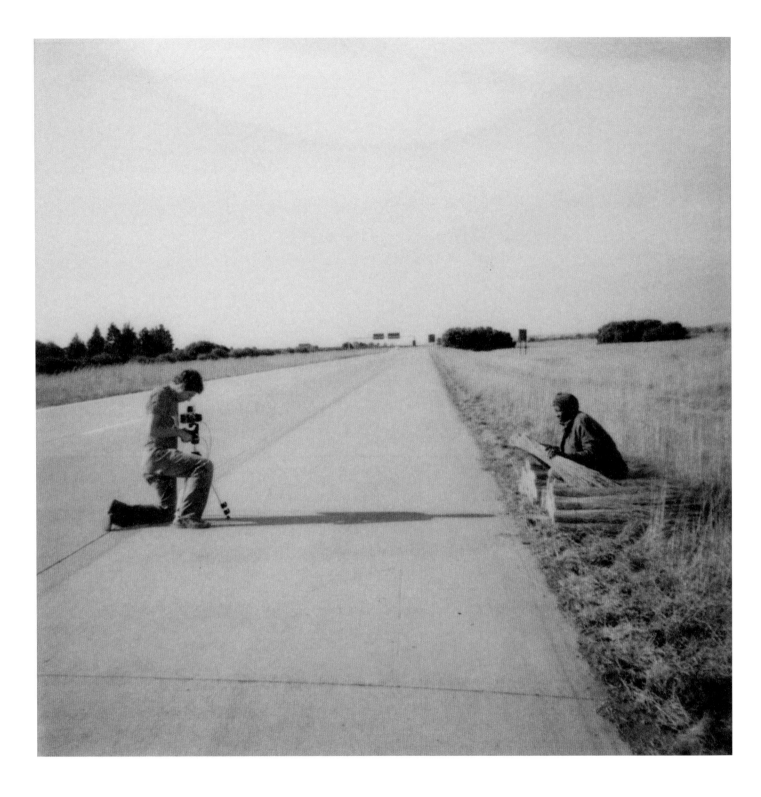

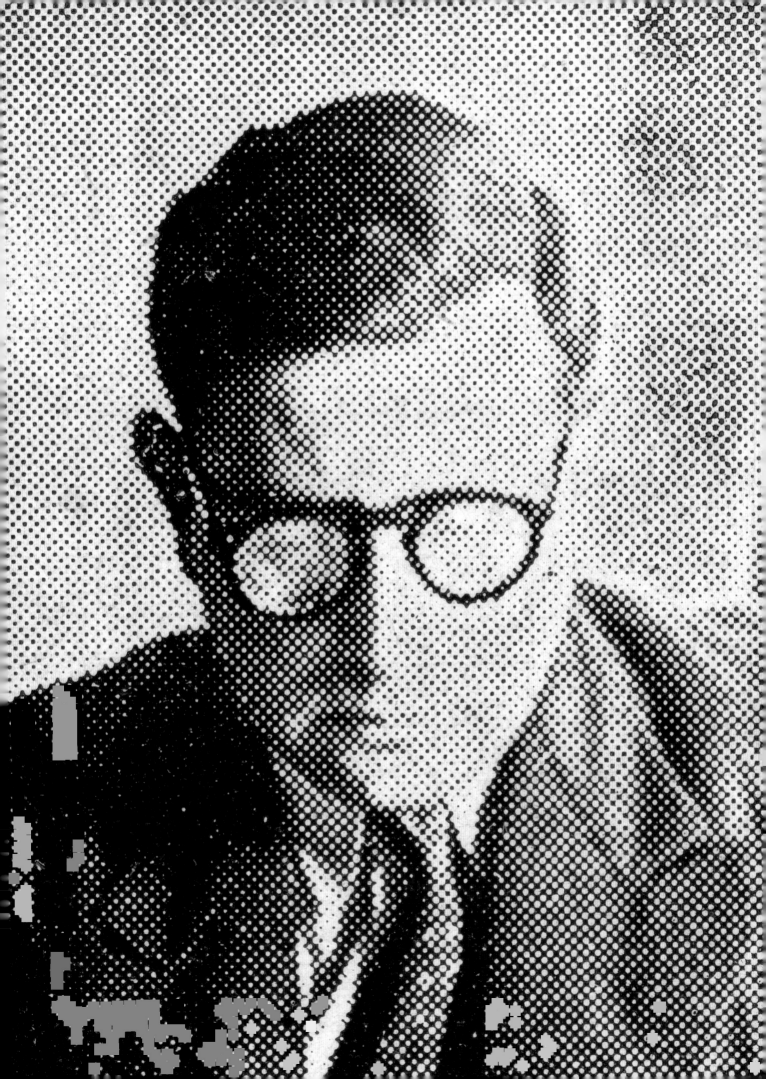

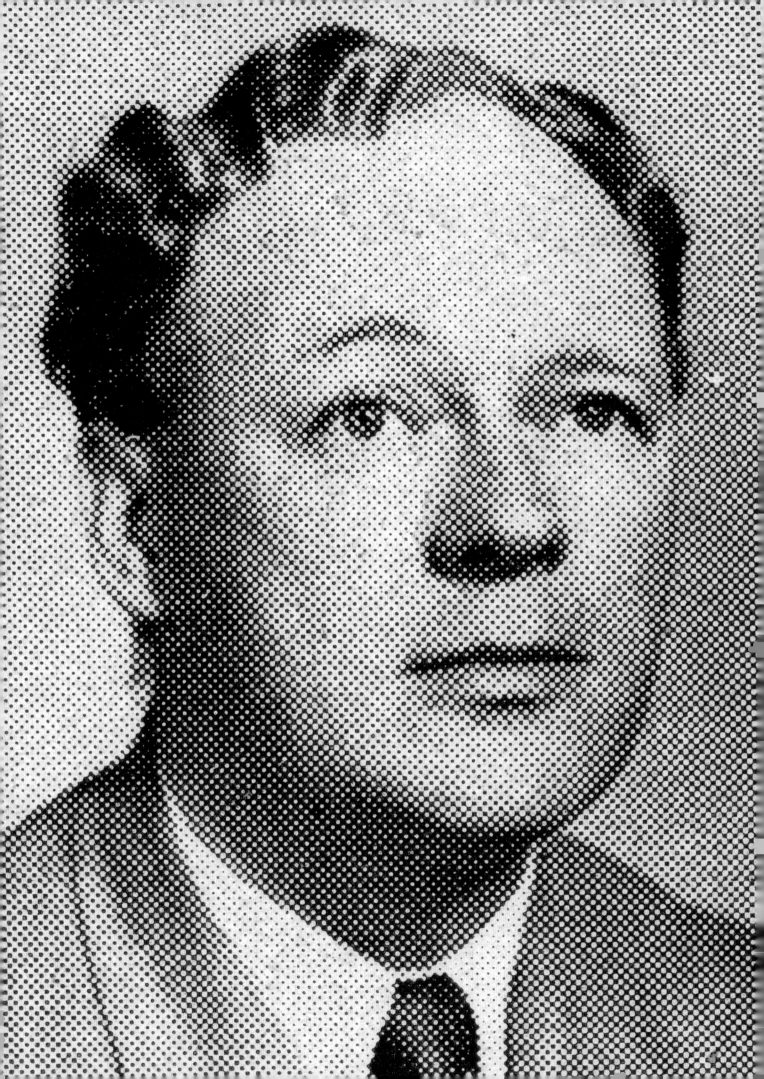

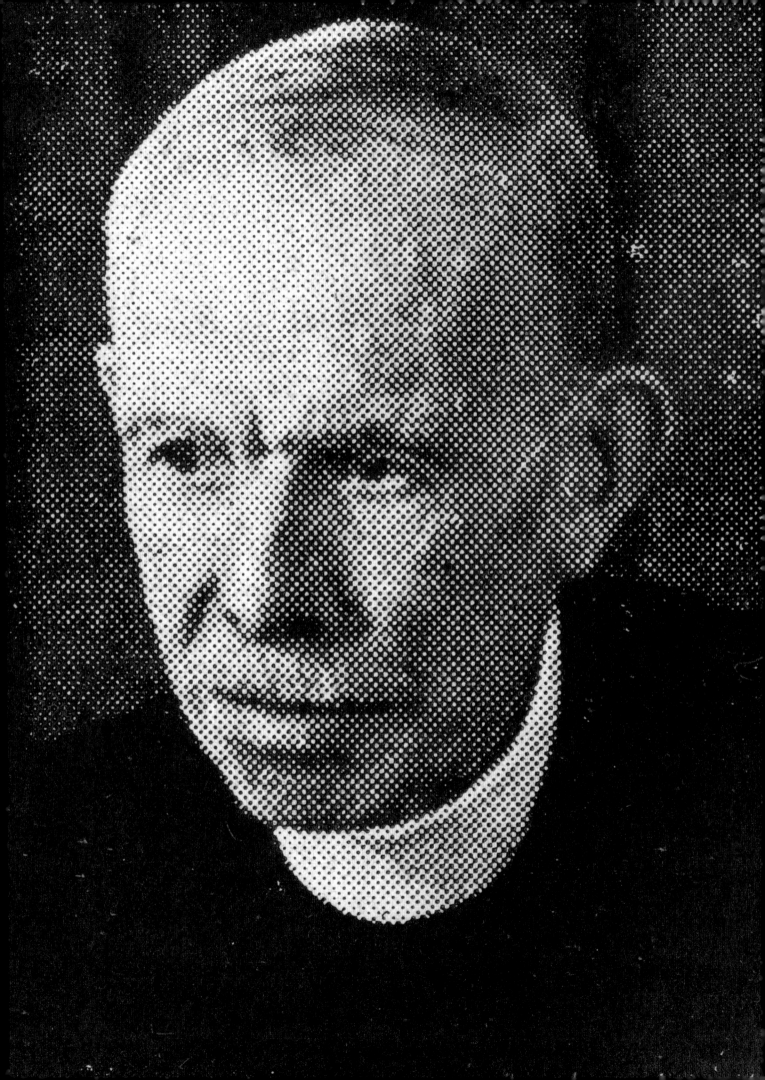

CC

Assault GBH &
Robbery

Business
Burglary & Theft

Theft of
TV Set

Theft of
Cable

Robbery &
Assault GBH

Theft of
Manhole Cover

Theft from
Vegetable Shop

Malicious Damage to
Property & Theft

Robbery of
Motorists
(Smash & Grab)

Murder by
Students

Possession of
Stolen Property

Attempted Theft
of Manhole Cover

TV

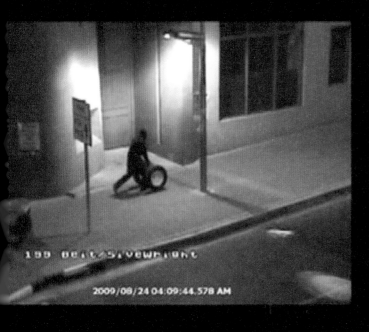

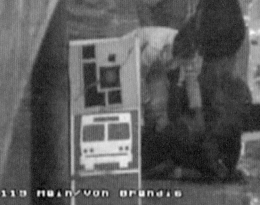

119 Main/von Brandis

(119) Cam 119 2010/08/08 05:57:33.015 PM

160 Siemertstraße

2009/08/24 04:18:19.781 AM

119 Main/Von Brandis

(119) Cam 119 2010/08/08 05:57:55.406 PM

96 Fountain/High

2009/09/02 04:18:16.468 AM

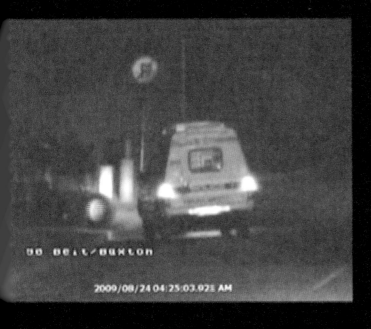

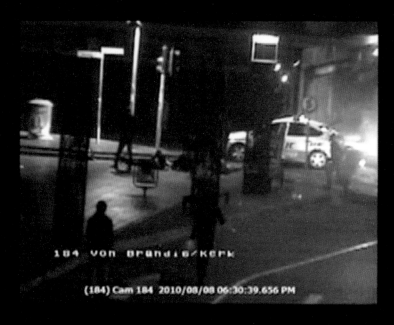

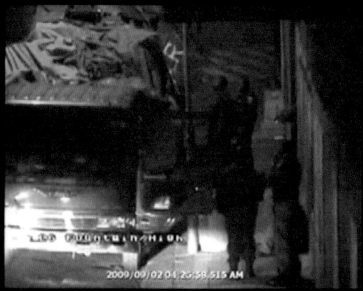

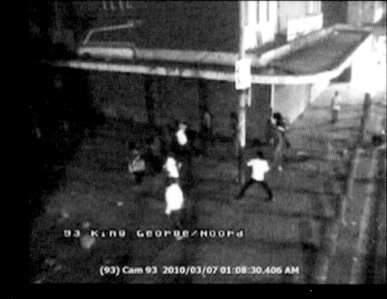

93 King George/Noord

(93) Cam 93 2010/03/07 01:08:30.406 AM

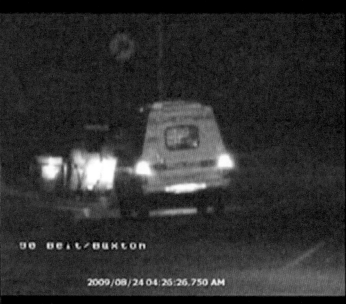

98 Beit/Buxton

2009/08/24 04:25:26.750 AM

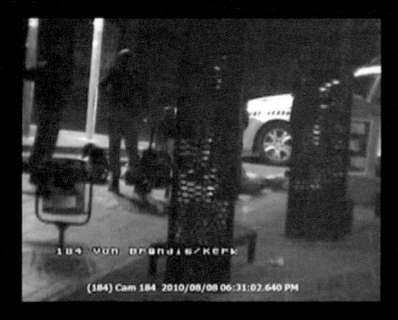

(184) Cam 184 2010/08/08 06:31:02.640 PM

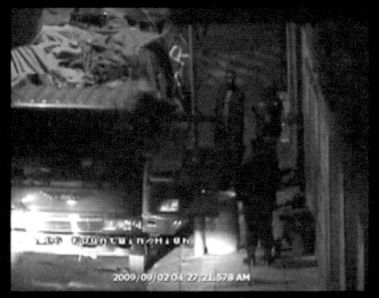

2009/09/02 04:27:21.578 AM

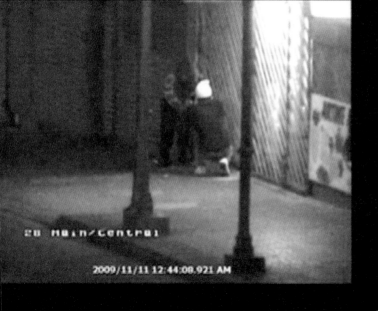

28 Main/Central

2009/11/11 12:44:08.921 AM

93 King George/Noord

(93) Cam 93 2010/03/07 01:08:53.390 AM

90 Beit/Buxton

2009/08/24 04:26:40.781 AM

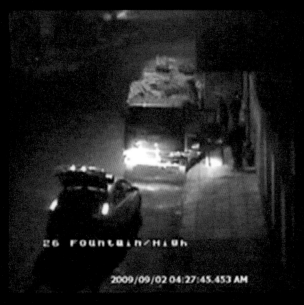

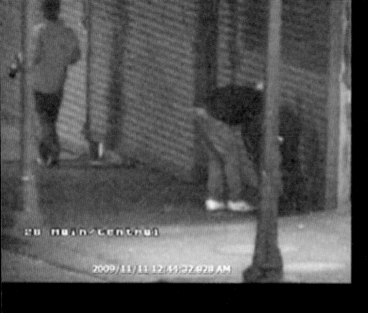

98 Main/Central
2009/11/11 12:44:22.828 AM

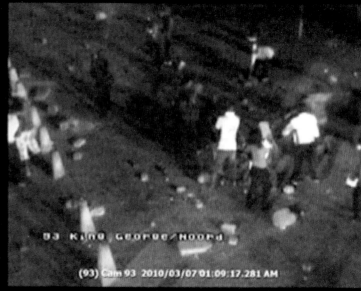

93 King George/Noord
(93) Cam 93 2010/03/07 01:09:17.281 AM

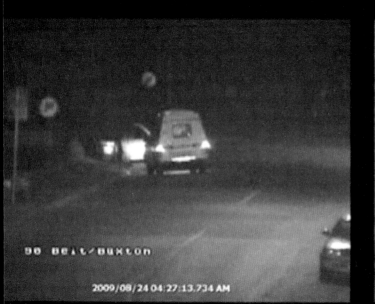

98 Beit/Buxton
2009/08/24 04:27:13.734 AM

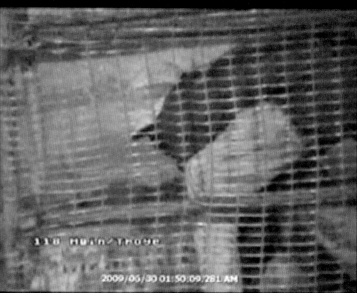

118 Main/Troye
2009/06/30 01:50:09.281 AM

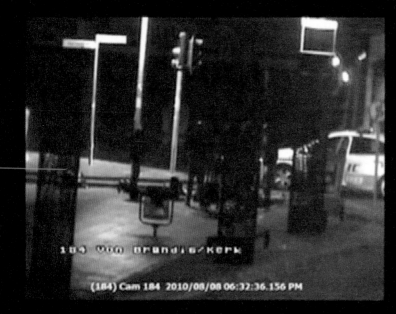

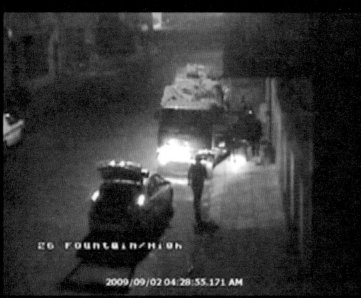

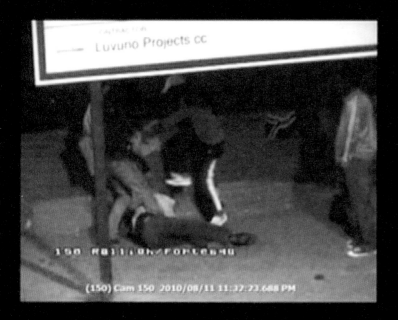

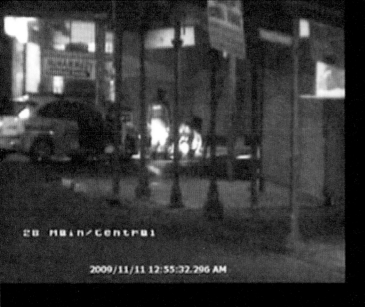

28 Main/Central

2000/11/11 12:55:32.206 AM

93 King George/Moora

(93) Cam 93 2010/03/07 01:10:26.953 AM

90 Beat/Buxton

2009/08/24 04:28:23.625 AM

118 Main/Trove

2009/06/30 01:51:18.968 AM

184 von Brandis/Kerk

(184) Cam 184 2010/08/08 06:33:12.875 PM

199 Beit/Sivewright

(199) Cam 199 2010/08/05 03:24:02.125 AM

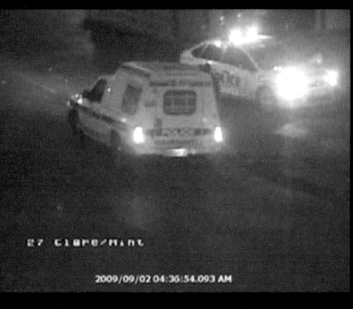

27 Clare/Mint

2009/09/02 04:36:54.093 AM

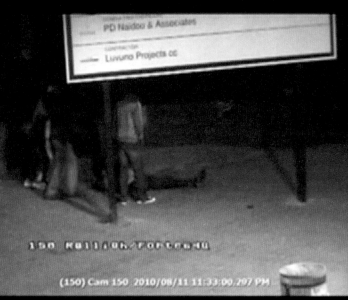

PD Naidoo & Associates

Luvuno Projects 08

150 Kallioh/Fortesmu

(150) Cam 150 2010/08/11 11:33:00.207 PM

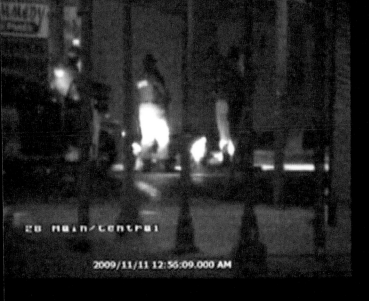

28 Main/Central
2009/11/11 12:56:09.000 AM

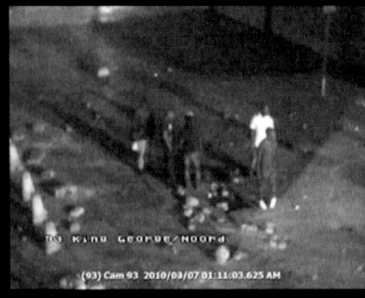

93 King George/Moore
(93) Cam 93 2010/03/07 01:11:03.625 AM

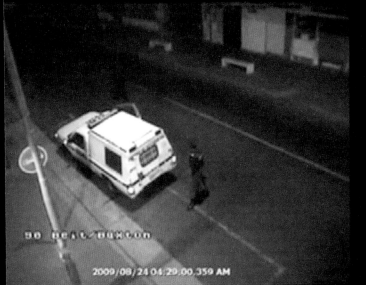

90 beat/Buxton
2009/08/24 04:20:00.359 AM

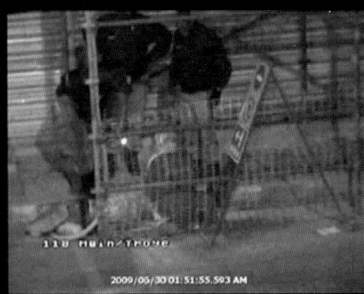

110 Main/Trove
2009/06/30 01:51:55.593 AM

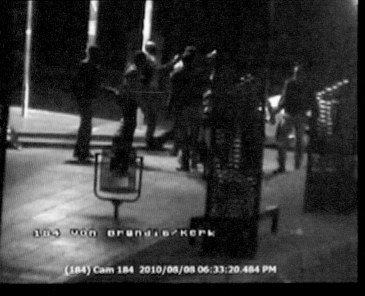

184 Von Brandis/Kerk

(184) Cam 184 2010/08/08 06:33:20.484 PM

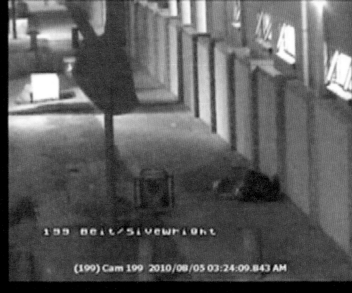

199 Beit/Sivewright

(199) Cam 199 2010/08/05 03:24:09.843 AM

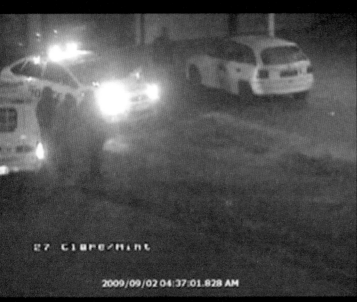

27 Claim/Mint

2009/09/02 04:37:01.828 AM

160 Siemert/Beit

(160) Cam 160 2010/11/27 03:21:49.750 AM

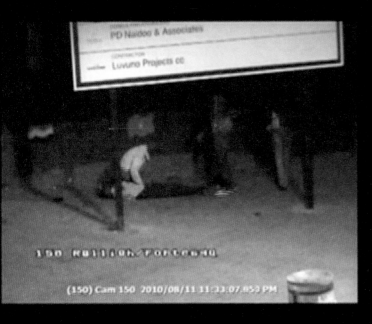

150 Kalloch/Torbes40

(150) Cam 150 2010/08/11 11:33:07.853 PM

28 Main/Central
2009/11/11 12:56:16.656 AM

93 King George/Noord
(93) Cam 93 2010/03/07 01:11:11.312 AM

90 Deal/Buxton
2009/08/24 04:29:08.003 AM

118 Main/Troye
2009/05/30 01:52:03.265 AM

cc

184 von Brandis/Kerk

(184) Cam 184 2010/08/08 06:33:29.125 PM

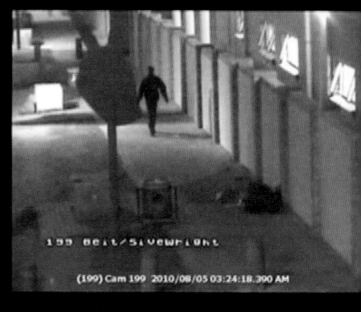

199 Beit/Sivewright

(199) Cam 199 2010/08/05 03:24:18.390 AM

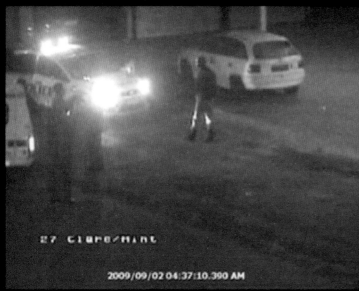

27 Claire/Mint

2009/09/02 04:37:10.390 AM

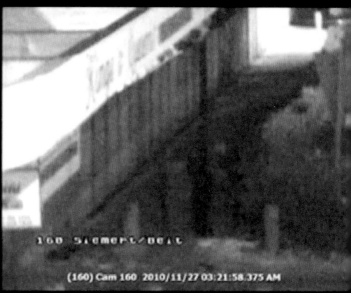

160 Siemert/Beit

(160) Cam 160 2010/11/27 03:21:58.375 AM

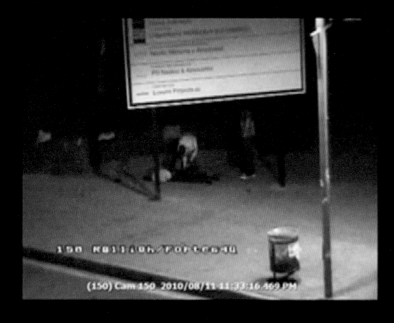

150 Rollich/Pottes40

(150) Cam 150 2010/08/11 11:33:16.469 PM

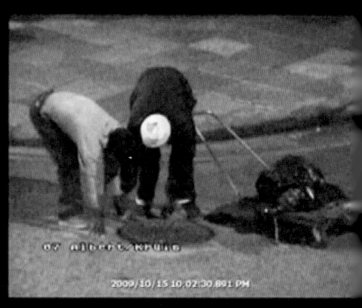

07 Albert/Kruis

2009/10/15 10:02:30.891 PM

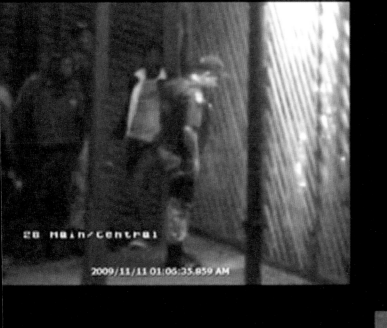

20 Main/Central

2009/11/11 01:06:35.859 AM

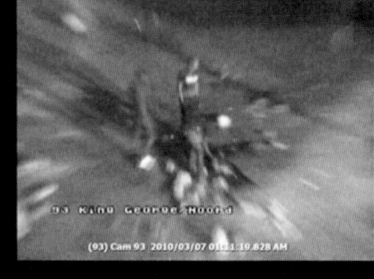

93 King George/Noord

(03) Cam 93 2010/03/07 01:21:10.828 AM

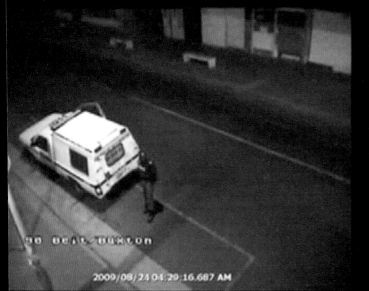

90 Beat/Buxton

2009/08/24 04:29:16.687 AM

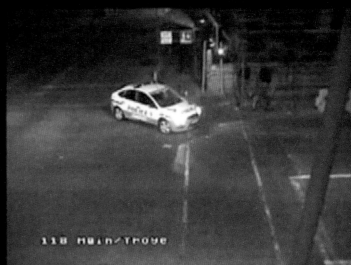

118 Main/Troye

2009/06/30 01:52:11.875 AM

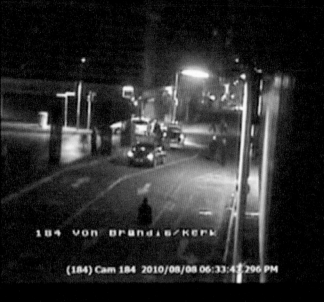

184 von Brandis/Kerk

(184) Cam 184 2010/08/08 06:33:41.296 PM

199 Beit/Sivewright

(199) Cam 199 2010/08/05 03:24:32.609 AM

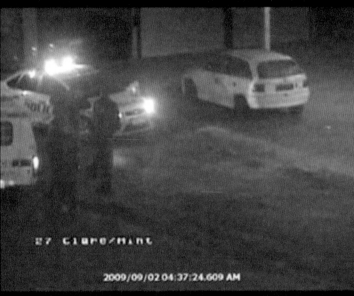

27 Clare/Mint

2009/09/02 04:37:24.609 AM

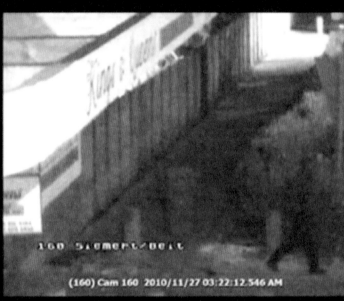

160 Siemert/Beit

(160) Cam 160 2010/11/27 03:22:12.546 AM

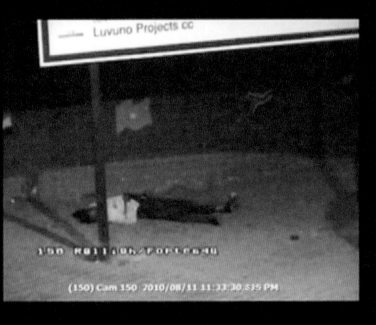

Luvuno Projects cc

150 Kruijak/Fortesku

(150) Cam 150 2010/08/11 11:33:30.835 PM

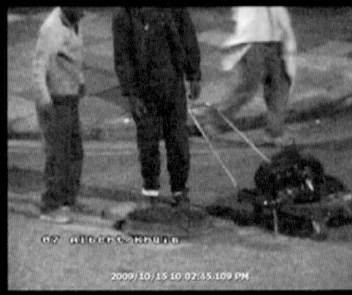

67 Albert/Kruhn

2009/10/15 10 02:45.109 PM

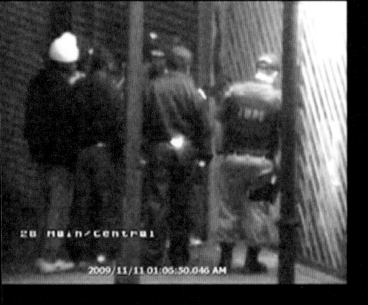

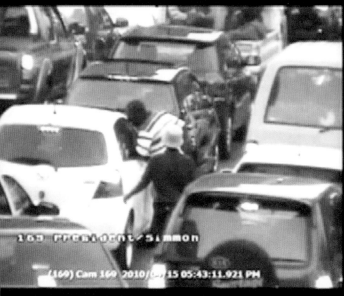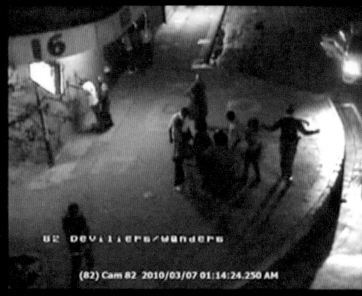

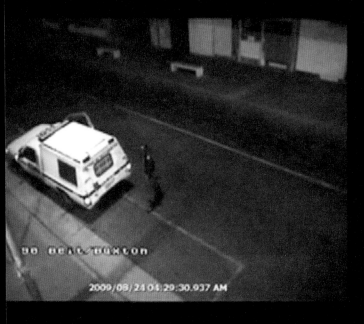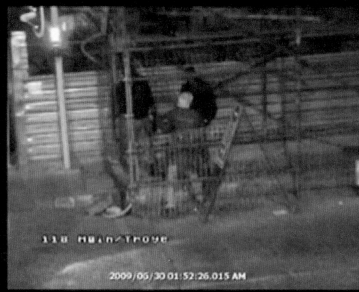

241

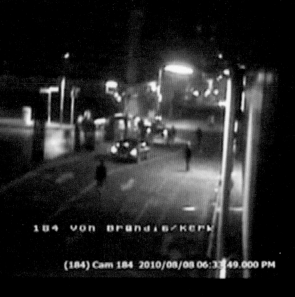

184 von Brandis/Kern

(184) Cam 184 2010/08/08 06:33:49.000 PM

199 Beit/Sivewright

(199) Cam 199 2010/08/05 03:24:38.250 AM

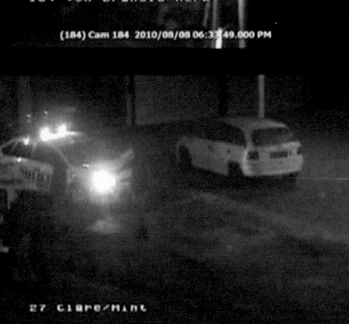

27 Clare/Mint

2009/09/02 04:37:30.250 AM

160 Siemert/Beit

(160) Cam 160 2010/11/27 03:22:18.265 AM

150 Rellifus/

(150) Cam 150 2010/08/11 11:33:36.391 PM

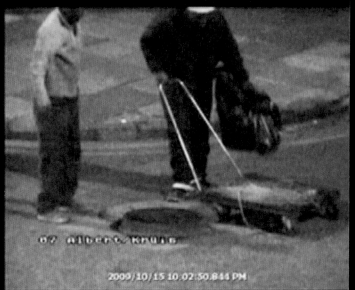

67 Albert/Kruis

2009/10/15 10.02:50.844 PM

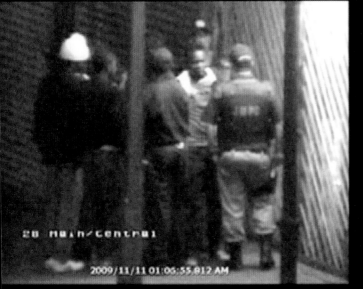

28 Main/Central

2009/11/11 01:06:55.012 AM

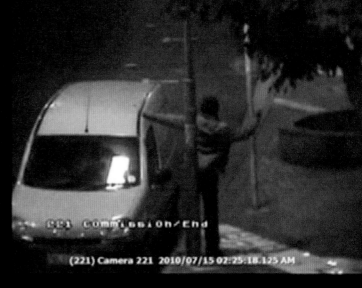

221 Commission/End

(221) Camera 221 2010/07/15 02:25:18.125 AM

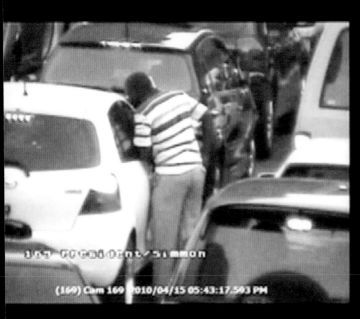

169 President/Simmon

(169) Cam 169 2010/04/15 05:43:17.593 PM

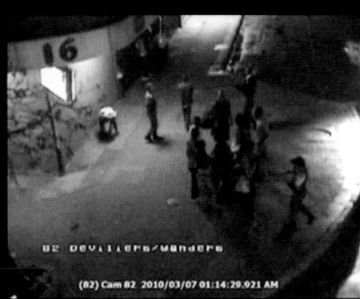

82 Devilliers/Wanders

(82) Cam 82 2010/03/07 01:14:29.921 AM

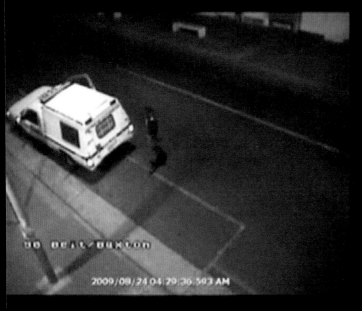

90 Deal/Buxton

2009/08/24 04:29:30.503 AM

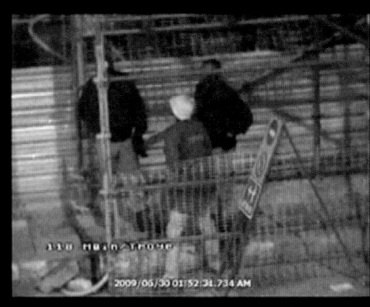

118 Main/Trome

2009/06/30 01:52:31.734 AM

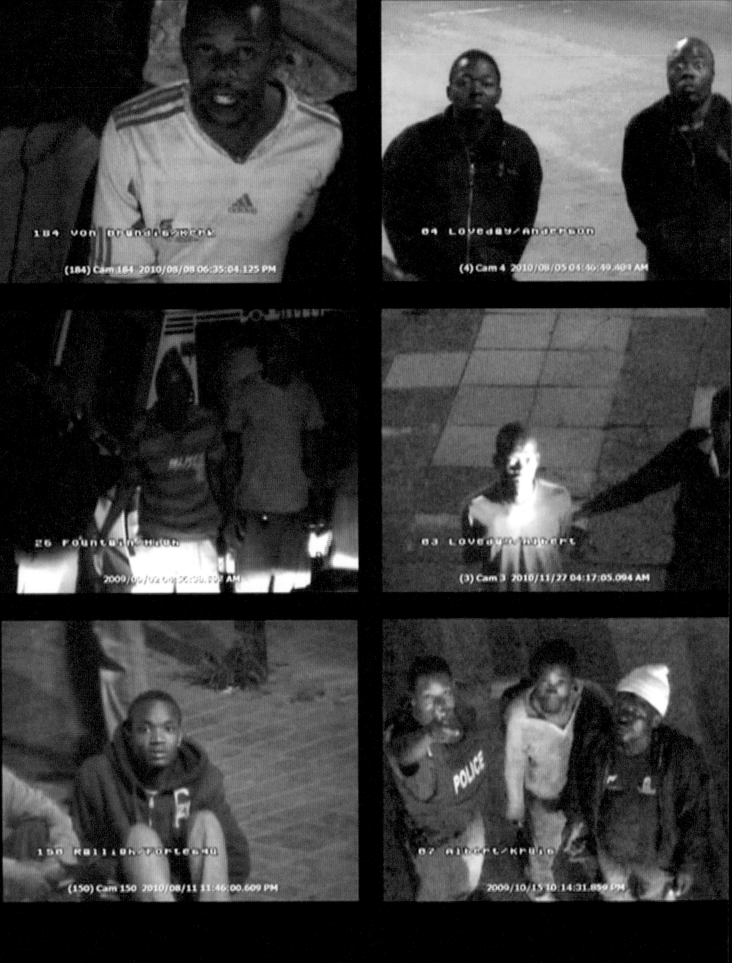

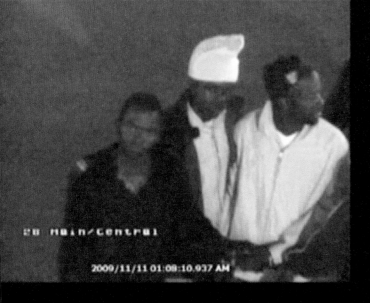

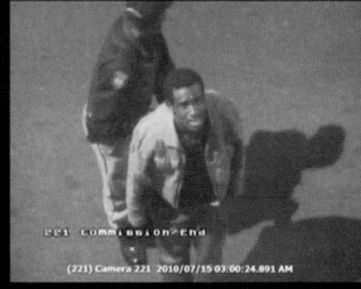

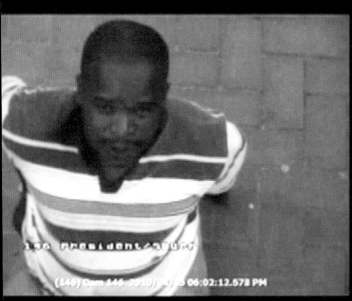

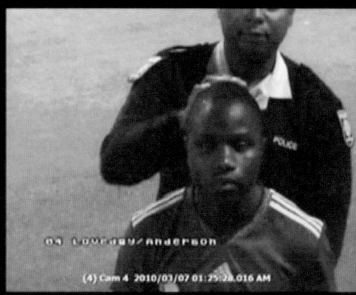

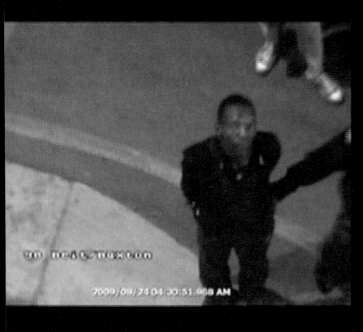

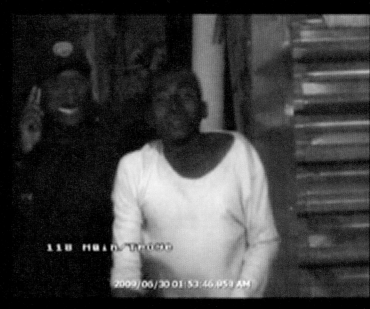

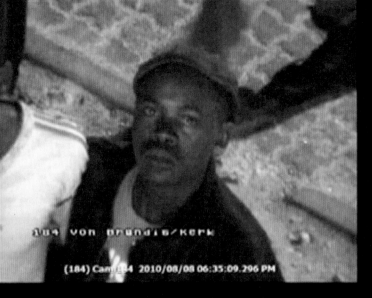

184 von Brandis/Kerk

(184) Cam 184 2010/08/08 06:35:09.296 PM

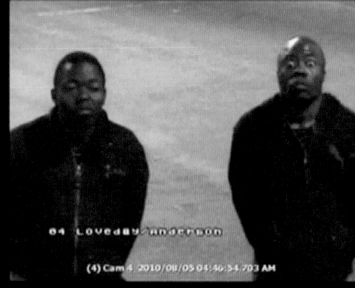

04 Loveday/Anderson

(4) Cam 4 2010/08/05 04:40:54.703 AM

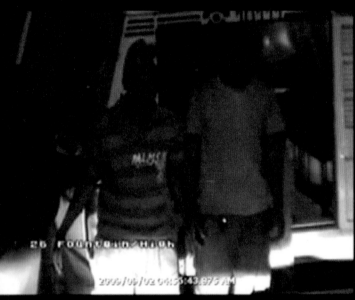

25 Fountain/High

2009/09/02 04:55:43.875 AM

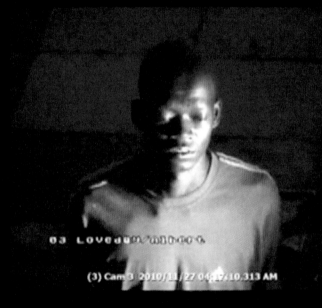

03 Loveday/Albert

(3) Cam 3 2010/11/27 04:17:10.313 AM

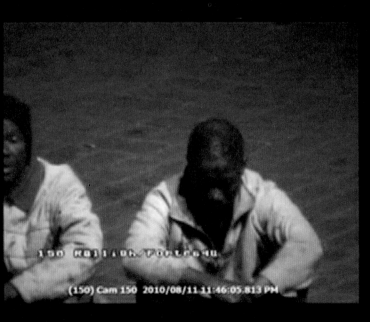

150 Kallach/Portland

(150) Cam 150 2010/08/11 11:46:05.813 PM

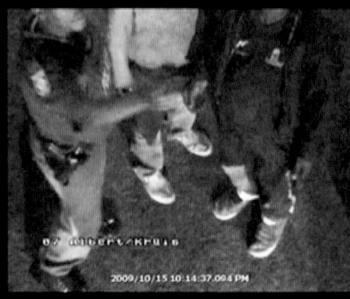

07 Albert/Kruis

2009/10/15 10:14:37.094 PM

246

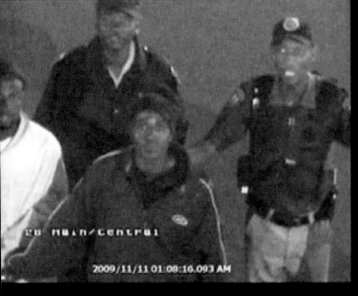

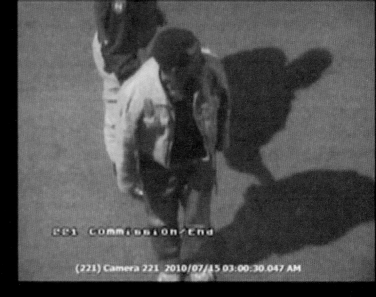

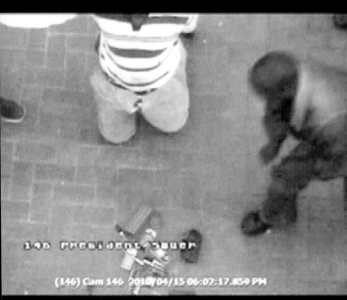

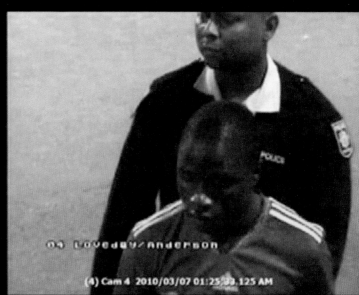

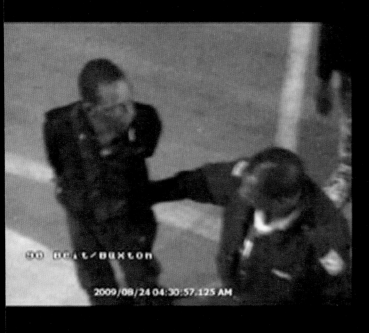

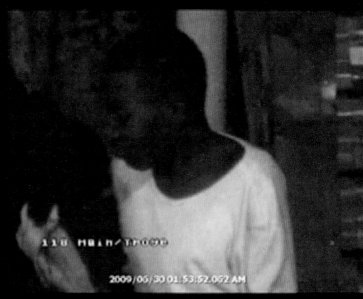

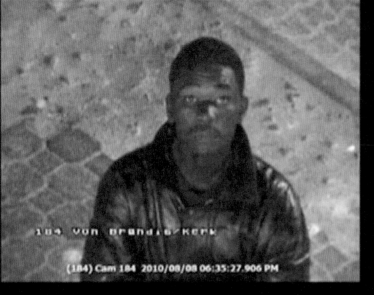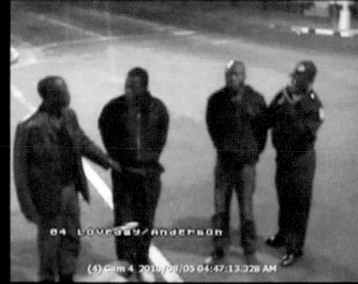
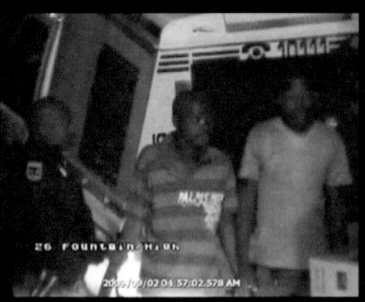
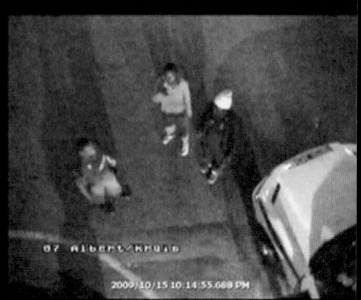

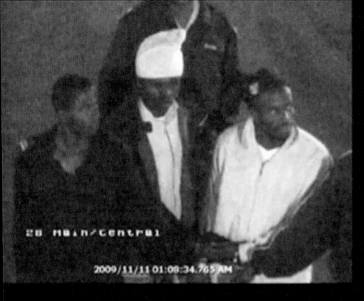

28 Main/Central

2009/11/11 01:08:34.765 AM

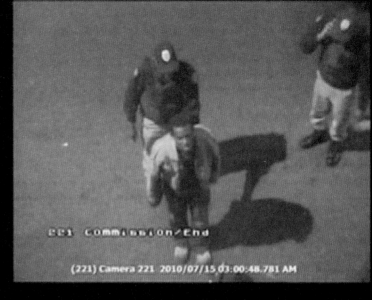

221 Commission/End

(221) Camera 221 2010/07/15 03:00:48.781 AM

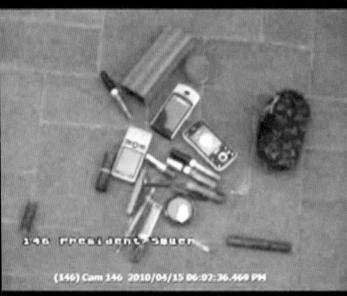

146 President/Sauer

(146) Cam 146 2010/04/15 06:02:36.469 PM

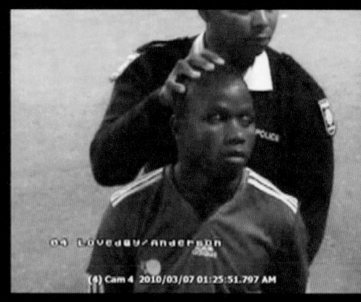

04 Loveday/Anderson

(4) Cam 4 2010/03/07 01:25:51.797 AM

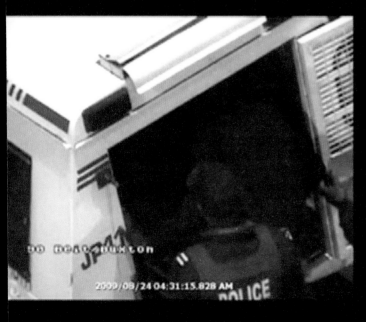

00 Reid/Buxton

2009/08/24 04:31:15.828 AM

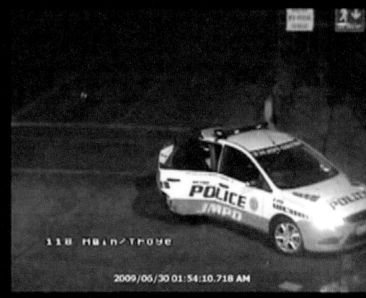

118 Main/Troye

2009/06/30 01:54:10.718 AM

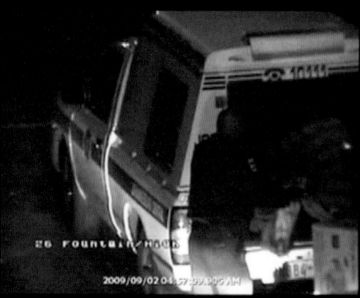

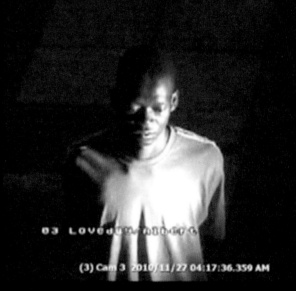

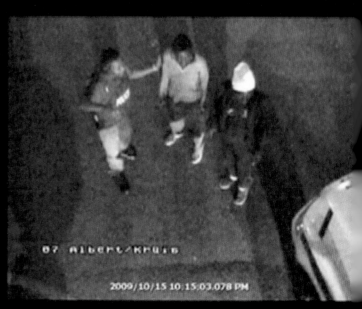

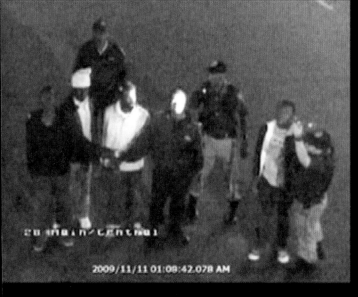

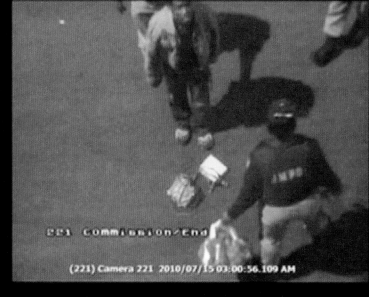

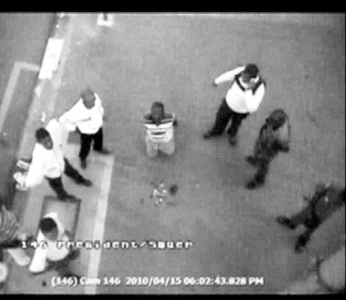

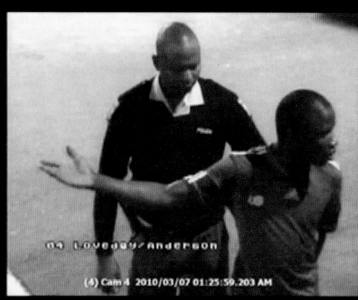

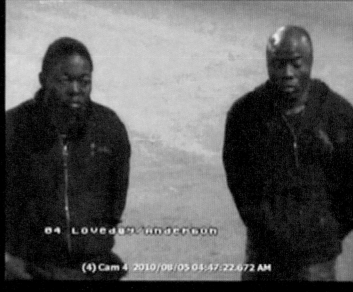

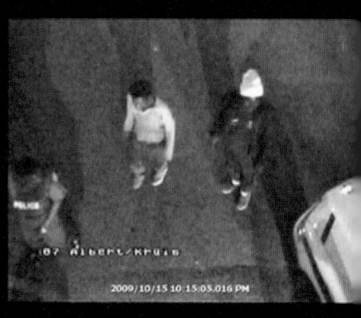

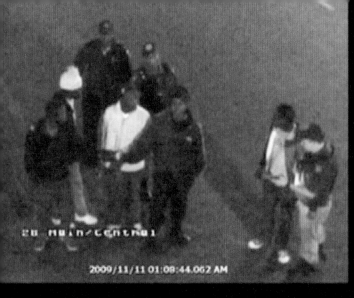

2U Main/Central

2009/11/11 01:08:44.062 AM

221 Commission/End

(221) Camera 221 2010/07/15 03:00:58.141 AM

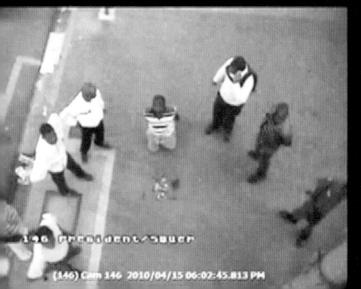

146 President/Sauer

(146) Cam 146 2010/04/15 06:02:45.813 PM

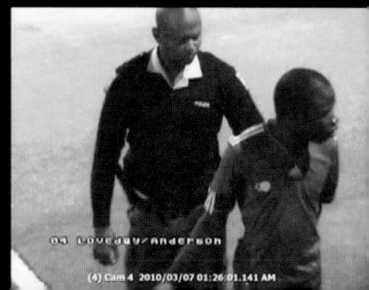

04 Loveday/Anderson

(4) Cam 4 2010/03/07 01:26:01.141 AM

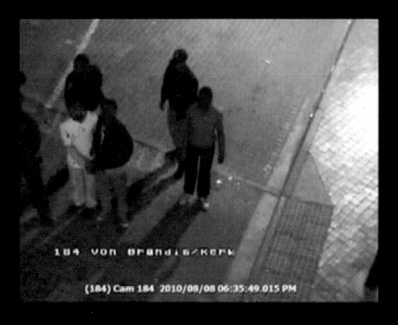

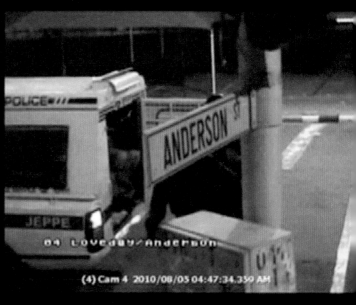

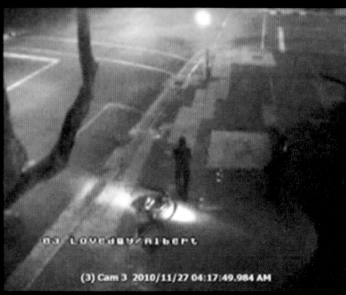

254

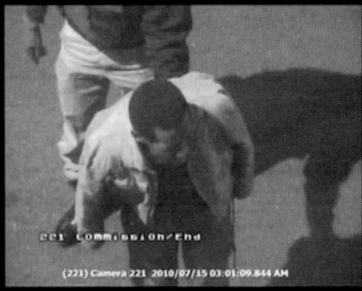

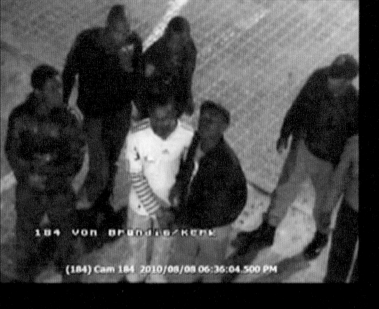

221 Commission/End

(221) Camera 221 2010/07/15 03:01:25.406 AM

04 Loveday/Anderson

(4) Cam 4 2010/03/07 01:26:28.359 AM

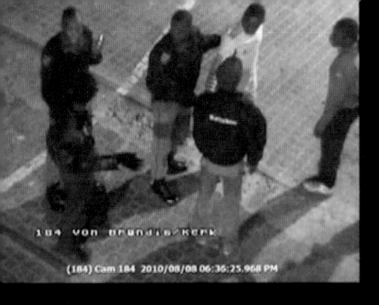

184 Von Brandis/Kerk

(184) Cam 184 2010/08/08 06:36:25.968 PM

04 Loveday/Anderson

(4) Cam 4 2010/08/05 04:48:11.328 AM

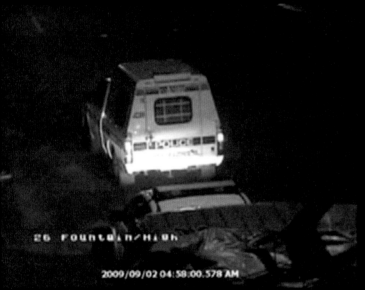

26 Fountain/High

2009/09/02 04:58:00.578 AM

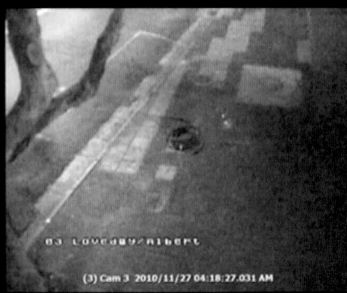

03 Loveday/Albert

(3) Cam 3 2010/11/27 04:18:27.031 AM

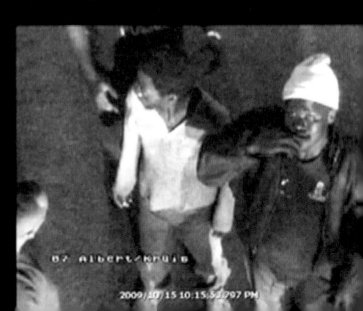

07 Albert/Kruis

2009/10/15 10:15:53.797 PM

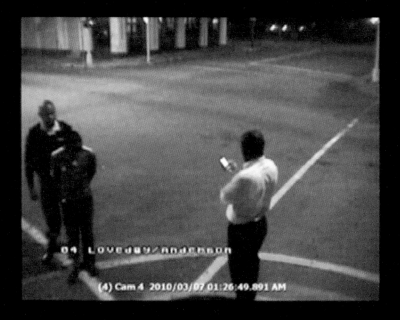

cc

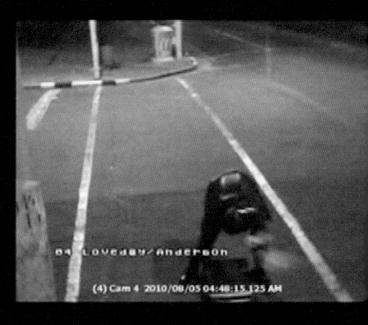

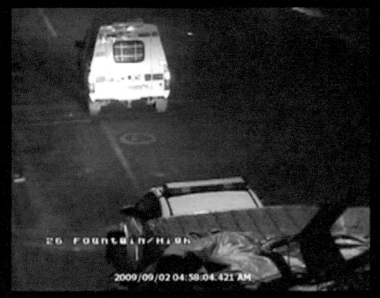

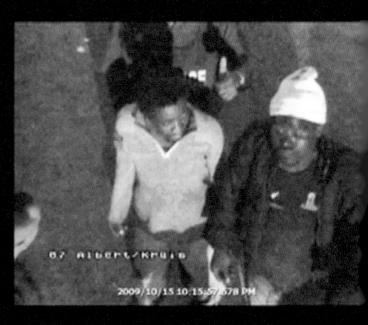

04 Loveday/Anderson

(4) Cam 4 2010/03/07 01:26:53.656 AM

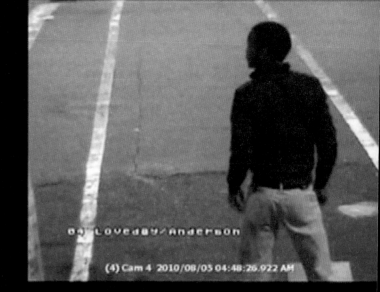

Loveday/Anderson

(4) Cam 4 2010/08/05 04:48:26.922 AM

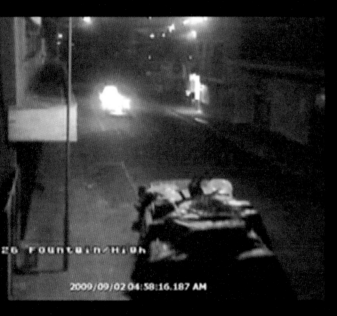

26 Fountain/High

2009/09/02 04:58:16.187 AM

07 Albert/Kruis

2009/10/15 10:16:09.234 PM

04 Loveday/Anderson

(4) Cam 4 2010/03/07 01:27:05.422 AM

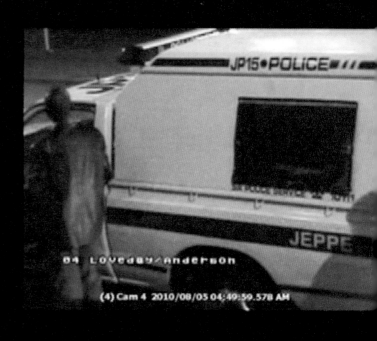

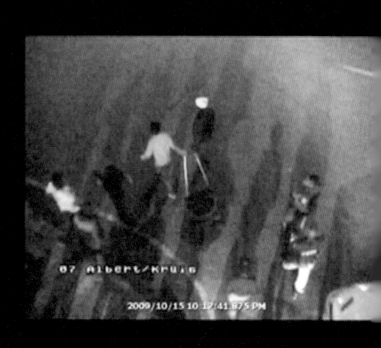

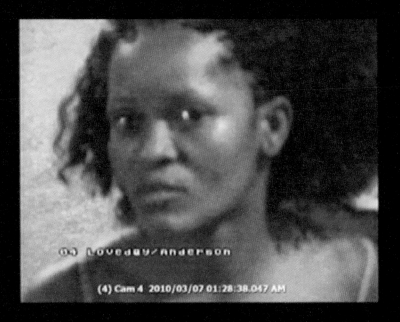

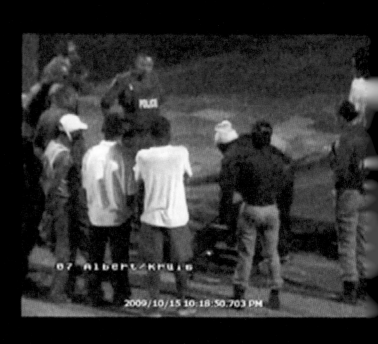

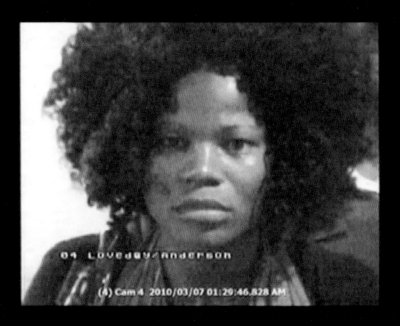

cc

04 Loveday/Anderson
(4) Cam 4 2010/03/07 01:35:31.578 AM

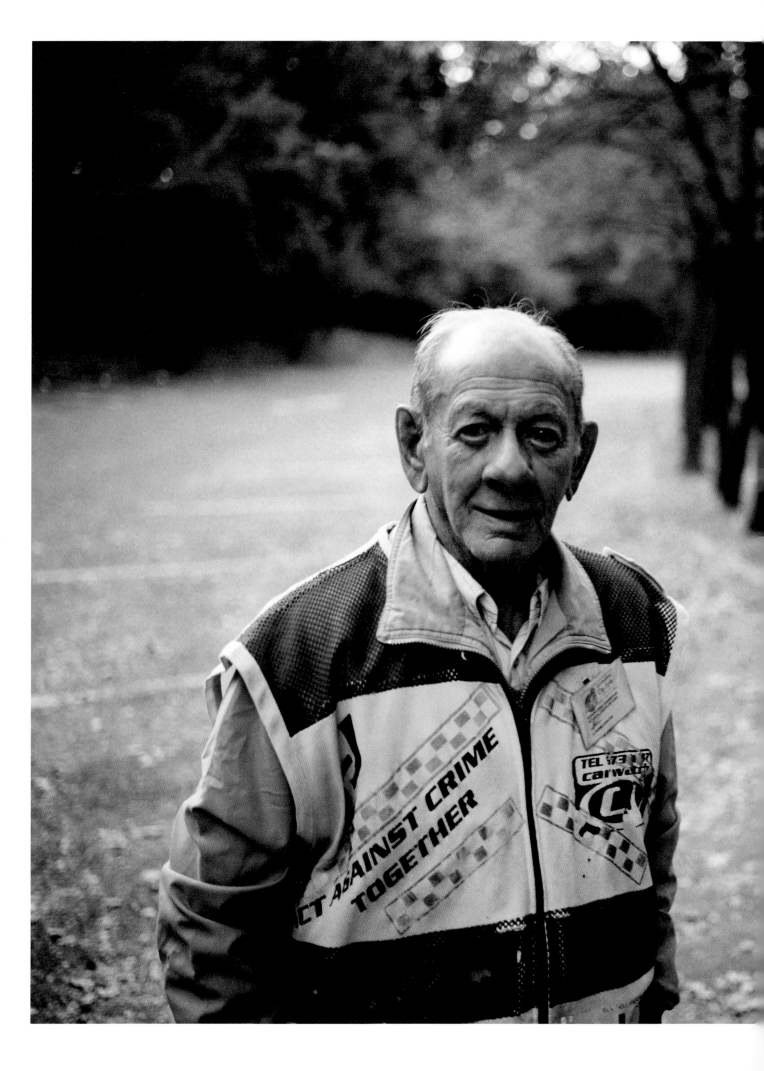

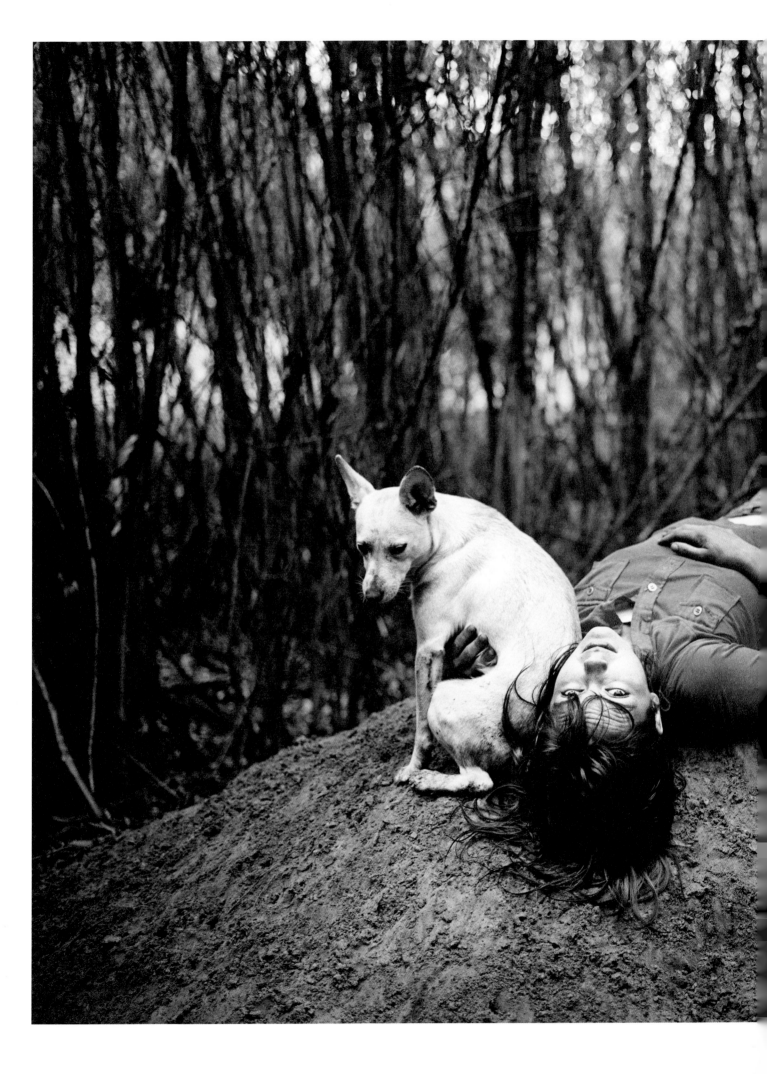

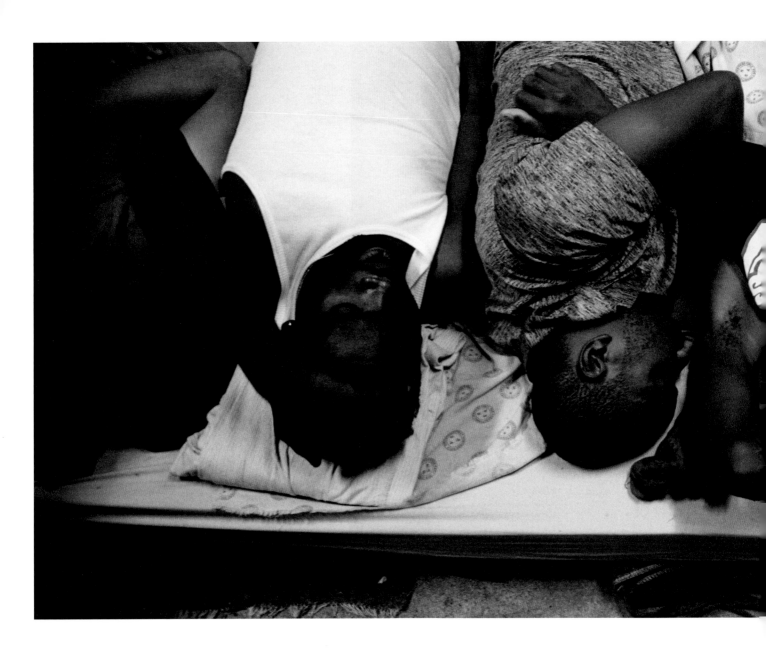

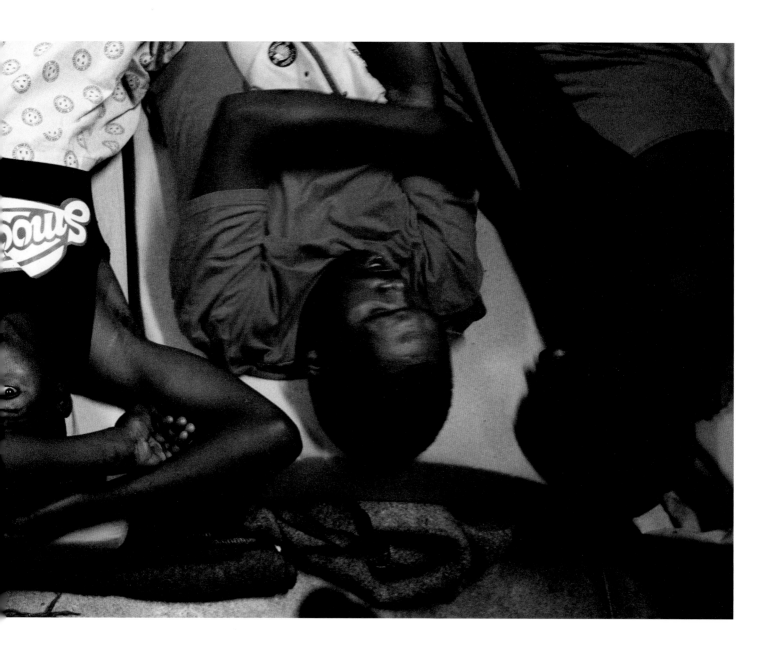

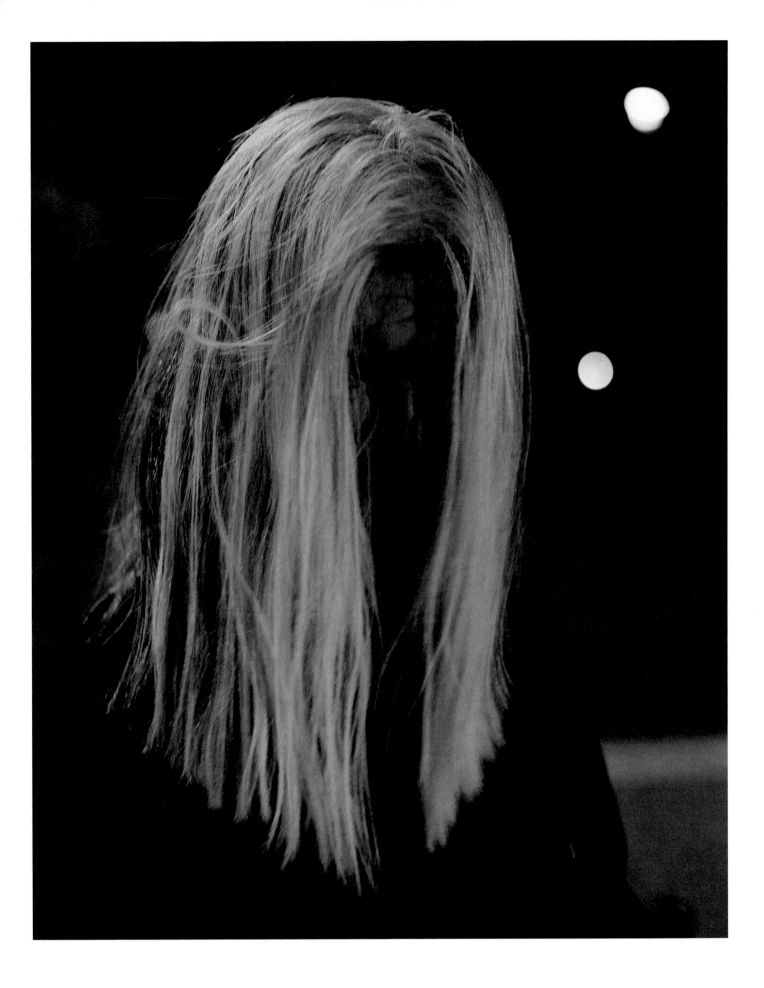

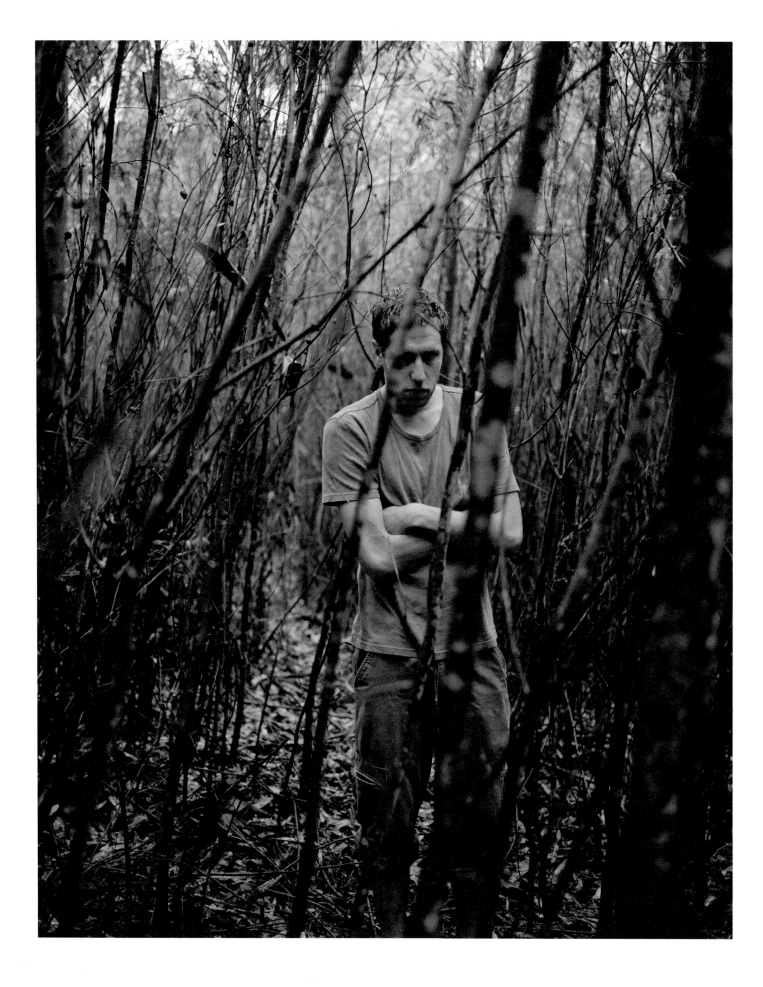

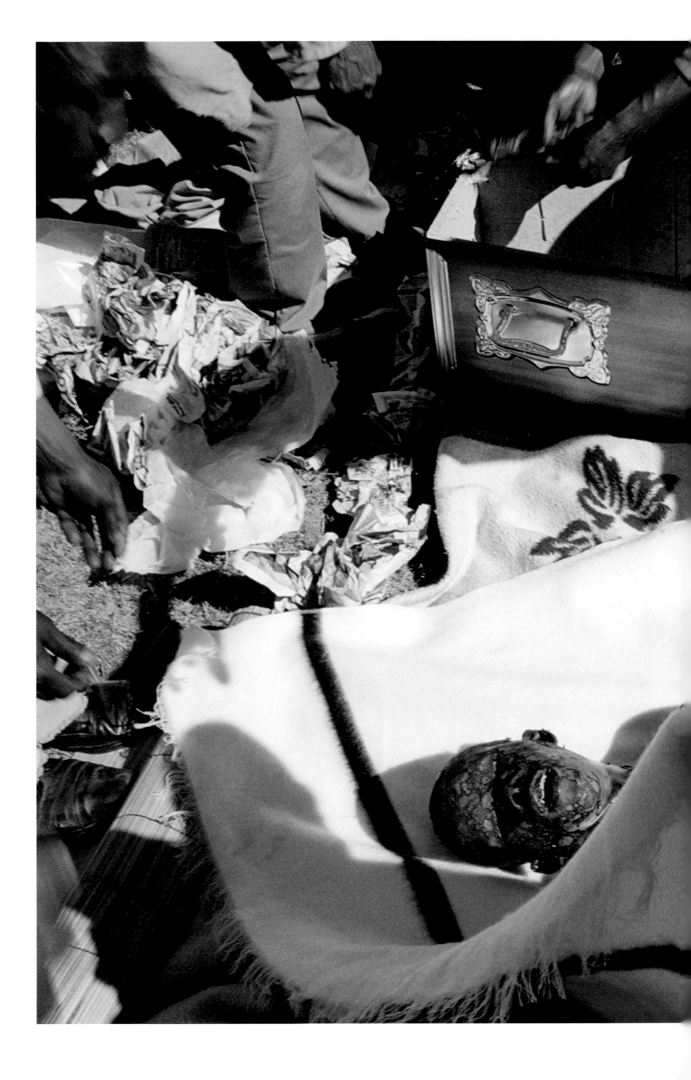

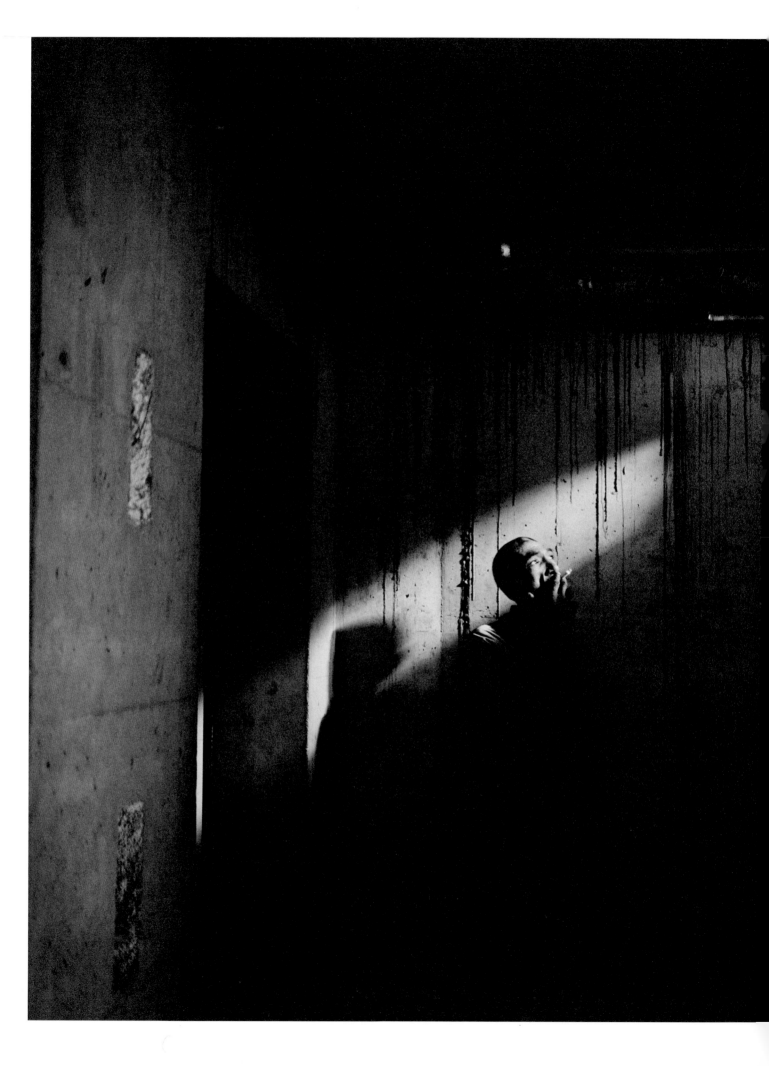

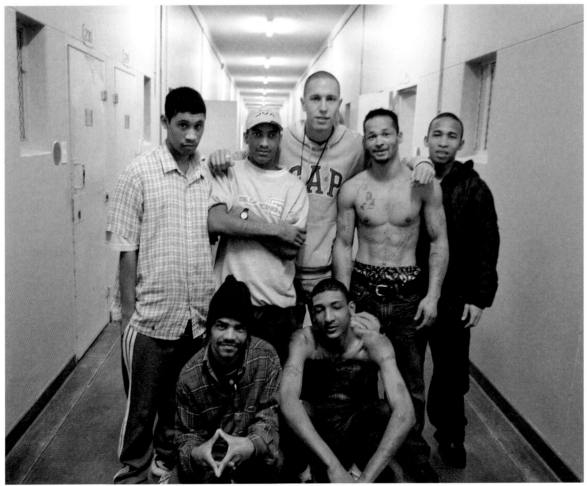

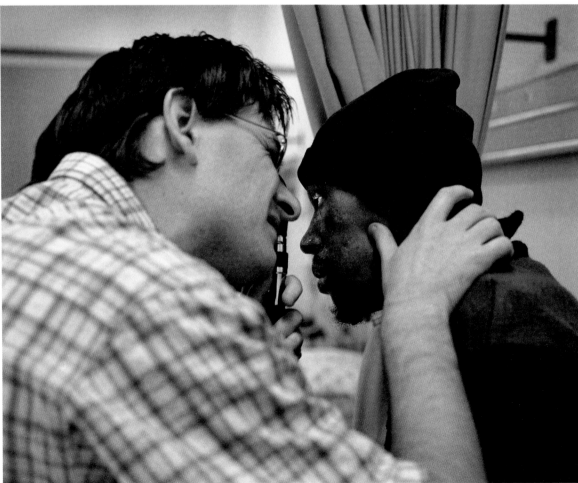

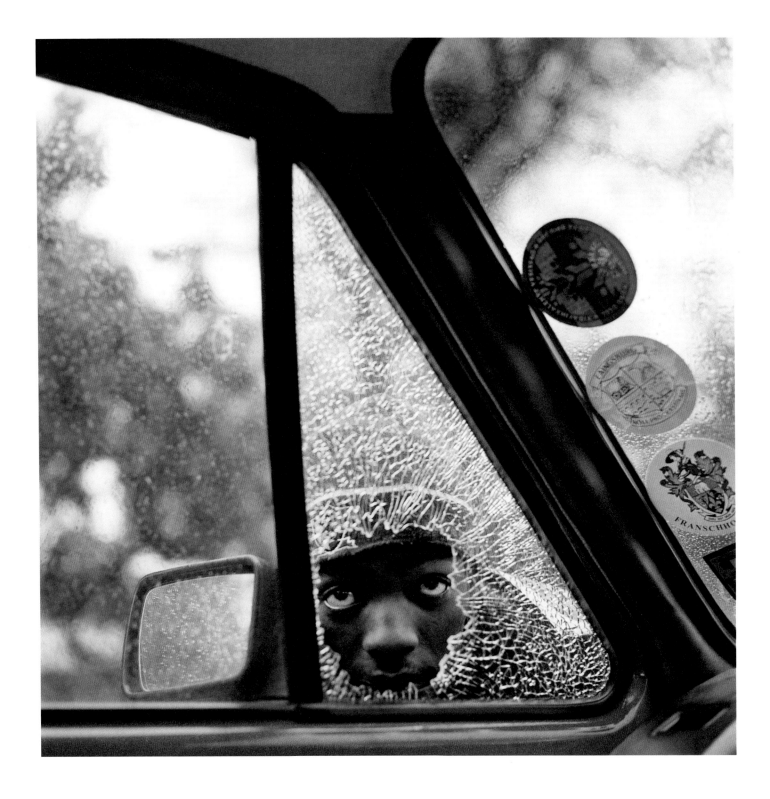

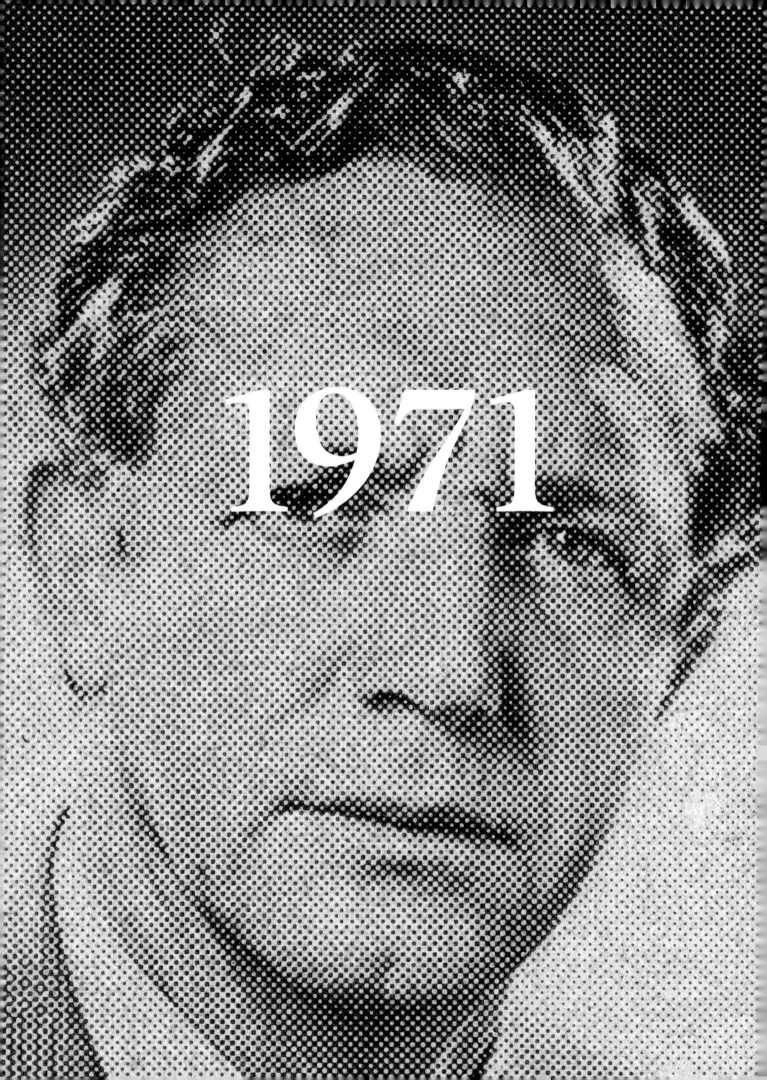

1971

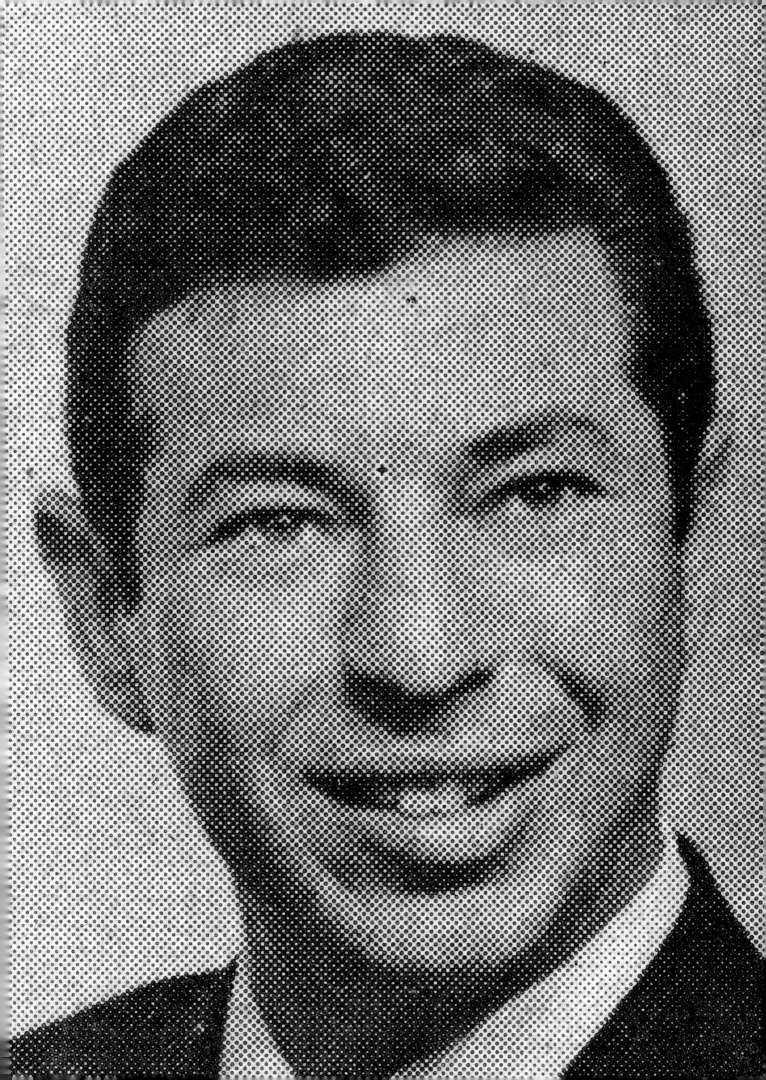

DON'T EVEN

THINK OF IT

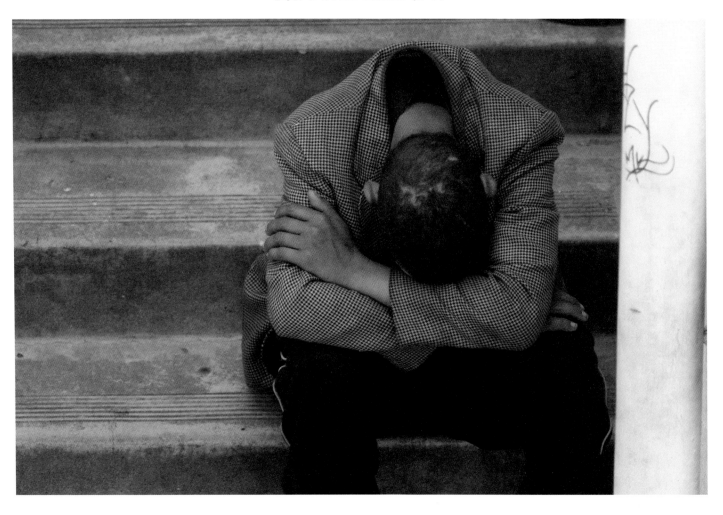

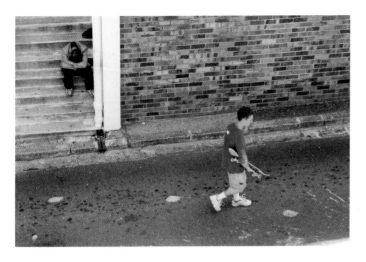

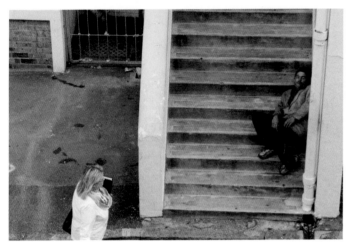

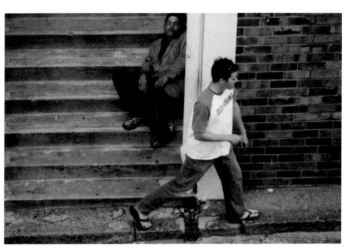

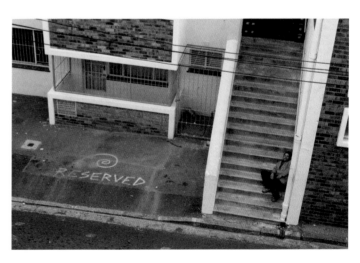

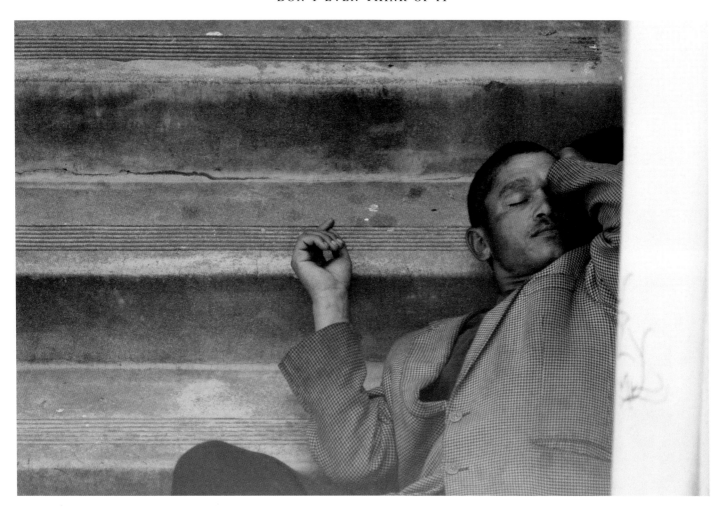

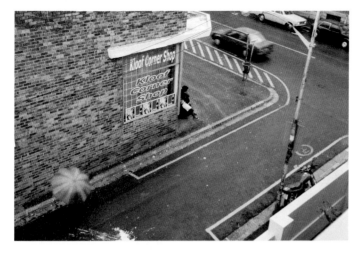
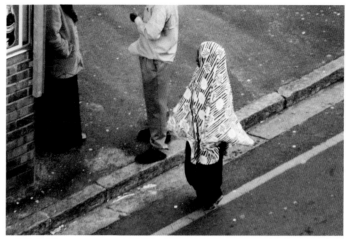

328

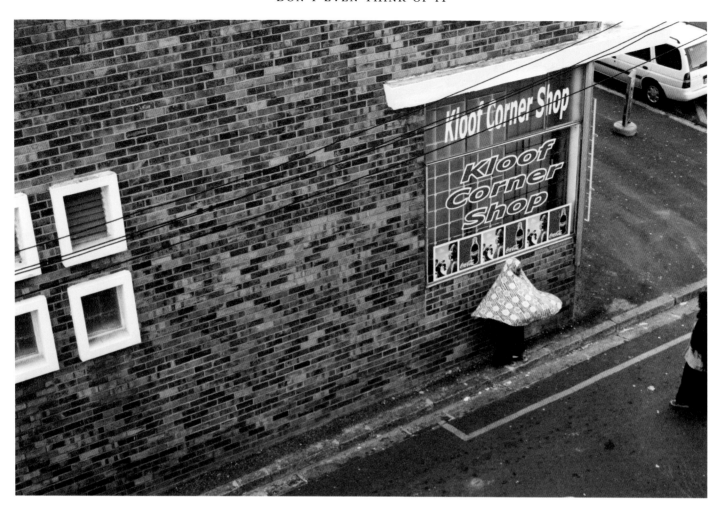

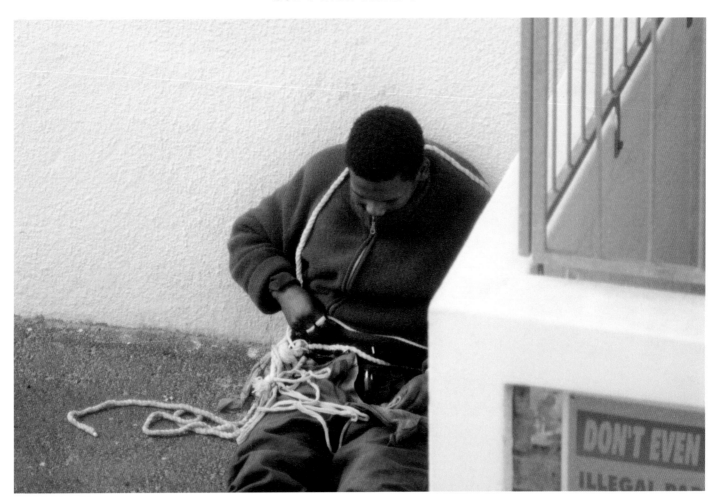

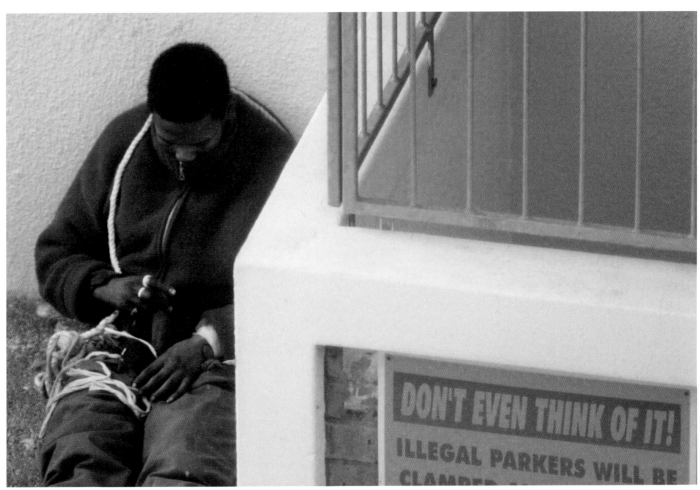

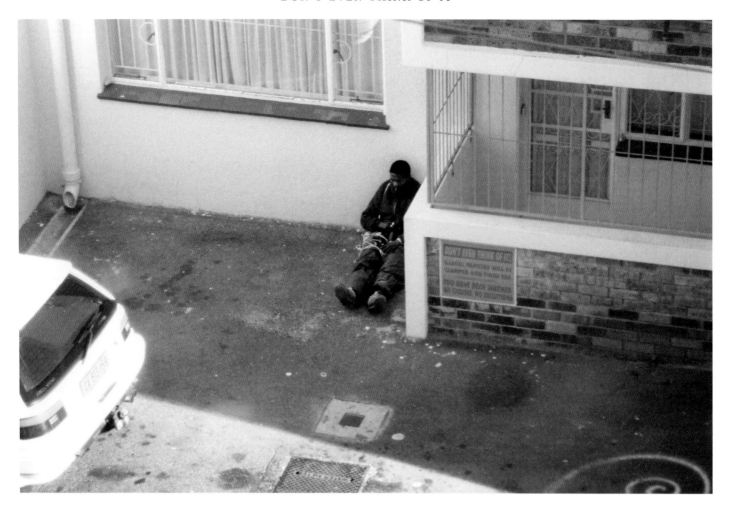

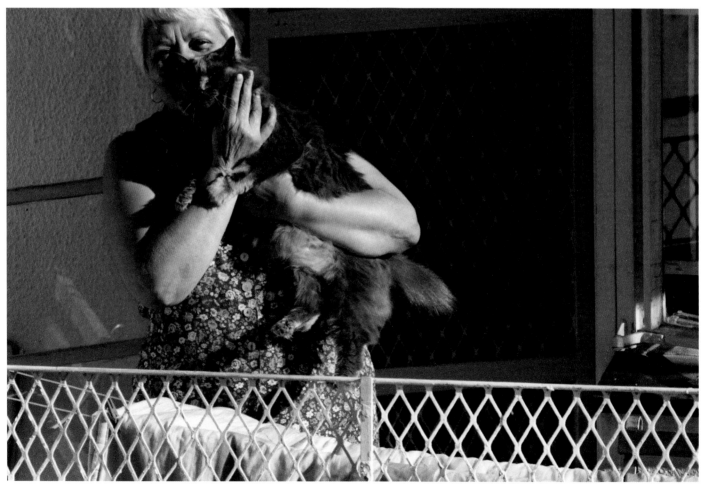

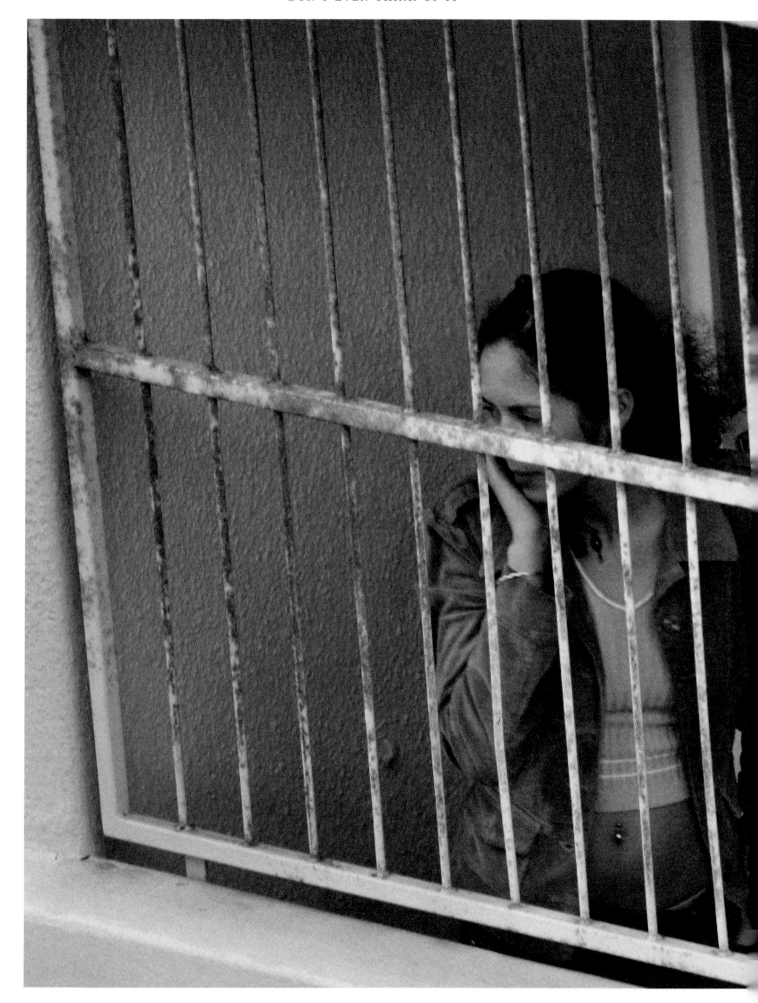

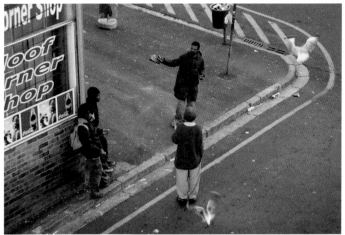

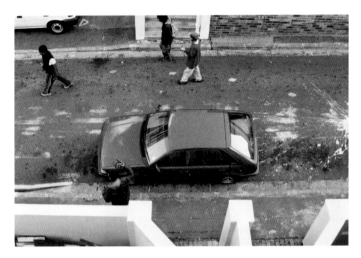

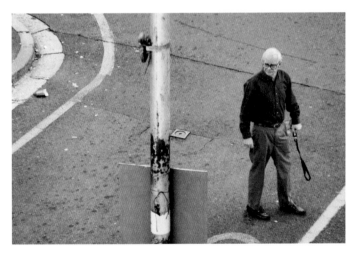

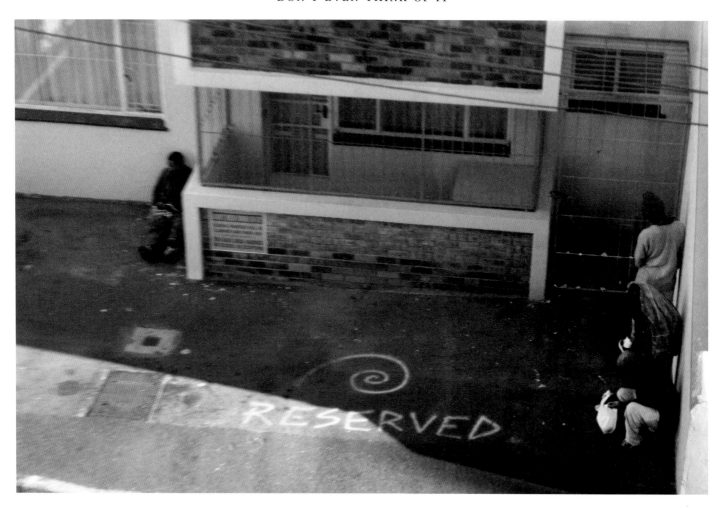

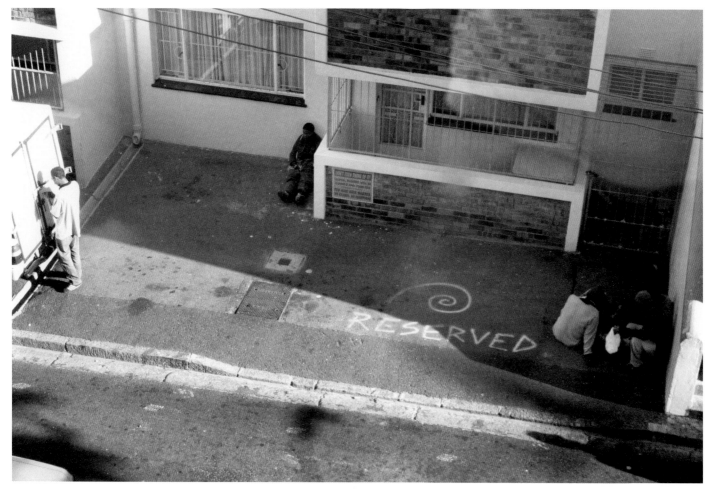

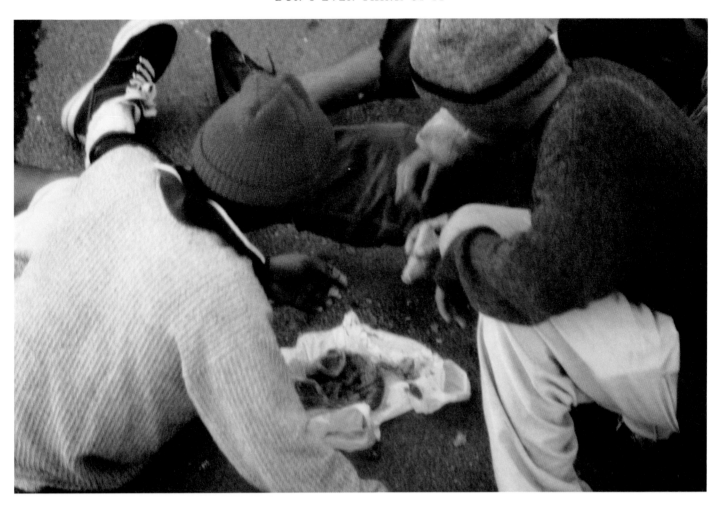

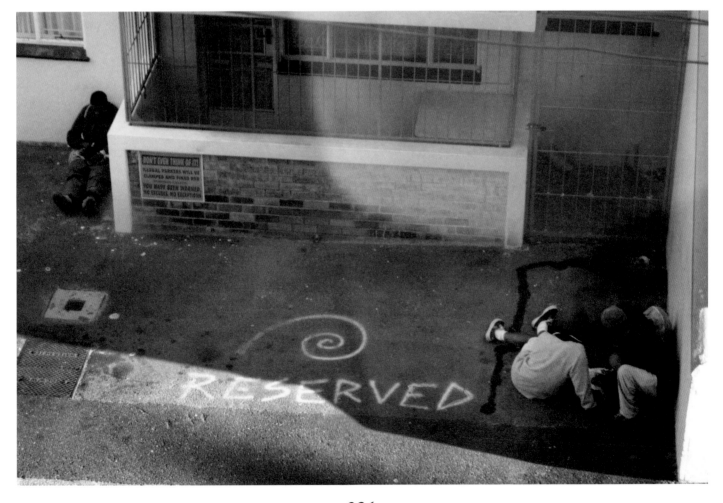

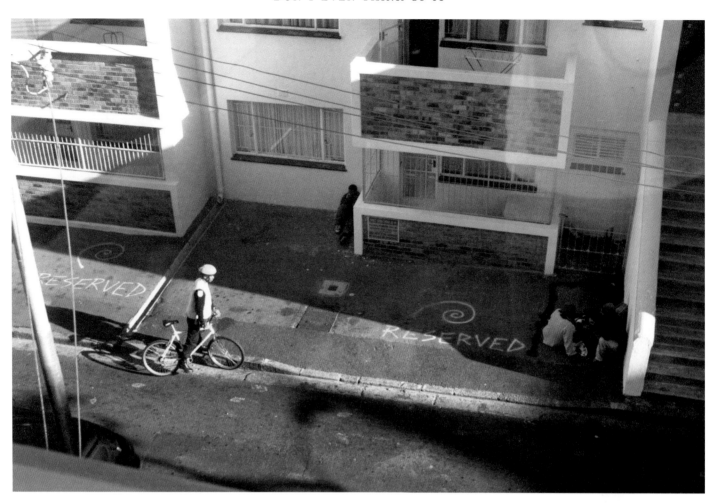

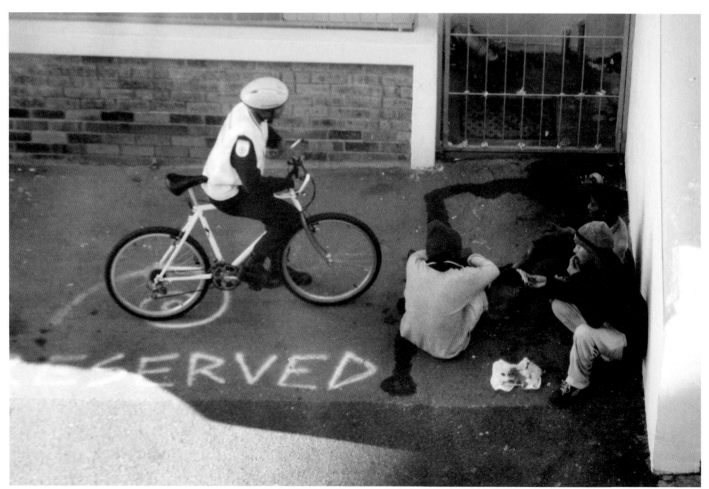

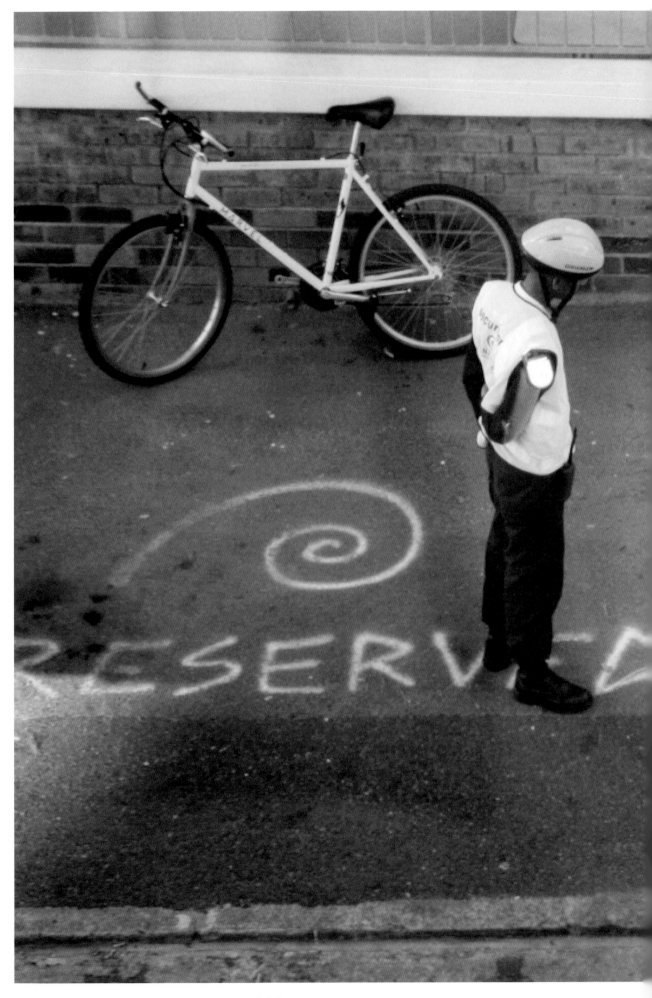

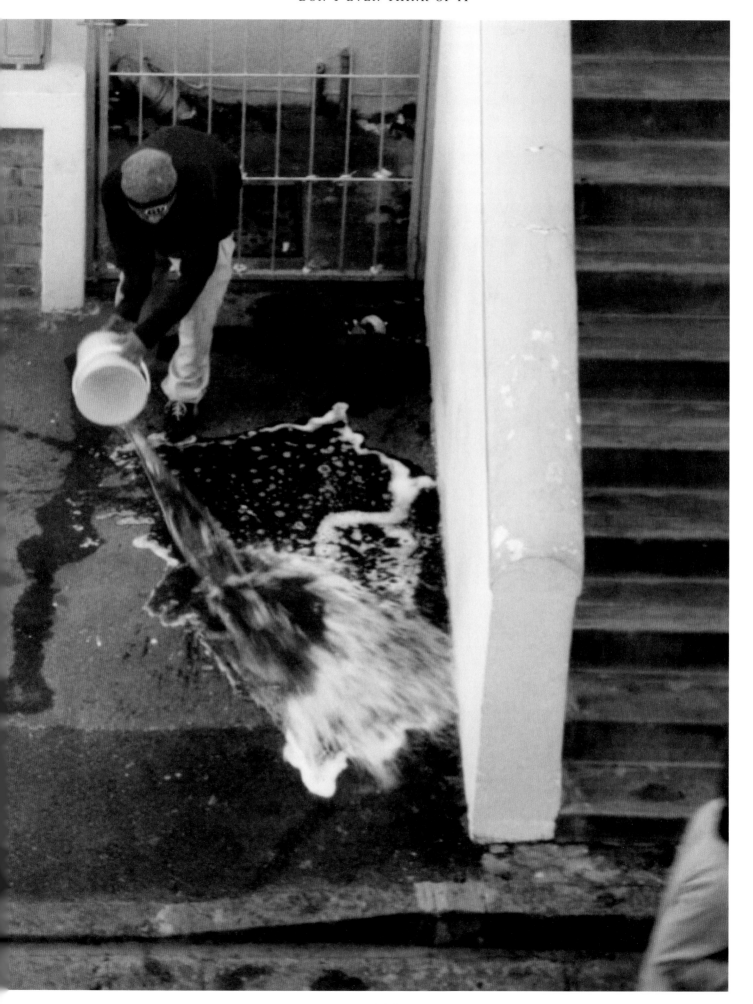

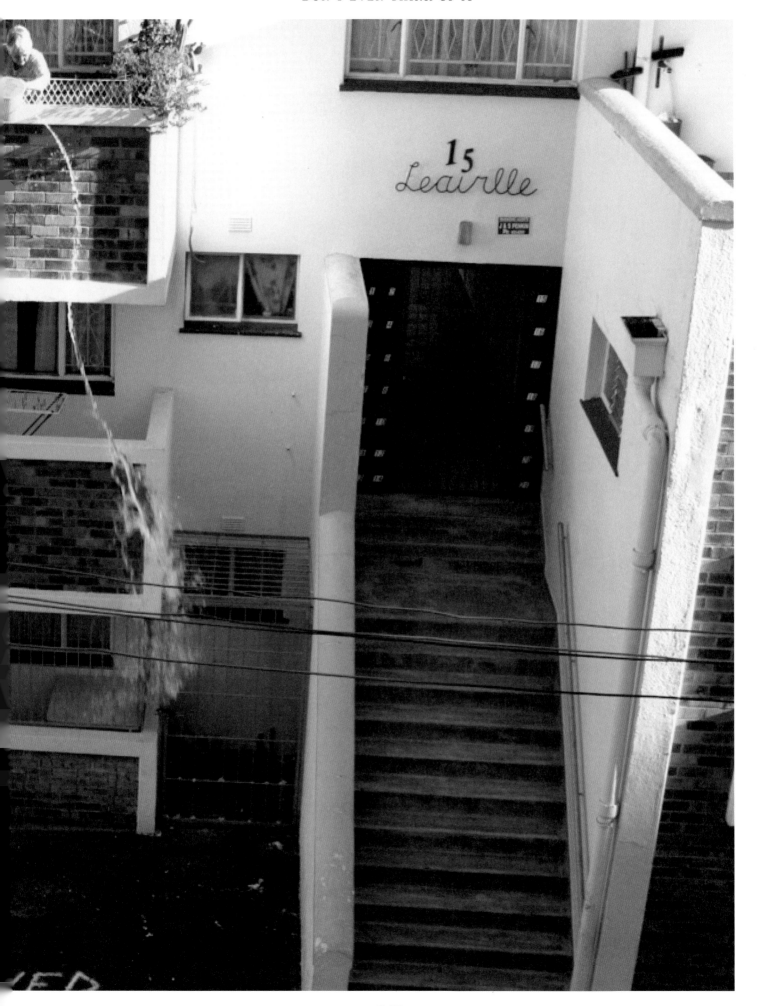

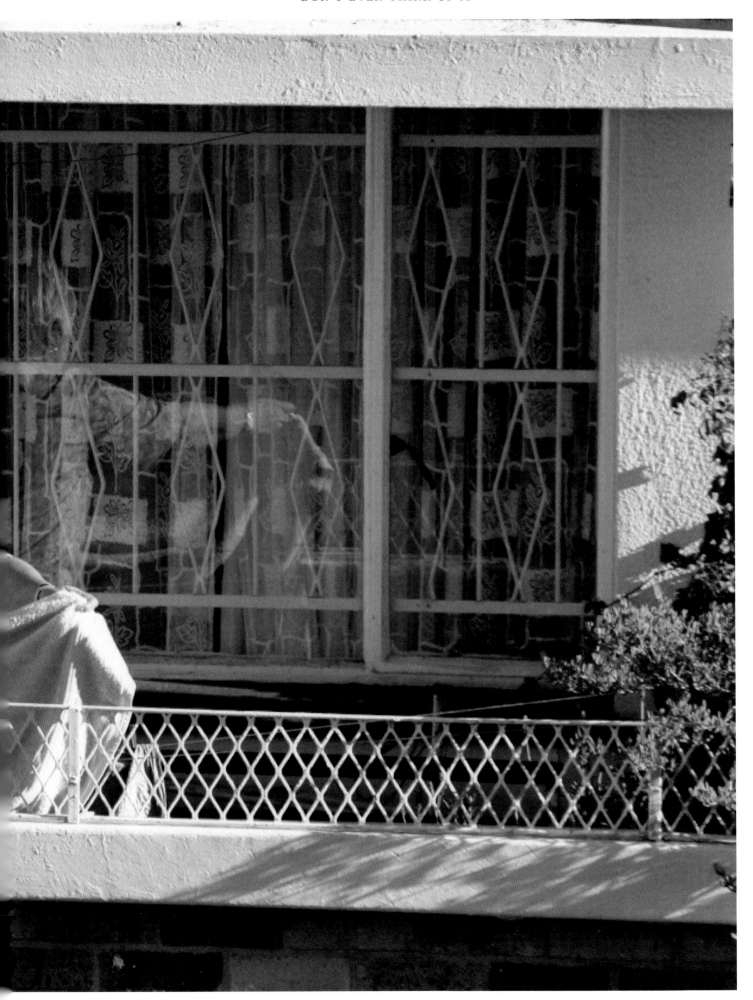

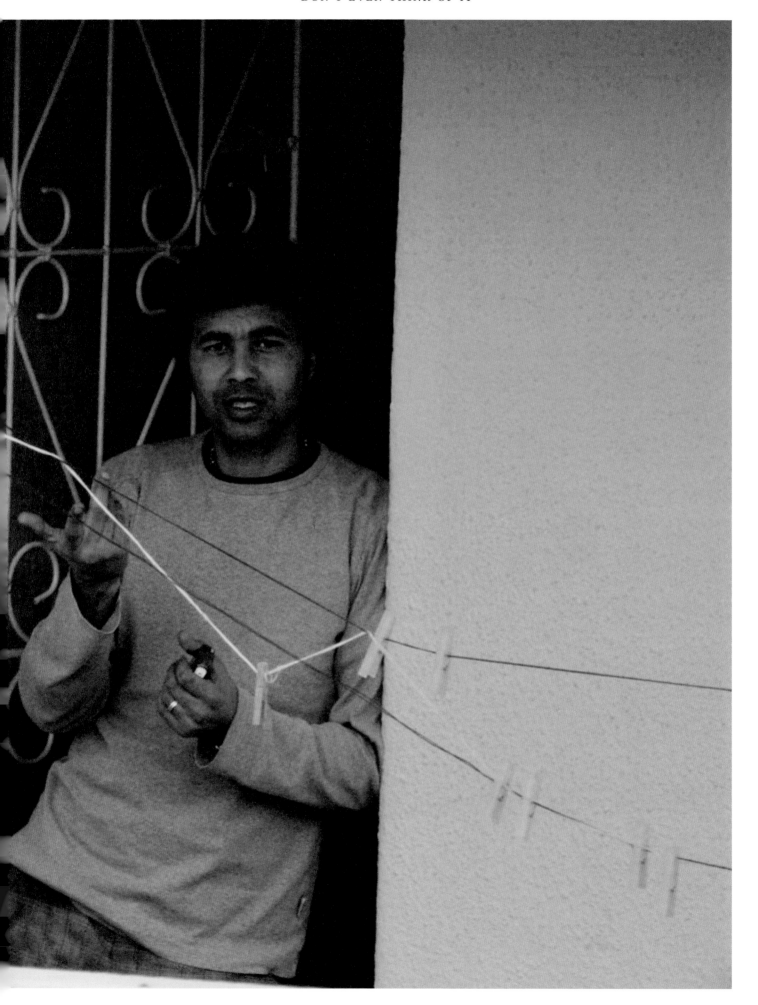

1981

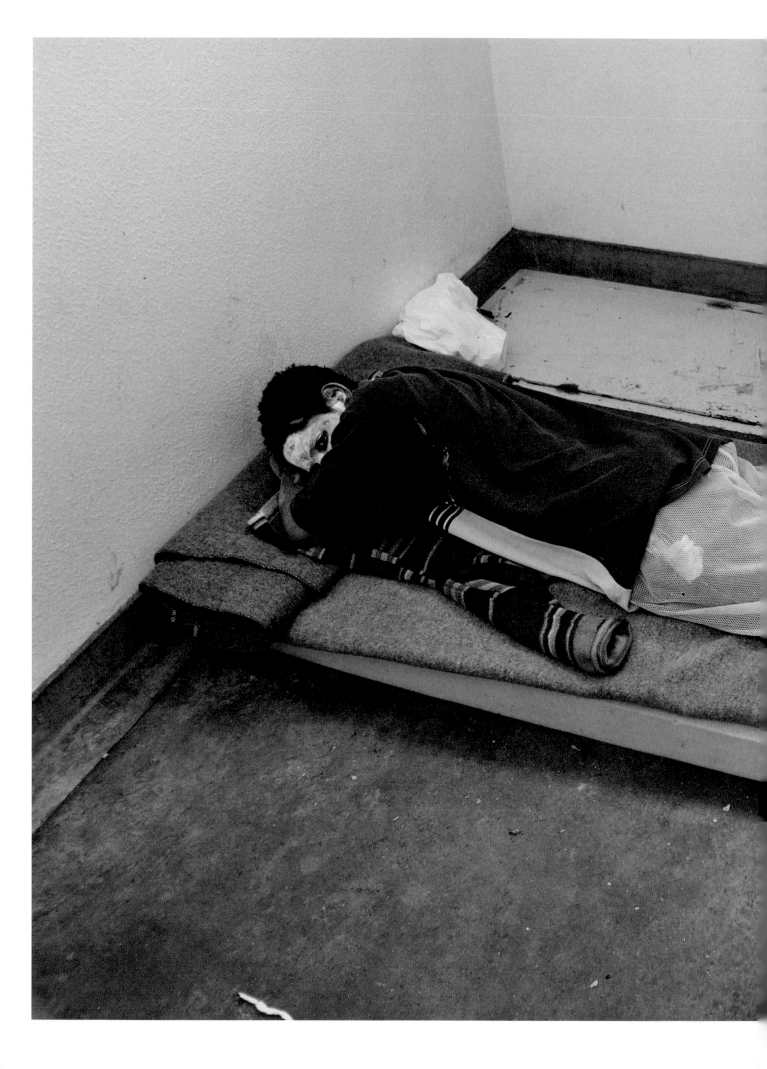

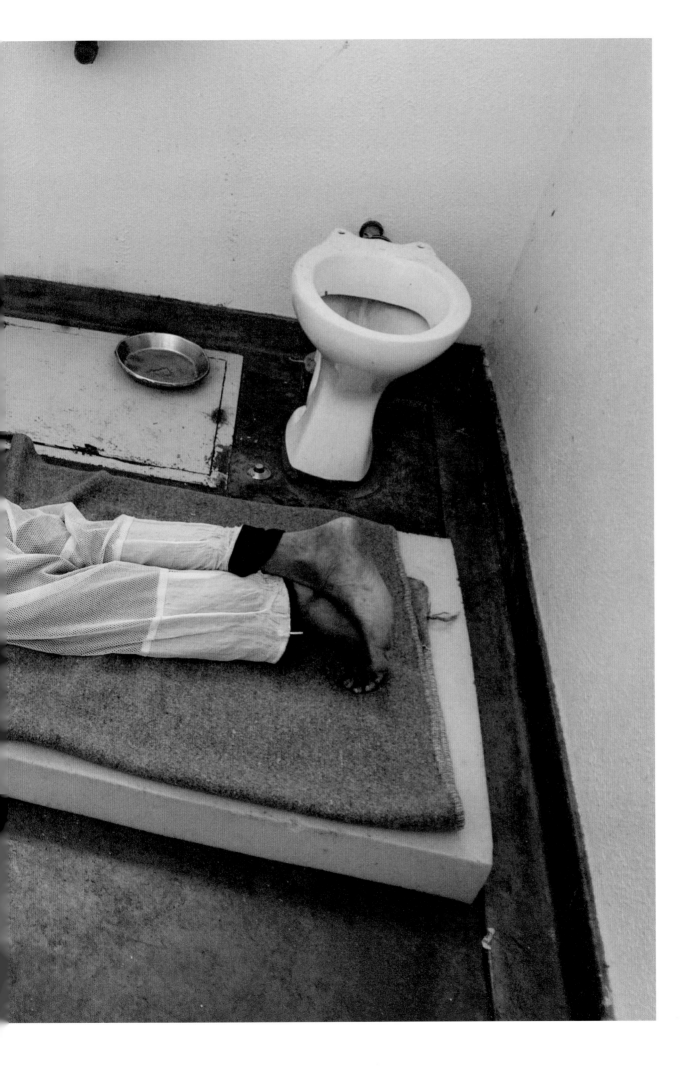

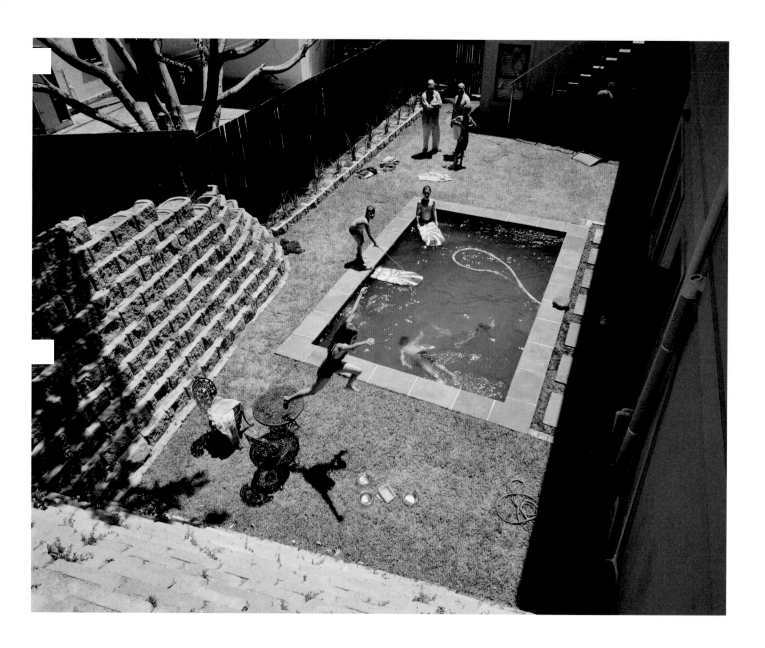

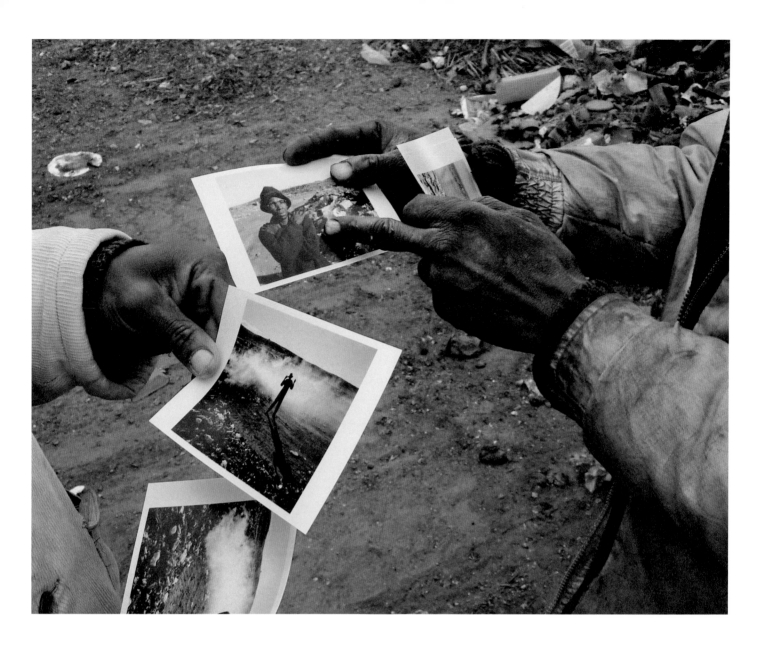

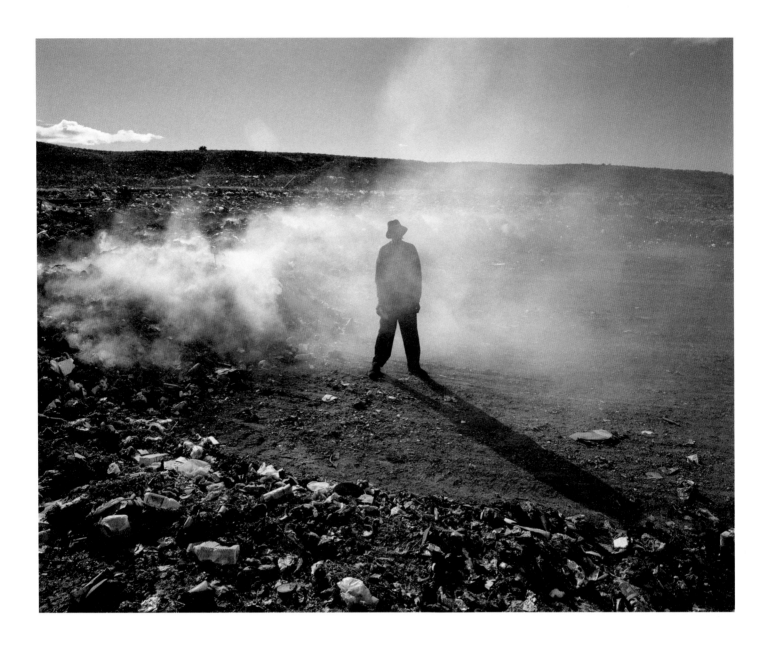

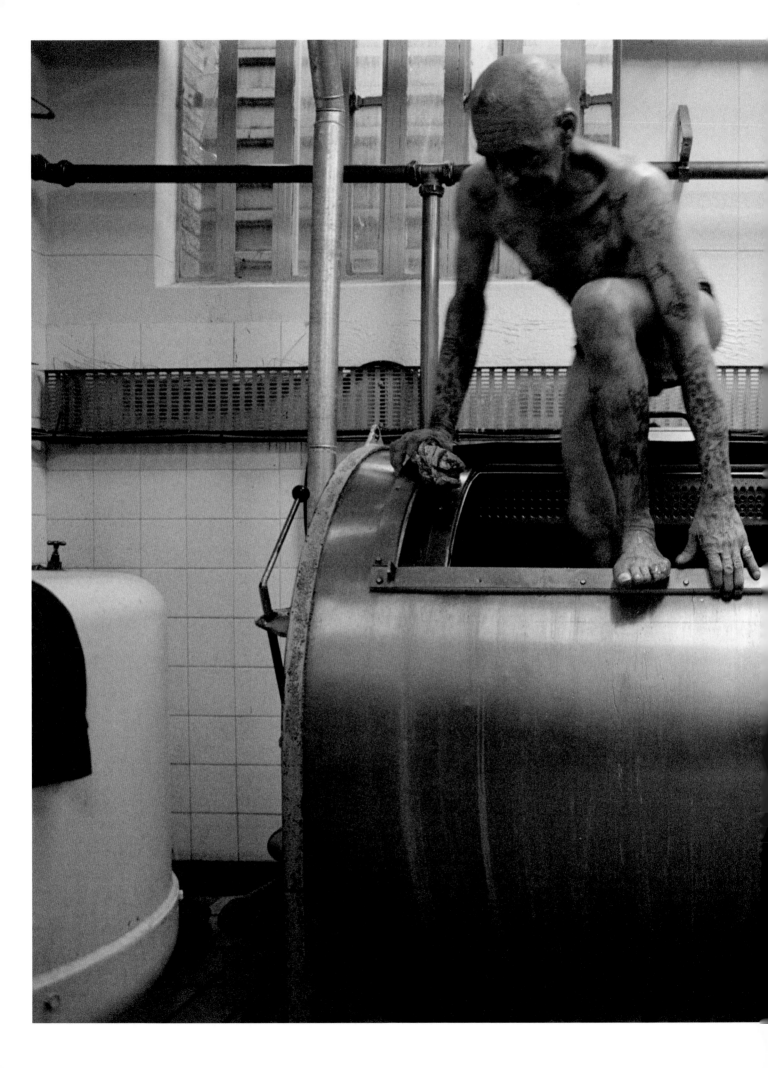

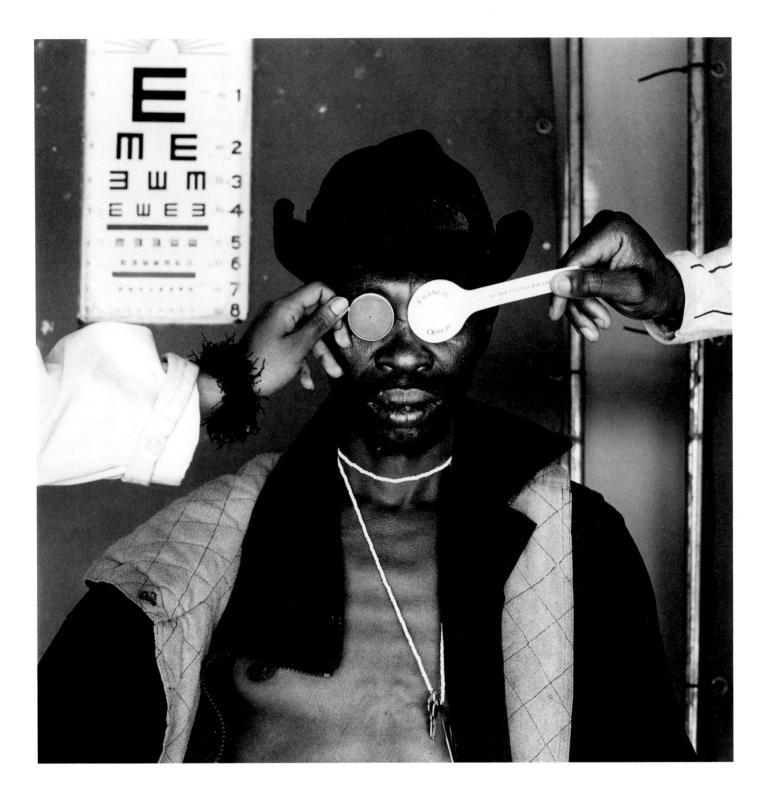

EYEING

Anthea Buys

OTHERS

THE MONUMENT

Griffiths Sokuyeka's laughter is misplaced. He uses it to punctuate trifling facts, like the age of the building, or the common names of the sections in which we linger: 'foyer', 'atrium', 'fountain', 'theatre'. He has been giving the same tour of the 1820 Settlers Monument in Grahamstown for over a decade. The sequence and wording are of his own invention, with occasional guidance from his employers, the senior custodians of the Grahamstown Foundation and its assets. Griffiths Sokuyeka is a caretaker in the building, and, indeed, he takes care in his responsibilities, which extend to hoisting and lowering the flags of South Africa and the Grahamstown Foundation each day, turning the fountain on and off, and generally preventing disorder within his ambit. He does these things with a proficiency that signals a greater aptitude. There are visitors to this site for whom he hopes to make the experience exceptional – schoolchildren, especially those who come for day trips from the townships. And so he invests these tasks, which a different person might have thought mundane, with a special gravity. It is still summer, but his collared shirt and tie are immaculate over what must be a thick vest. He has the decorum of a waning generation.

Sokuyeka features as one of two protagonists in a new film work by Mikhael Subotzky. The film, titled *Moses and Griffiths* after its principal subjects, reconstructs Grahamstown's history through the narratives presented by Sokuyeka and Moses Lamani, who works as a guide at the Observatory Museum on the other side of the town. By the time I arrive in Grahamstown to observe Subotzky's work-in-progress and meet Lamani and Sokuyeka, he has interviewed them almost daily during several long sojourns in this small Eastern Cape town.

Subotzky received the Standard Bank Young Artist Award for Visual Art in 2012. The Award grants the winner a travelling solo exhibition, which customarily starts at the Monument Gallery in Grahamstown and then shows at as many public institutions around the country as are able to include it in their annual programme. Subotzky has been preparing *Moses and Griffiths*, a key element of his award show *Retinal Shift*, in the town itself. There are five other pieces, some of which reconfigure material he has made or collected in the last ten years, while others, like *Moses and Griffiths*, are newly filmed.

Moses and Griffiths proceeds from two architectural sites symbolic of inspection: the Observatory Museum, which contains a Victorian camera obscura built for the purpose of locating the town doctor, and the 1820 Settlers Monument, a brutalist hulk erected in the 1960s to 'watch over' the English language in South Africa. The tours given by both Lamani and Sokuyeka originate in some physical feature of the buildings where they work, whether the mechanism of the camera obscura itself or the assortment and layout of rooms and theatres named to honour cultural saints, and then vault to the history of the town. At Subotzky's prompting, the men have also been talking about their own lives on film, revealing their personal histories embedded in the streets and buildings of the town. These four stories, each man's official tour and the

personal tour that is its counterpoint, their clashes and convergences, will be orchestrated in the installation.

Sokuyeka's tour starts with the history of the British citizens who sailed to and finally settled in South Africa in 1820. Their saga is punctuated by numerous 'challenges': destitution in their homeland, a long time at sea and then a protracted war with the Boers. Although Britain's colonization of South Africa was fraught with abuses, he portrays the settlers as well-intentioned and vulnerable. The inception of the Nationalist government in South Africa in 1948 is described as a threat to the survival of the English language in the country. The advent of apartheid does not figure in his narrative, as though within the concrete and yellowwood shell of the Monument a world exists where the most sinister thing D.F. Malan could have done was ban the reading of Thomas Pringle.

With little change, Sokuyeka has been faithful to the settler history he tells, often deliberately avoiding other narrative strands in South Africa's past. After a blaze destroyed the Monument in 1994, much of the building's interior had to be reconstructed, and many South African artists offered support by donating artworks to the Grahamstown Foundation. Despite Sokuyeka's efforts to solicit information about these more recent works, his knowledge of the Foundation's art collection ends at the Cecil Skotnes woodcut panels commissioned in 1985. These hang in the central atrium of the Monument, and Sokuyeka regards them as a highlight of his tour. He decodes them slowly, one at a time, adding ornamental pauses and repetitions. Now and again, he looks the camera straight in the eye.

The effect, when the footage is played back, is that Sokuyeka appears to look directly at the viewer. In so doing, he breaks with the cinematic convention that so well facilitates an audience's suspension of disbelief: in the ordinary course of things, the actors never look directly at the camera. We pretend they are unaware of being watched, and nothing is demanded in return, besides, perhaps, the cost of a movie ticket.

With Sokuyeka looking occasionally into the lens, it is possible for us to fantasize that the inspection proceeds in both directions, that we are not simply voyeurs. In fact, as we might with a photograph, we may imagine that he *does* look at us. His image holds this power for as long as Subotzky's material survives, even after the embodied Sokuyeka is no more. This simple, vertiginous truth – that the photograph (or film) can survive its human subject—preoccupies Roland Barthes in his personal account of looking at photographs, *Camera Lucida* (1981, English). It is the only quality that Barthes insists is essential to photography, as it manifests the medium's most affective power, or its '*punctum*': the displacement of time.

Though *Camera Lucida* has often been treated as theory since its publication, Barthes himself positioned the text as a personal meditation. It is plain in the work that his objective is to find a language to enclose the dispossession he feels when looking at a photograph of his deceased mother as a young girl. This image, which is not reproduced in the book, is its fulcrum. He replicates the melancholy with which he pores over the photograph in his reading of a selection of images of strangers. He identifies

the most powerful components of these images as those incidental features that strike him as laden with pathos. The straps on a pair of outmoded pumps worn by an African American woman in an early twentieth-century family portrait; the way a grieving mother clutches a sheet in a 1979 Koen Wessing photograph taken in Nicaragua. For Barthes, these are examples of the *punctum*: the things in a picture which induce not a feeling of shock, but something like sadness (if not sadness itself). The *punctum* is 'that accident which pricks me (but also bruises me, is poignant to me)' (27). In the case of the photograph of his mother, this 'accident' is the time that has accumulated between the taking of the photograph and Barthes's discovery of it. This too is incidental. Time accumulates with no regard for the picture or its viewer.

Barthes grimly reads this as the inscription of death within the medium of photography: a photograph of a living subject is a *memento mori*. It allows someone to 'look at us' into perpetuity, even from beyond the grave. Moreover, he writes, it reminds us of the inevitability of our own death. In this respect, the photograph is a kind of monument. Barthes writes of the experience of looking at a photograph as peering back in time. But taking photographs, rather than looking at them, is about future memory, or imagining a future in which one looks back in time. In Barthes's day, the eventual decay of analogue photographic images meant that these small paper monuments were themselves 'mortal'. They were at least less permanent than stone. However, with the digitization of the medium, the possibility exists that photographic and filmic images will survive as far as we can imagine into the future. The potential of the digital image to live on into perpetuity recalls a line near the end of Geoff Dyer's *The Ongoing Moment*, in which he challenges Barthes's macabre conclusion. There is a 'simple message that is also there in all photographs,' writes Dyer: '"You are alive."' (254)

What *Camera Lucida* fails to acknowledge is that one's sense of being looked at from the past (or from a future past), by the eyes of a photographic subject, is misleading. When Sokuyeka looks directly into the lens of Subotzky's camera, he is not looking at another person, even though he appears to be. When we look at him on screen and assume the position of his addressee, we are really only inserting ourselves in place of a machine with a single, prosthetic eye. During the filming process, the direction of Sokuyeka's gaze is a measure of his personal connection to what he says. Some weeks into their work together, Subotzky encourages him to alternate his routine tour of the Monument with an improvised one about himself. This personal tour, a history of Grahamstown peppered with his own experiences, Sokuyeka calls his 'profile'. In these sessions, it is as if he wants to look over or through the camera, to reach Subotzky's eyes. In response, Subotzky moves the camera to his shoulder while still filming, and Sokuyeka anchors his eyes in Subotzky's. In these moments, it is just as Barthes writes: 'The Photographer's "second sight" does not consist in "seeing" but in being there' (47).

As with his regular tour, Sokuyeka becomes increasingly at ease with per-

forming his personal tour, sloughing off his stories. He tells us that during the evenings, at his home, he looks through a box of photographs in search of 'things'—by which he means memories – for Subotzky and the film he is making. The camera's promise has given a particular curvature to his life; Sokuyeka too wants to be remembered. Amongst all the plaques and stones, he wants one of his own that recognizes his having 'done something for the Foundation'. He says, 'They must put my name on the wall over there, and they must always say, "Griffiths: we remember everything he did for this place."'

A BLINDING FLASH

There is a scene near the end of Alfred Hitchcock's 1954 thriller *Rear Window*, in which the protagonist, a wheelchair-bound photographer with a penchant for spying on his neighbours, watches as his girlfriend is caught snooping in the apartment of a man suspected of murder. Jeffries, the photographer, calls the police and they arrive just in time to save her, but as she is being escorted out of the apartment, the murderer, Thorwald, realizes that he is being watched. He looks back at Jeffries with intent, and the lights in his apartment go out. Within seconds he is in Jeffries's building, on his way up the stairs to the photographer's apartment. All Jeffries can find to defend himself against the imminent attack is a box of flashbulbs. Once Thorwald gains entry, Jeffries closes his eyes and fires off the flashes one after another, blinding Thorwald for a few seconds. In order to protect himself from the penalty for his uninvited

looking, Jeffries blinds his opponent, re-instating himself momentarily as the only one capable of using his eyes against the other.

At the entrance to *Retinal Shift* are two giant, blind eyeballs. They are images of Subotzky's eyes, and were made under circumstances which recall the climactic scene in *Rear Window* (bar the mortal threat to the protagonist). Very near to the camera obscura in Grahamstown, there is a small optometry practice, where, amongst other things, the optometrist must occasionally photograph people's retinas. This is done to check for irregularities that do not reveal themselves conclusively in compromised sight. Subotzky, who as far as he can tell has perfect vision, asks for a portrait of his eyes. The image can only be made using a bright light, which is flashed directly into the pupils. It is momentarily blinding. In an especially bare way, this gives a lesson: the difference between a reciprocal, consenting gaze and the kind of looking that analyses and takes stock – and surveillance is precisely this sort of looking – is someone's blindness.

In an interview with Bernard Stiegler titled 'Spectographies', Jacques Derrida compares the gaze of Barthes's photographic subject with that of a ghost. The connection is already embedded in Barthes's text, and follows naturally from his fixation on death. For Derrida, though, the 'ghostliness' of the photographic gaze consists in our not being able to return it, just as the feeling of being haunted is related to an inability to see something we suspect is present. Derrida calls the 'right of absolute inspection' which both the ghost and the photographic subject enjoy a 'visor

effect' (Derrida and Stiegler, 121). In surveillance, the visor effect is reversed. The voyeur exercises absolute inspection, regardless of whether or not it is his right to do so. It is only when the subject by accident looks back at the surveying apparatus, whether an eye or a lens, that this relation fractures.

Surveillance imagery does not feature in *Camera Lucida*, but if it did, Barthes might have introduced a third kind of *punctum*, the awareness of looking with absolute power. This is the power that shatters when Thorwald in *Rear Window* looks back at the spying Jeffries, jolting him into a fearful awareness of his own guilt. There are similar moments in two of the works on *Retinal Shift*, namely *Don't even think of it* and *CCTV*.

Don't even think of it is a film made from material collected when Subotzky was still an undergraduate. Its rough, stop-frame aesthetic is a consequence of the limited SLR camera technology available at the time – today affordable SLR cameras can shoot seamless high-definition digital films – and this is the first time Subotzky, after some deliberation, is showing the piece. Shot from the window of his apartment on Kloof Street in Cape Town, the film surveys the goings-on down below in the street. The subjects of the work are oblivious passers-by and loiterers, some destitute or simply languid, and others on their way to work or to buy bread. For a while, we watch people sleep, scratch, bicker. At one point, there is a prolonged shot of a man sitting in a corner trying to masturbate. When people walk past, he covers himself up, but thanks to the activity on the street, he can never find a long enough stretch of privacy to finish his

task. It belongs in a private space, in a dark room, not on a public pavement. Some men who have stopped to eat are driven away by a guard and then a woman in a flat above pours buckets of water down on the spot to clean up the mess. Towards the end of the piece, the camera is trained on other apartments in the area. Until now, no one has noticed Subotzky spying through his lens, and then suddenly, a young man standing on his own balcony sees him. With an accusing look, he raises an open palm towards the camera, as if to chastise Subotzky for what is clearly felt to be an invasion.

The ability to look, at one's leisure, at 'once-privileged views' (Phillips, 11) is one of the most significant outcomes of the development of camera technology in the twentieth century. The reduction in scale of cameras, the increased range of their lenses and their progressive affordability have, in the words of Sandra Phillips, 'encouraged viewers to tolerate or seek out or breech [sic] or at least question what we, as a culture, did not seek out before this invention ... without the threat of public approbation ...' (11). Naturally, there is a long precedent in the history of photography of images of subjects who are, or seem to be, unaware of being photographed. Among many examples, one could mention Walker Evans's well-known *Subway Portraits* (1938–41), taken with a hidden camera; Merry Alpern's *Dirty Windows* series (1994), which shows the clientele and staff of a high-class brothel in New York's financial district, shot from a window across the street; and the remarkable series of four images by Brassaï, also shot from a window, titled *A man dies in the street, Paris* (1932). The first

image in this series shows a man, soon to be discovered as a corpse, lying on a pavement. As people realize he is dead, a crowd gathers around the body. The crowd swells, and then dissipates again, revealing that the body has been cleared away. The subject of the work is not so much the dead man as the crowd's fascination with him.

A similarly morbid spectacle is the focus of the second of Subotzky's surveillance works on *Retinal Shift*, a piece titled *CCTV* (2012). This time, however, the viewer of the work takes the place of the crowd. The piece comprises 12 clips of colour CCTV footage captured at night in various locations around Johannesburg's inner city. These clips of varying length are presented in a grid; they begin at different times, but two thirds of the way through the piece they are all playing simultaneously. These glimpses of the night-time city range from the mundane to the horrific: besides two blithe tyre thieves and a pair trying to remove a manhole from the road, two men are badly battered and then robbed and left lying on the street. In a particularly unnerving clip a mob of men and women beat and stone a man. It is impossible to conceive of his survival as he lies on the ground afterwards like a rag. All the way through these episodes, the surveillance cameras zoom in and out of the scene, following certain characters and scanning the surrounds. The control-room operators change the view at all the right moments: just when one wants a closer look at a brawl or someone's secret pottering, the camera zooms in, as if at the viewer's will.

CCTV ends unexpectedly, with a piece of choreography that is partly Subotzky's and partly the Johannesburg Metropolitan Police Department's. After being arrested, the perpetrators of the various crimes we have just witnessed are forced to look directly at the hidden surveillance cameras. The cameras zoom in and, for a few seconds, it is as if the actors in all these dramas leave their fictional worlds and peer out at the audience. The moment recalls others in *Retinal Shift* – Griffiths looking into the camera, the man on the balcony asking a question of the hidden camera and the voyeur behind it – and reminds the viewer that the material consumed is not cinema. It is real, and like Brassaï's crowd, we have been engrossed in witnessing real violence and the termination of a life.

War photography and photojournalism in the twentieth century have established a convention in which the photographic representation of violence is almost always associated with gore, or at least the suggestion of gore (what is traumatic in an image of a bomb blast is the suggestion that bodies will have been destroyed). Susan Sontag writes on this topic critically in the polemic *On Photography* (1977), and more sympathetically in her later work *Regarding the Pain of Others* (2003). These works have had great influence on the reception and presentation of images of violence, but in the discourses of trauma and witness studies, which have emerged subsequently, comparatively little attention has been paid to the experience and effects of various kinds of structural or institutional violence (rather than *institutionalized* violence, such as the routine violence in concentration camps or prisons). This is a kind of savagery by systematic silence and silencing. Its victims

may perceive themselves as its beneficiaries, or even its accomplices. It is a kind of violence that South Africa has preserved in many of its public institutions, despite the collapse of apartheid. *Retinal Shift* sets up a complex equation between physical and institutional violence, suggesting a generative, and often complicit, connection between the two. This is evident in the presentation of *Moses and Griffiths* in the same exhibition context as *CCTV*, but the subtler implications of South Africa's retention of structural violence are conveyed in the large installation *I was looking back*.

In *I was looking back*, Subotzky presents a selection of photographs from his archive, displayed collectively on a single wall in the exhibition. The viewer's eye glides from images of the artist's friends and lovers at leisure, and a family picnicking in the street (apparently under the watch of a private security guard), to the shocking image of the charred corpse of a Pollsmoor Prison inmate who died in a fire. In this wide-ranging assemblage of personal and professional images – as indeed in *Retinal Shift* in its entirety – Subotzky appears to be taking stock of his work and career thus far. But the whole he creates, one the viewer's gaze might wish to glide over effortlessly, is subjected to a disruptive new interpretation: the glass shielding several of the images has been deliberately shattered. The effect is a visualization of Barthes's *punctum*, a literal rupture in the smooth, obliging surface of the picture. This paradoxical gesture both draws attention to these works and obscures them. Even as he asserts his authorship of the work, his presence at the scene represented, he complicates the nature of the violence done in image-making. Here violence is done not only to the subjects but to their representations, perhaps to the notion of representation itself.

A DARK ROOM

Across the valley in which Grahamstown shelters, in the dark turret of a Victorian house museum, Moses Lamani examines the sunshine as it hits a gaping crack in the road. He peers closely at the street from inside the camera obscura atop the Observatory Museum, where he spends hours with Subotzky, both of them watching the day get on with itself. An employee of Grahamstown's Albany Museum, which manages the Observatory Museum, Lamani is sombre, a would-be historian. On most days his task is to act hospitably towards tourists, almost always foreign, who wander into the Observatory Museum. When they do, invariably sweaty and in groups, he leads them up a gnarled staircase to the roof of the building and then encloses himself with them in the pungent darkness of the camera obscura.

With even greater rote precision than Sokuyeka, Lamani gives a panoramic 'tour' of Grahamstown using a camera obscura that was originally built for the purpose of locating the town doctor. Completed in 1882, the device was intended as both a scientific curiosity and a tool for surveillance. Today it is so redundant it is almost arcane. Each time Lamani gives a tour, he replicates identically every tour that has come before. Not only are the words entirely without variation, even his tonal inflections and emphases are the same. He

405

does it automatically, with neither obvious fervour, nor obvious boredom. He begins the tour in half-light, the door ajar, with a quick overview of the mechanics of the camera obscura. Then he closes the door, grabs two ropes hanging from the ceiling, and begins to pull, as if he were steering a medieval boat. A mirror turns and after a white flash there is a swatch of Grahamstown, spread out in real time on a white concave disc.

The white disc onto which the camera obscura throws its projection is a tiny stage in the round. The actors are the pedestrians and commuters in the streets around the museum. They walk onstage and off again, as if in a procession, carrying loads and pushing trolleys. They appear to be oblivious of being watched. No one ever looks up to check the direction of the mirror, and their performances are never shy. Subotzky spends days observing the world on the white disc. His own camera is perched on the rim, recording what happens there. Sometimes he wants to run downstairs and climb into the turret's secret theatre and meet its characters. Upstairs he wills them to move into shot. But when they won't cooperate, Lamani transports him to a new view with the tug of a rope. 'Can you take me to the Monument?' Subotzky asks, and the town whirls, and the Settlers Monument squats on the horizon. Subotzky zooms in and out. Together, Subotzky's digital camera and Lamani's lurching mechanical one are a voyeuristic monster-machine.

The Observatory Museum's locale has become the 'wrong' side of town over the years. The camera itself gives excellent views of the Shoprite Checkers supermarket, a petrol station and the courtyards of various hotels. These feature in Lamani's tour of the town, a 360 degree survey of its highlights, as per the camera's reach. Initially, it is perplexing that they should be included, alongside other such obvious points of interest as the Cathedral of St Michael and St George, and the Monument in the distance. Then it becomes clear: Lamani, like Sokuyeka, has been encouraged to share his personal account. Although Lamani is less forthcoming, these seemingly random 'stops' on his tour begin to make sense as he interrupts himself to tell his own stories. The petrol station, up the hill from the old Odeon Cinema, is the place to which his girlfriend's brother would drive to fill his car with petrol. On weekends, Lamani and his future wife would go along for the ride and walk down to the Odeon to see a movie. The former Grand Hotel, today a student residence, was where his mother used to work as a cook, often bringing Lamani and his siblings leftover food at the end of a work day.

His personal interjections shipwreck the tour. Fresh thoughts unmoor him, and the only way he can navigate back 'home', to the street outside the museum, is by grasping for phrases he knows by heart.

THE FIRE

One afternoon, as Subotzky sits in the darkened cabin with his camera poised, the scene on the white disc curdles. There is a great wind propelling a fire up a hill, towards the local Afrikaans high school, Hoërskool P.J. Olivier. Local university students and middle-aged couples drive up to the Monument

to look at the fire and what it has ruined. Subotzky and I go up there too. The hillside is black and fuming, and at the cusp of the slope there is the vermillion charge on the school. Subotzky sets up his camera on a tripod on one of the Monument's balconies. There is not much left to see besides smoke and two dauntless men with pails. Spectators come and go. The real action was around lunchtime, and it is already close to four.

That evening and the next day the fire is on the front page of the local paper, and it takes a week for it to travel through the sheaf of newsprint and burn itself out.

A fire destroyed much of the Monument in August 1994, and the memory of this municipal trauma envelopes the afternoon hillside blaze. It is as if a scar has been pricked, right through the dumb, translucent tissue at the surface to the knot of nerves that grow underneath, where the wound is remembered. Sokuyeka recalls that first fire. It happened one night while he was on duty. He found it. It started in the old auditorium at 2 a.m. He telephoned the fire brigade and then ran. When it came to giving statements at the police station later, what should have been a matter of recording an eyewitness account became a protracted and racist interrogation. His employers accused him of politically motivated arson, and he spent two months enduring the caprices of newly post-apartheid, small-town policing. 'I've still got that in my heart,' he says. 'Still here.'

Sokuyeka's story crumbles on the Yellowwood Terrace, a sun-bleached, superfluous walkway, on which he began his career at the Monument sweeping the carpet. This is his favourite place in the building. It reminds him of his career's humble beginnings, and from here he can see all of Grahamstown's churches, the township where he lives and the house in which he was born. It is here, one day, that he goes too far into himself. He finds himself alone on camera, and he weeps for everything: his family, the ancestors on Makana Kop, his exclusion from school, the word 'kaffir', his own memorability.

It is 4.30 p.m. The Grahamstown Foundation taxies its staff home, and Sokuyeka still has work to do. He straightens his shirt, shares a brittle hug with Subotzky and rubs his hands together. He is ready for tomorrow's session, he says, and away we stride in his wake, to the flags.

REFERENCES

Roland Barthes, 1993 (1980), *Camera Lucida: Reflections on Photography*, London, Vintage Classics.

Jacques Derrida and Bernard Stiegler, 2002 (1996), 'Spectographies', in *Ecographies of Television*, Cambridge, Polity Press, pp. 113–35.

Geoff Dyer, 2006, *The Ongoing Moment*, London, Abacus.

Michael Fried, 2008, *Why Photography Matters as Art as Never Before*, New Haven, Yale University Press.

Thomas Y. Levin, Ursula Frohne and Peter Weibel (eds), 2002, *CTRL [SPACE]*, Cambridge, MA: MIT Press.

Sandra Phillips (ed.), 2010, *Exposed: Voyeurism, Surveillance and the Camera since 1870*, New Haven, Yale University Press.

Susan Sontag, 2001 (1977), *On Photography*, London, Picador.

Susan Sontag, 2003, *Regarding the Pain of Others*, New York, Farrar, Straus and Giroux.

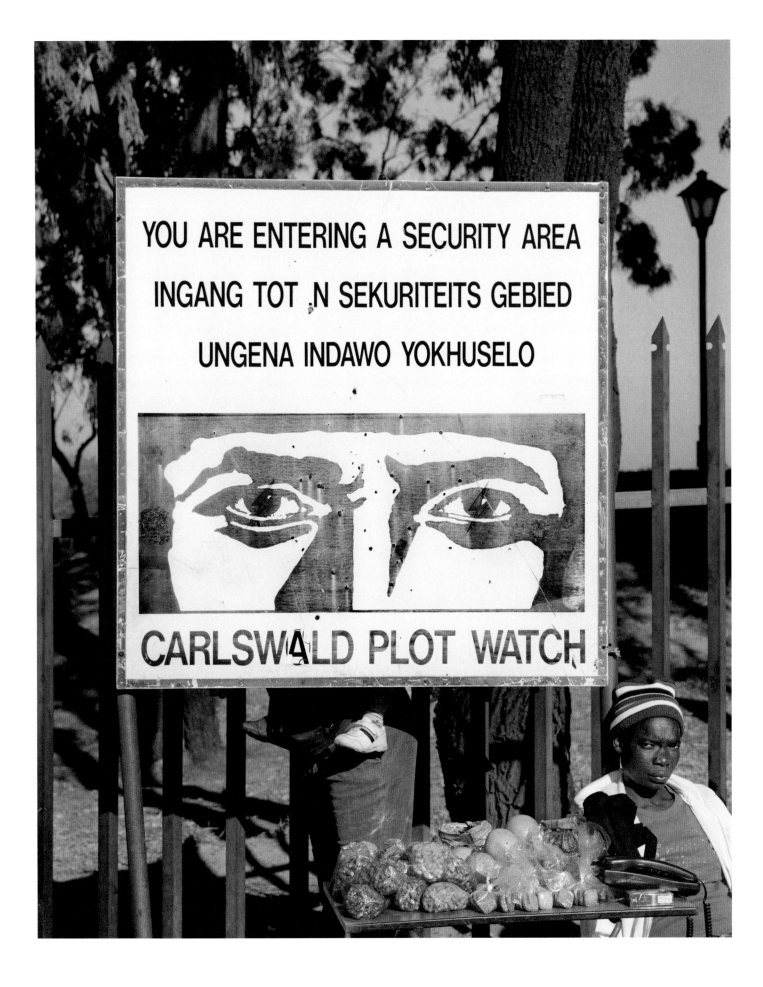

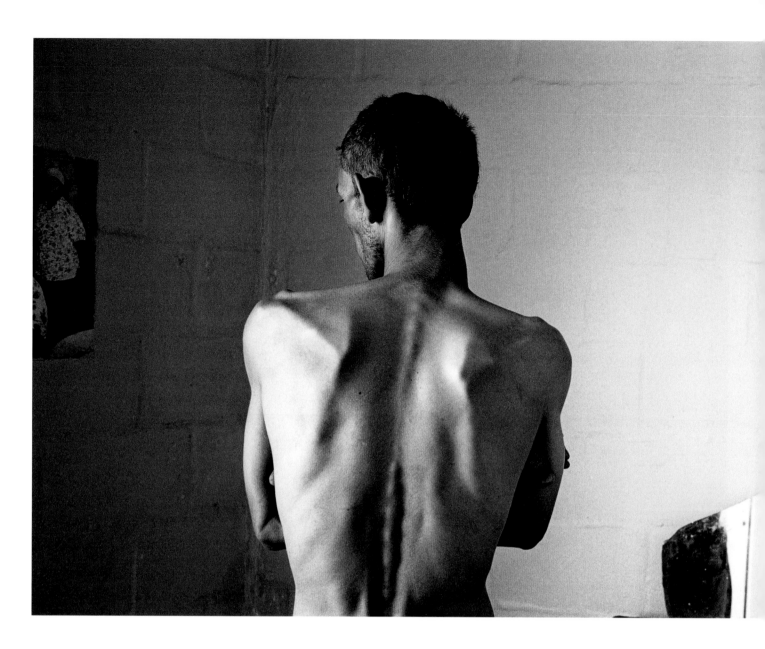

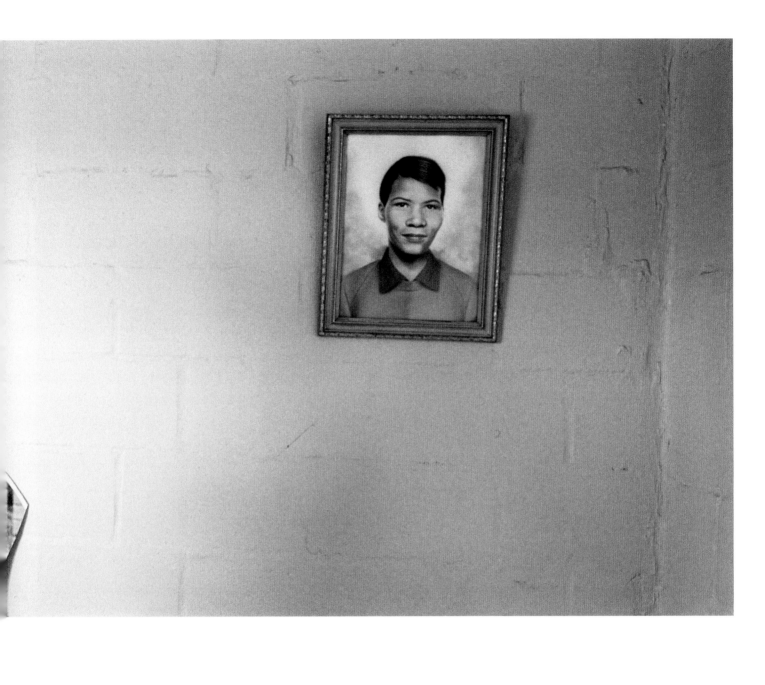

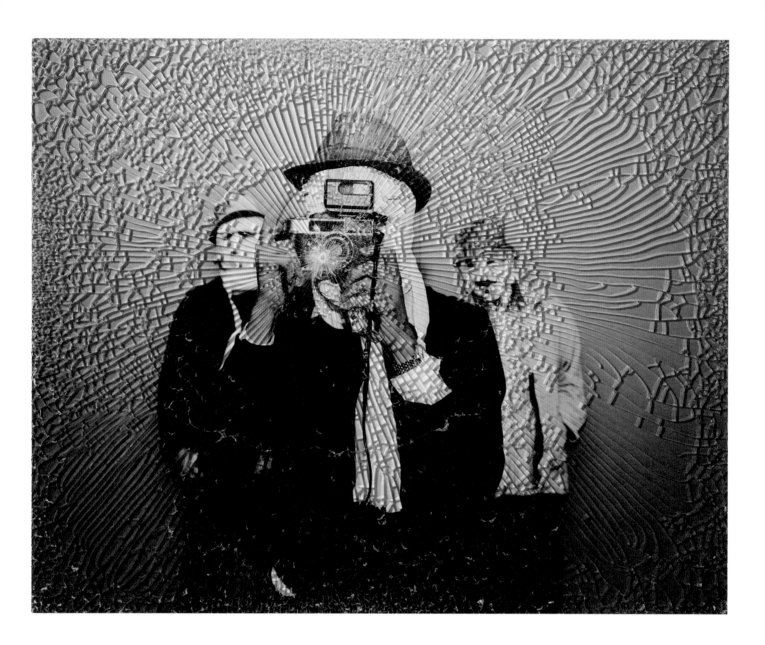

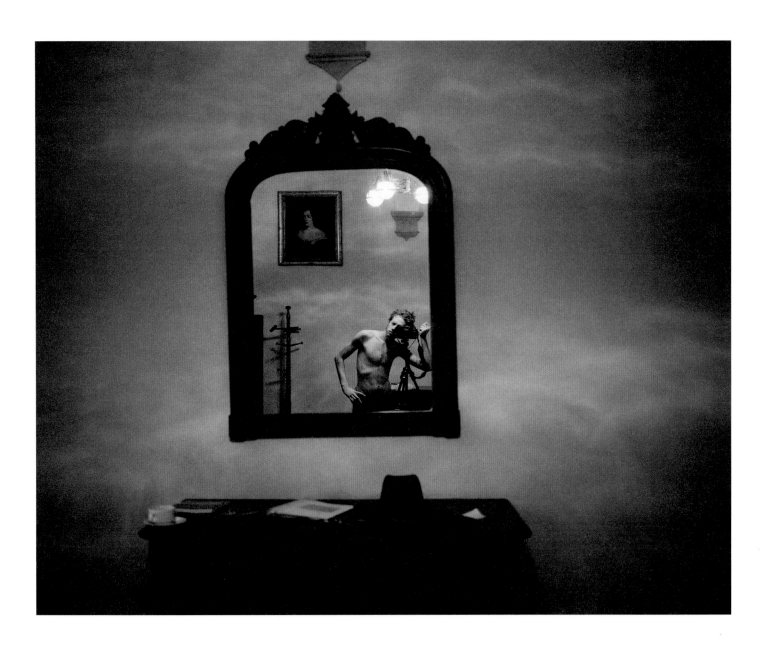

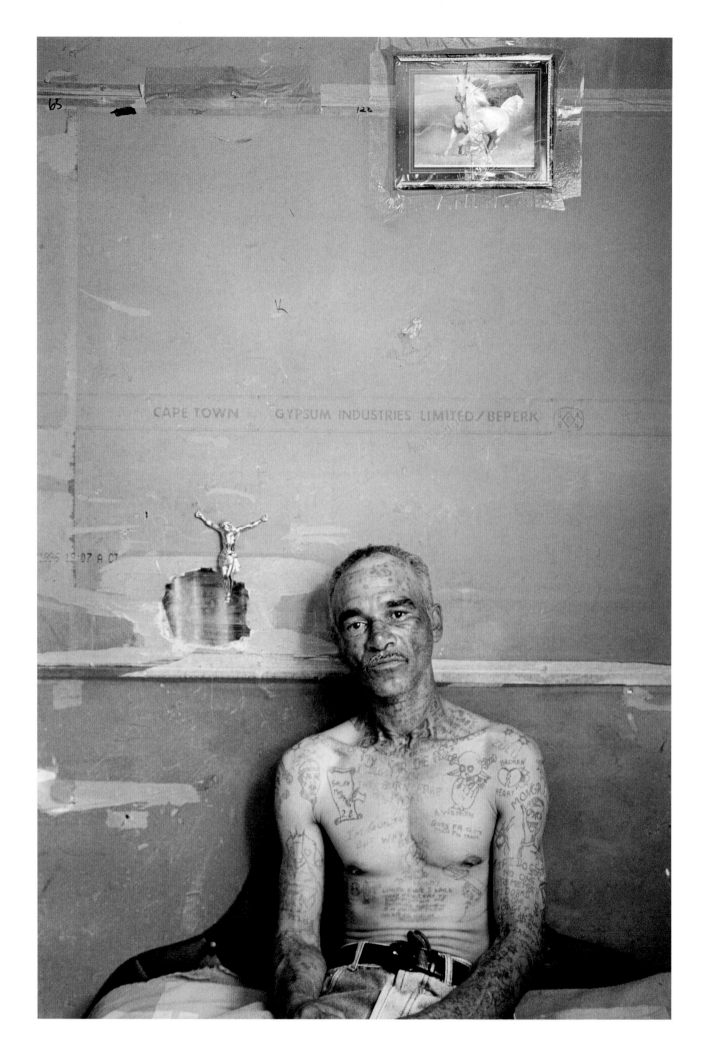

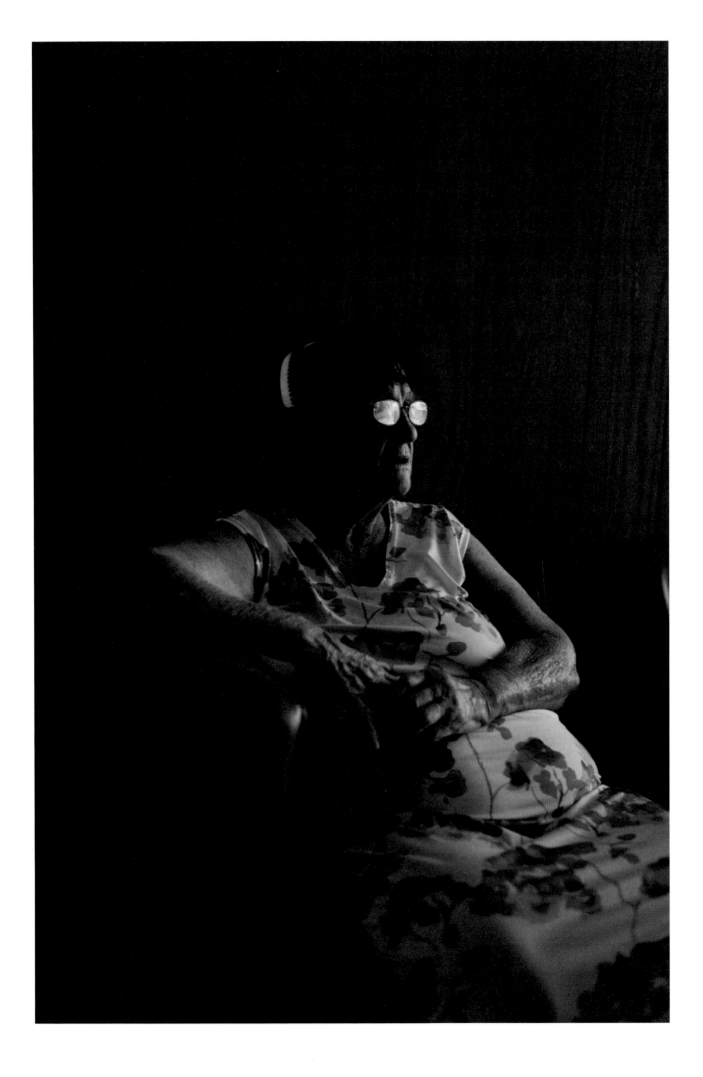

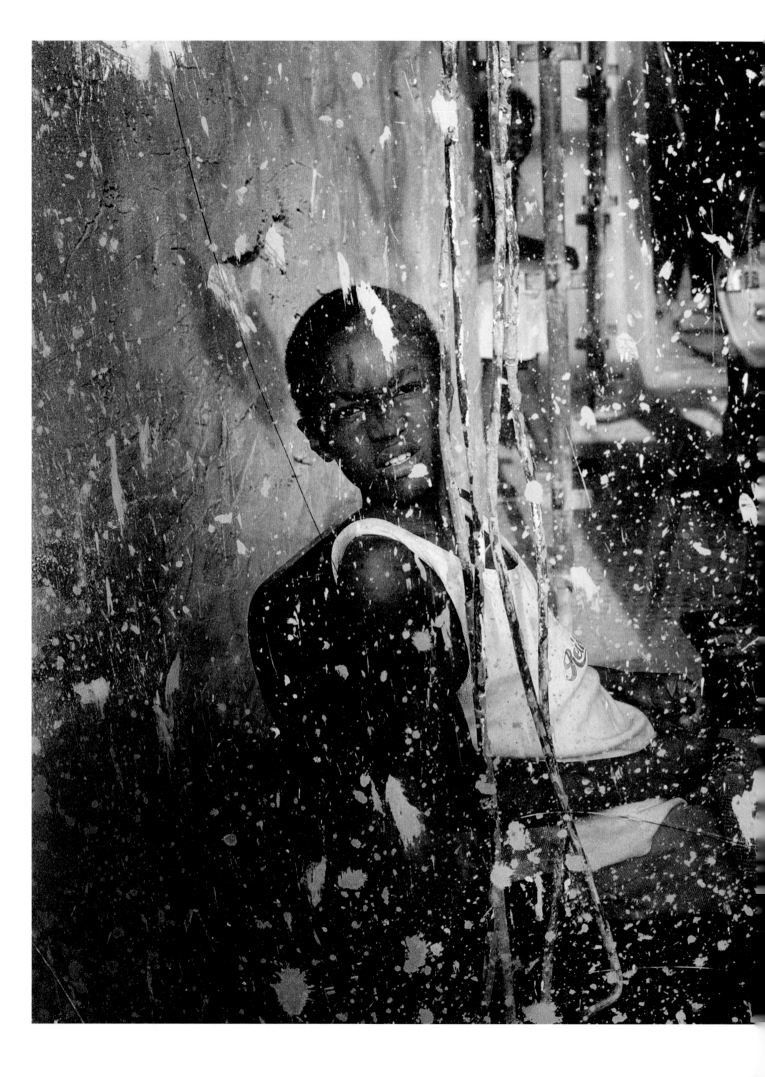

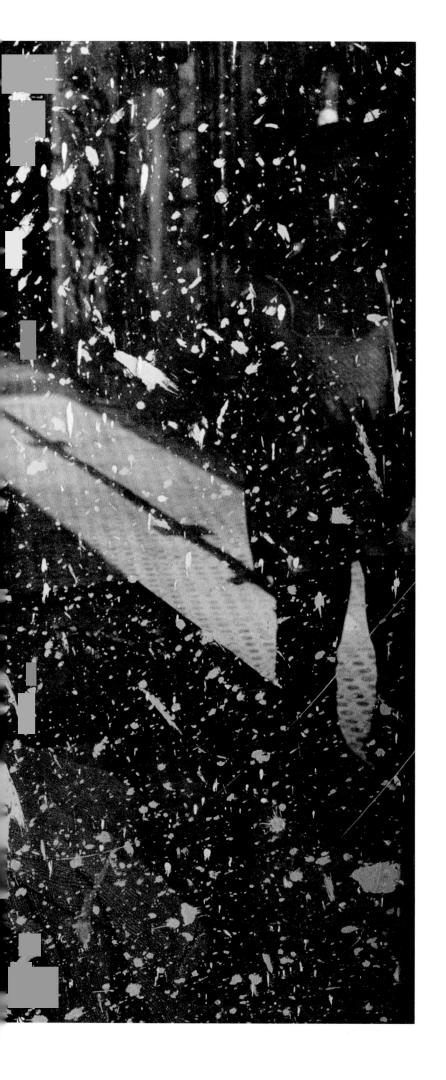

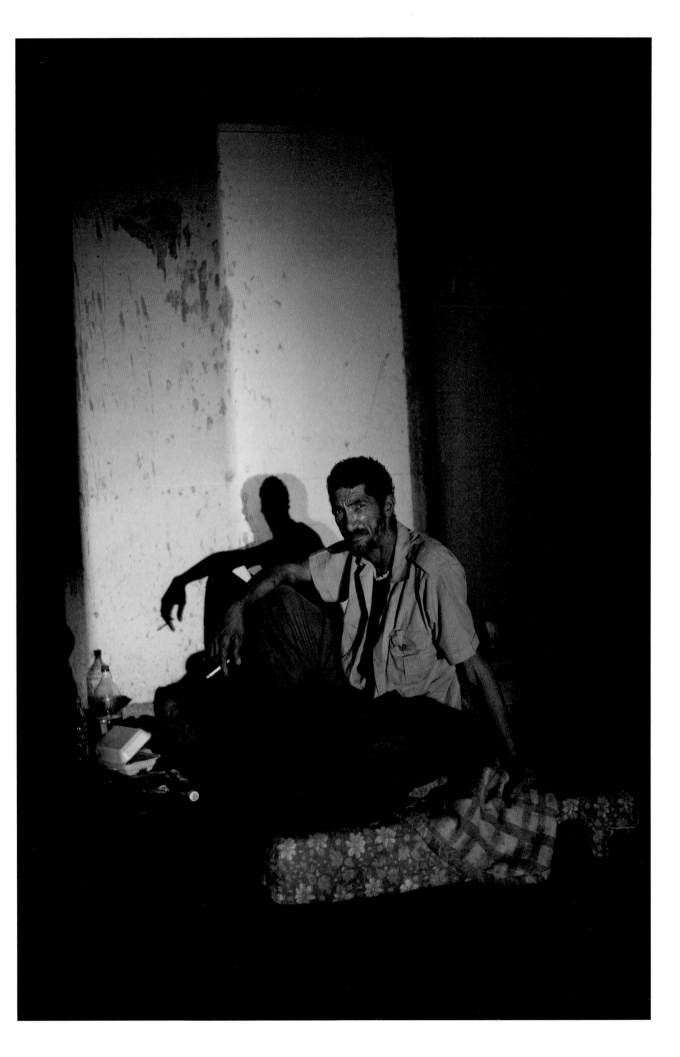

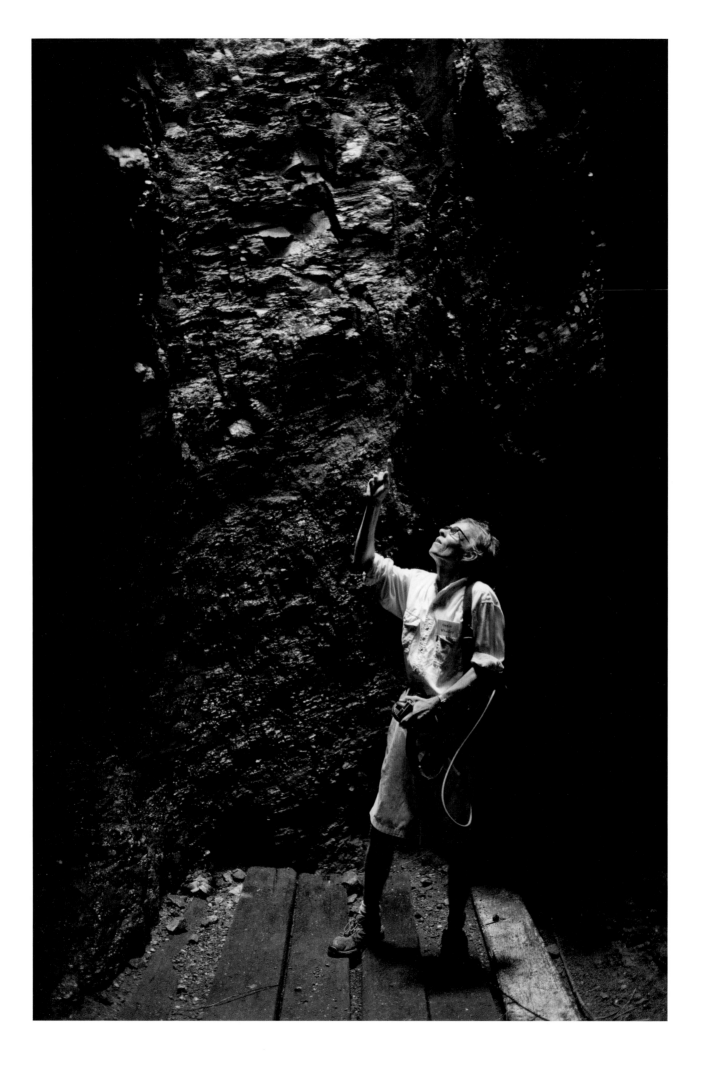

2001

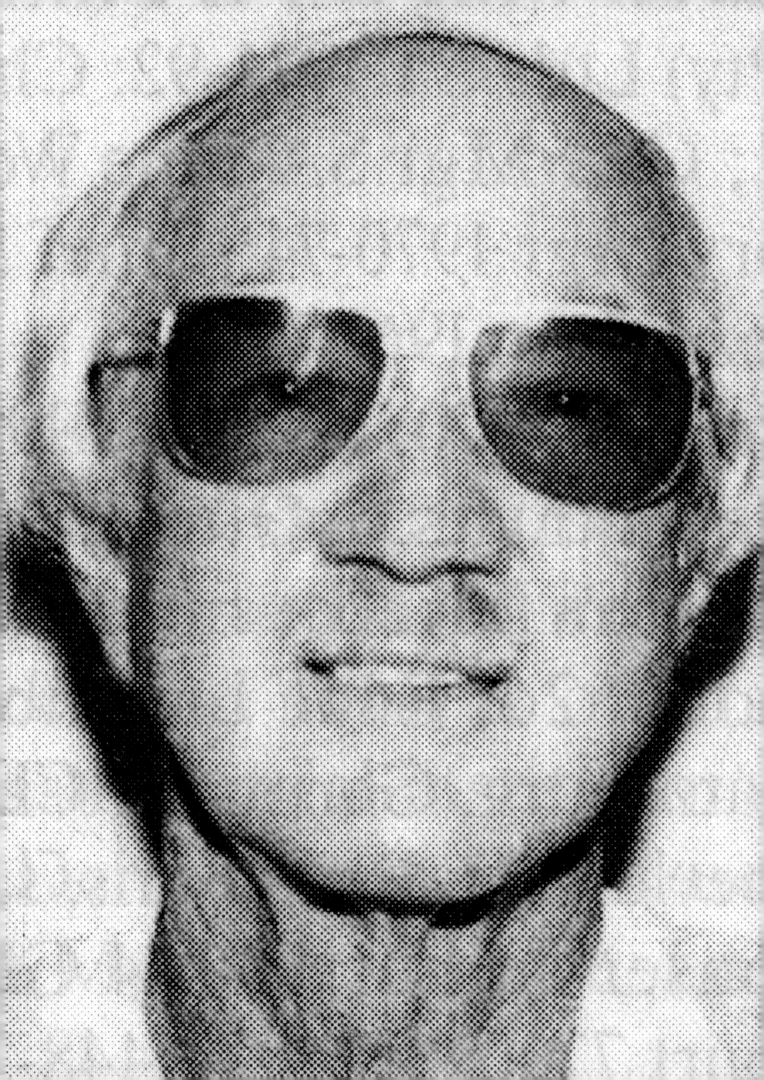

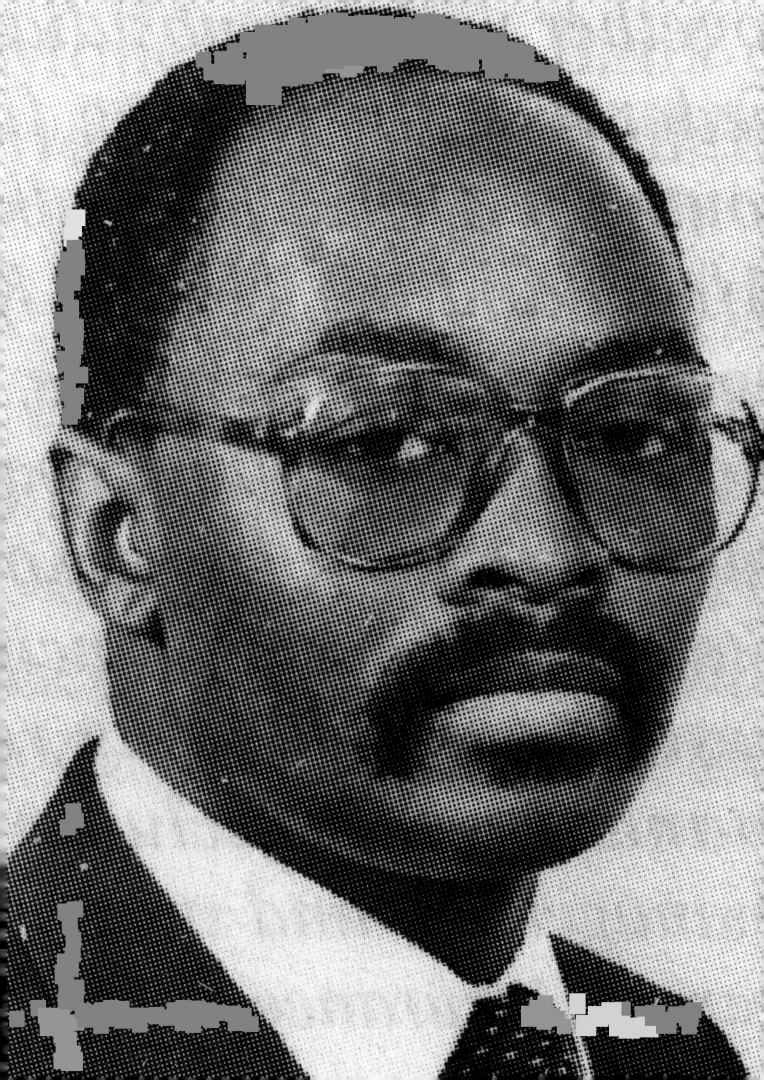

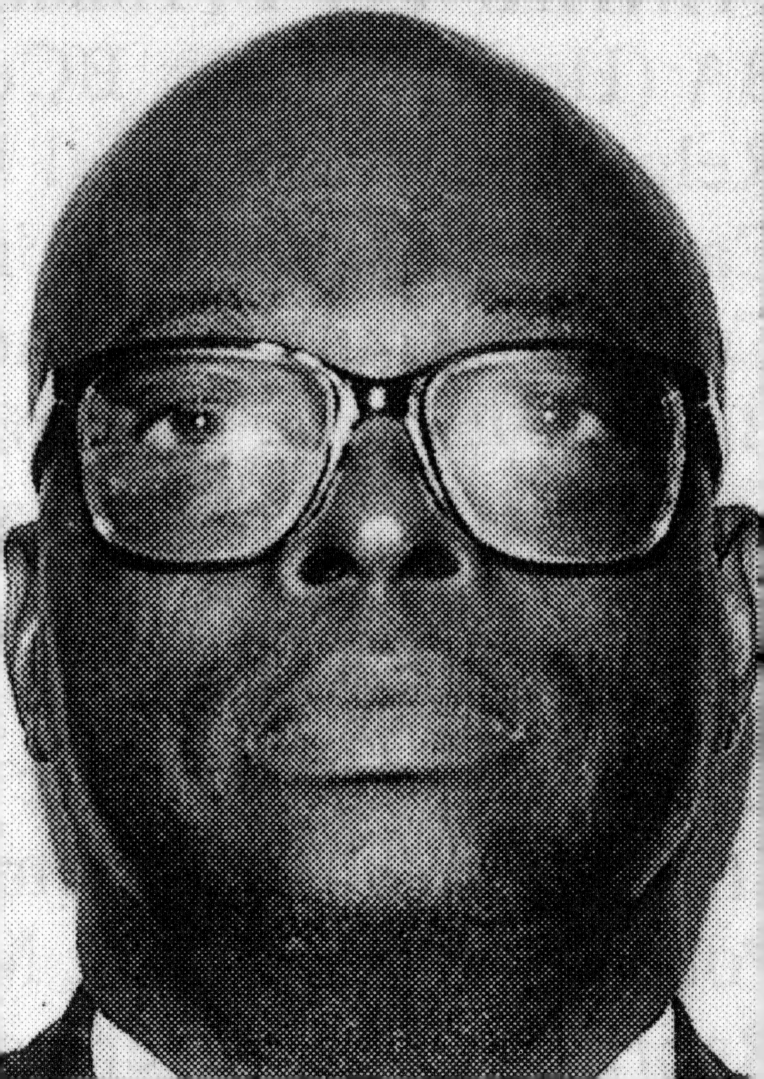

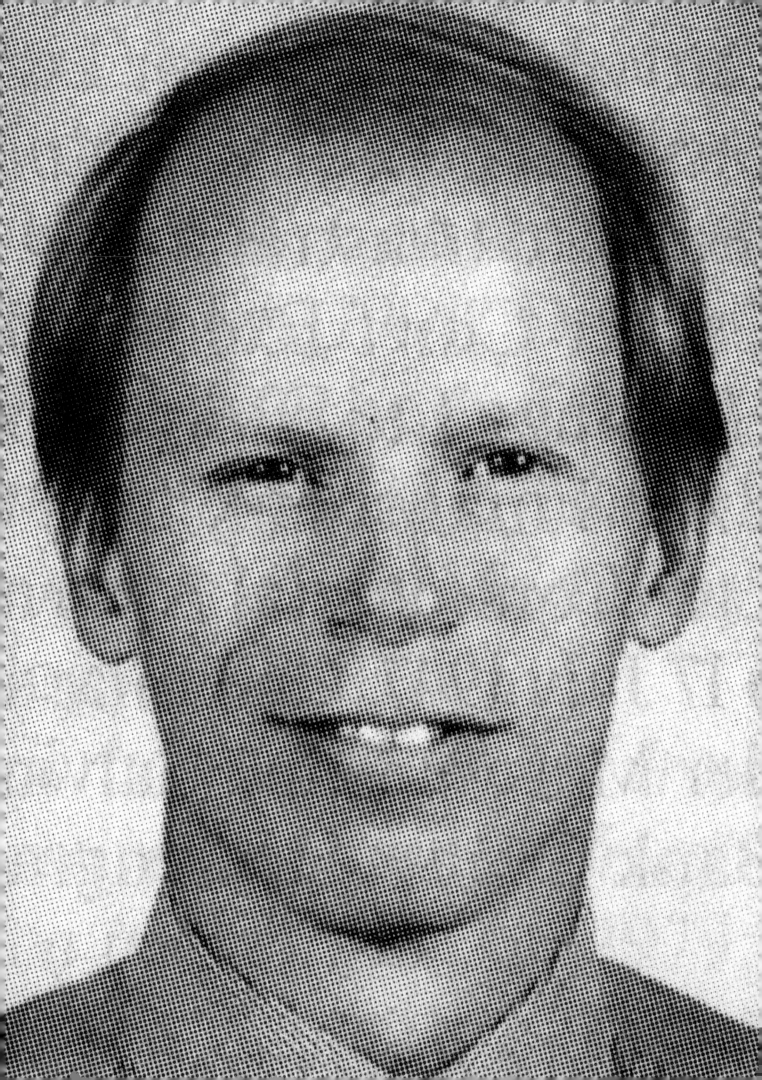

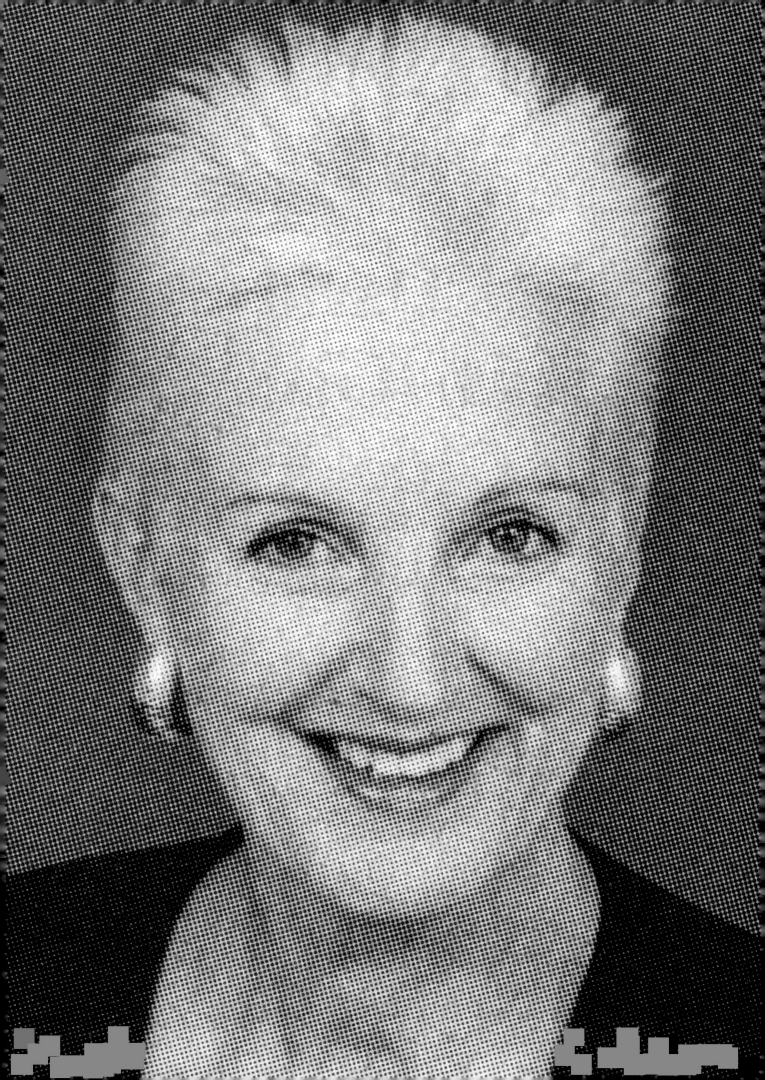

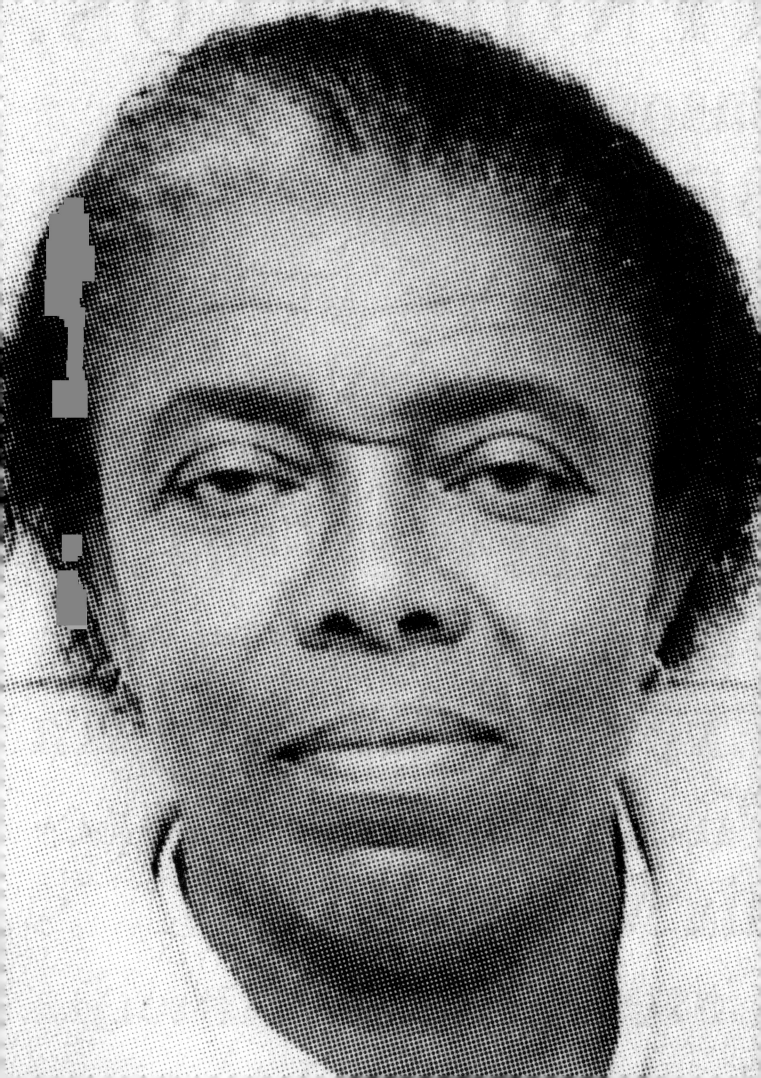

A GROUP

Sean O'Toole

PORTRAIT

Three years separate the opening of Mikhael Subotzky's debut exhibition inside Pollsmoor Prison on the eleventh anniversary of South Africa's democracy (27 April 2005) and the publication of his first book, *Beaufort West*. Whereas the ambition, form and content of this one-day exhibition, staged in a maximum security jail south of Cape Town, a short distance from where Subotzky grew up, now exist only as an impressionistic collage of press reports, descriptive photographs and remembered details, the photobook is something far more tangible. It is a portable object capable of travelling across time, unchanged. This is what distinguishes a book from an exhibition: the book arrives at every reader whole and intact, as its originator intended. Safer to start with this physical thing, with a book that not only confirmed a career already in the ascent, but also synthesized into a coherent singular statement a lengthy period of photographic enquiry into crime and punishment in South Africa.

In a book that employs a no-frills documentary grammar – single, rectangular-framed photos, mostly portraits, some candid, others posed – one photo in particular stands out. It is the final photograph in Subotzky's book, a composite group portrait of the inmates and warders from Beaufort West Prison. The photo, which bleeds across the full width of two pages, shows its subjects posing against the swimming-pool blue walls of the open-air exercise yard. Its interior walls are decorated with a wraparound mural depicting a kind of etiolated South African sublime: there is a lone kudu, a fenced-off farmhouse, some fuzzily presented trees, a windmill on the far horizon, and lots of scrub desert. The bland mural, painted by an inmate and subsequently covered over during renovations, recalls a passage from the Russian émigré writer Sergei Dovlatov's autobiographical novel, *The Zone* (1985). Commenting on the habitual orthodoxies of Soviet-era prison life, Dovlatov, a former labour camp guard, writes: 'Take camp painting. If it's a landscape, it will be done in incredible, tropical, Andalusian colours.' (118) Modernism has no place in the prison imagination, he adds. 'The closer the resemblance to a photograph, the better. Modigliani and Gauguin would have little success here.' (119)

I count a total of 50 men wearing prison-issue uniforms in this panoramic photo, which together with an earlier portrait of the mural's creator, Jaco, elegantly summarizes the book's intention: to describe the blurred dichotomy between outside and inside. Scattered among the assembled prisoners, like blockages in an orange line of Morse code, are 12 guards in chocolate brown uniforms, one of them a heavy-set man nicknamed Big Show. While most of the inmates, including Frisco, Romeo and Tamatie, the latter a young man with dark eyes and the habit of tilting his head when photographed by Subotzky, are seated on benches, some prefer to stand, arms held behind their backs. One man, his name is Dan, squats on his haunches. His right hand cups his face. He looks bored.

Bracketed by an essay and a series of explanatory captions, this wide-angle montage reiterates Subotzky's long-standing fascination with the panoptic view. This interest was announced in

Die Vier Hoeke (2004), a university thesis project that earned Subotzky a perfect grade and elicited immediate press interest before it was exhibited inside Pollsmoor in 2005; and it continues to inform new works, such as *CCTV* (2012), an unstable composite portrait of criminality in inner-city Johannesburg made using police footage, and *Moses and Griffiths* (2012), an installation that includes voyeuristic Rodchenko-like top-down views of Grahamstown made using a nineteenth-century camera obscura. The formal presentation of these all-seeing views has become increasingly volatile, grainy and blurred since 2004, when Subotzky travelled to Dwarsrivier Prison to photograph inmates voting, after a landmark court ruling had made this possible.

For his Beaufort West portrait, Subotzky asked all 62 sitters to write their names on the photo. The outcome is a graffitied document containing birth names, nicknames, gang symbols and doodles. Its unvarnished appearance is not dissimilar to the tattooed bodies of the shirtless men appearing in *Die Vier Hoeke* and *Umjiegwana* (2006). Where Subotzky used a digital camera mounted on a specially designed tripod and capable of taking 18 consecutive frames on a rotating axis to photograph at Dwarsrivier and Pollsmoor, the Beaufort West panorama was made using a film camera. Once digitized, the individual shots were however similarly 'stitched' together using proprietary software capable of seamlessly joining photographs describing a continuous scene into a near faultless digital montage.

The result differs greatly from David Hockney's wide-angle cubist photomontages from the 1970s and 80s, experiments that were almost entirely formal exercises aimed at pushing back 'the edge' of the photographic frame, both to challenge notions of perspective and draw attention to the limitations of western optics. Subotzky's approach has more in common with Jo Ractliffe's overlapping sequential montages from the late 1990s and early 2000s, shot in and around Johannesburg using a modified plastic-bodied box camera. His large panoramic portraits share an operating logic with Ractliffe's *Vlakplaas: 2 June 1999 (Drive-by Shooting)*, a panoramic montage of overlapping black and white photos describing the visual blandness of the landscape around a former apartheid death camp. Both photographers ally formal or aesthetic experimentation with an ethical purpose. Like the documentary photographer Gideon Mendel, who now routinely uses the panorama to compact multitudes into a single frame, Subotzky and Ractliffe use this aesthetic device to bear fuller witness, to show more reality, not map its boundaries or limits – although in Ractliffe's work, the failure to access anything other than a kind of quotidian truth at the trauma site does gesture to a different limitation for photography. Mendel is Subotzky's uncle and was an influential early mentor, teaching him the basics of working with the panoramic format.

Ractliffe and Mendel both came to prominence in the 1980s, a period of intensified social unrest and visual activism that shaped a particular tradition and mythology of documentary photography. In a 1988 issue of the left-leaning literary journal *Staffrider*,

Joyce Ozynski, reviewing the struggle of documentary photography in the 1970s and 80s to establish itself 'in a culture that gave no encouragement to the making of such images', noted the 'dilemma' amongst *Staffrider*'s coterie of anti-apartheid photographers of 'trying to meet the demands of a formalist aesthetic while giving expression to a consciousness of social issues' (163). Subotzky's ongoing struggle to establish parity between his need to engage South Africa politically and socially through photography, and his more self-reflexive interest in photographic representation and the psychology of seeing suggests that the 'dilemma' identified by Ozynski is inherent in the genre, not simply momentary and historical. The exhibition *Retinal Shift* (2012) foregrounds the complicated and often interconnected nature of this relationship between expression and description.

It is a point picked up by the curator and art historian Okwui Enwezor, an early supporter of Subotzky's work. The documentary tradition, he wrote in a 2005 essay, 'has the unique position of being caught in a tautological game, which is to both document and analyse, to show and define, and to do so with aesthetic means and also to be oblivious of aesthetic' (28). This repetition of means and ends is not unique to the self-effacing tradition of documentary photography. Roland Barthes, in his inaugural lecture at the Collège de France in 1977, described the essay, a laissez-faire non-fiction literary form at which he excelled, as 'an ambiguous genre in which analysis vies with writing' (457). Without this tension, though, between showing and defining, essaying and analysing,

there would be no resolution. Everything would be formless, unhinged, possibly even unreal.

Rather than sequester formal aesthetic concerns from his practice, Subotzky allows them a dynamic agency. Although it is more obvious now, whether in his tall light-boxes portraying the doorways, window views and television screens from every residential unit of Ponte tower, or in the granulated typology of faces recorded in *Who's Who* (2012), Subotzky was already experimenting with form in his *Die Vier Hoeke* (2004) series. It is there in the panoramas showing the cramped living conditions of awaiting trial prisoners, and also in a remarkable portrait he made at the funeral of Loyanda Motomi, a Pollsmoor inmate who died in a fire and whose body Subotzky followed to a burial in the Eastern Cape. Drawing on post-production techniques available in the digital age, Subotzky composed scenarios way beyond the normal optic of the eye, scenes of abundance and multitude that verge on overstatement. His stretched scenes defamiliarize reality, which is different from making it appear unreal.

Semantics here is the entrée into a more nuanced argument, an argument that itself hinges on the subtlety of the written word in describing what photographs do, and cannot do. 'Photographers,' writes Robert Adams in *Beauty in Photography* (1996), 'have generally been held to a different set of responsibilities than have painters and sculptors, chiefly because of the widespread supposition that photographers want to and can give us objective Truth; the word "documentary" has abetted the prejudice. But does a photographer

really have less right to arrange life into a composition, into form, for instance, than a painter or sculptor?' The point of art, ventures Adams, a self-taught photographer and former English professor, 'has never been to make something synonymous with life, however, but to make something of reduced complexity that is nonetheless analogous to life and that can thereby clarify it' (68).

Analogous not synonymous: photographs are not facsimiles of reality, merely representations, visual descriptions that can function as aids to looking and guide understanding. The French photographer Eugène Atget played down the usability of photographs to the extent of classifying them as artistic documents (*documents pour artistes*) on a sign outside his Paris studio. Subotzky's interest in working with the camera obscura recalls the way photography has been subordinated to a role of pure description. Before the invention of modern photography, the camera obscura enabled painters to reproduce the shape of reality. In his essay, Adams offers the example of Goya's arranging into a pattern of the figures in *The Executions of May Third* (1808). We accept this manipulation, he says, because it is the essence of art, 'the revelation of shape' (68).

The extent of that manipulation, its permissibility and its limits, is always at issue in documentary photography, an undeniably supple tradition that is nonetheless bounded by the journalistic imperatives of detachment, accuracy and, for all its fuzziness as a concept, morality. Walker Evans, whose clandestinely photographed portraits of Depression-era New York subway passengers have

some vague affinity with Subotzky's grainy *CCTV* portraits – perhaps it is their egalitarian scope rather than the methodology – encapsulated the contradiction of the documentary genre as follows: 'Documentary photography has nothing whatsoever to do with art. But it is an art for all that.' (Morris: 185) One of the reasons it has nothing to do with art stems from its factuality, its indexical qualities, the correspondence between a portrait photograph and the person it depicts. It is a point dramatized in the blanked-out face of a man who appears in a panoramic vista showing the Pollsmoor abattoir in *Die Vier Hoeke*. The man later withdrew his permission to be pictured. Rather than dispose of the photo, Subotzky kept it in his series and obscured the features. The visual interruption, he says, is a reminder to the viewer that the right to look is not guaranteed.

Subotzky's willingness to venture a position is self-evident in his annotations to this new book. The photographer has, however, withdrawn from the ritual of bearing witness to his practice for an enquiring media. The decision is not hard to fathom. The press interview is a sort of occupational hazard that requires speaking unambiguously about equivocal things. Initially motivated by a somewhat stern, almost idealistic belief in the capabilities of documentary photography, Subotzky early on in his career began to qualify his ambitions. In 2007, shortly after he was accepted as a nominee member of Magnum Photos, a cooperative photography agency founded in 1947 and long at the vanguard of documentary practice, he told me: 'I am beginning to communicate

more subtly through my photographs. It isn't about a photograph showing overcrowding in prison; it is showing a particular feeling I had when I was in Beaufort West.'

Feeling? I queried. 'It is a certain atmosphere, what Barthes called the *punctum*, something which comes through that isn't necessarily describable as the action in the photograph. I don't want to sound mystical or anything but I think photographs can operate on that level, very effectively. I want my work to be subtler. I don't want to rely on drama and subject matter to make good photographs.' His words remind me of something David Goldblatt wrote in the introduction to *South Africa: The Structure of Things Then* (1998): 'I felt no driving need to record those situations and moments of extremity that were the stuff of the media. It was to the quiet and commonplace where nothing "happened" and yet all was contained and immanent that I was most drawn.' (7)

Goldblatt's influence, as a photographer foremost, but also (in the tradition of Evans and Adams) as an astute and literate thinker on photography, is evident in Subotzky's work. His *Umjieg-wana* series includes a portrait of a man named Joseph, convicted for murder and released after eight years, having his eyes tested. The portrait quotes Goldblatt's undated portrait, reprinted in *In Boksburg* (1982), of an elderly black woman having her eyesight tested by a Brylcreemed and moustached white man at the Vosloorus Eye Clinic. Goldblatt's photographic approach to Boksburg, a nominally discrete but really just-like-everywhere-else East

Rand town, at least in its apartheid-era logic, suggested the working idea for Subotzky's *Beaufort West* project. Here too was somewhere quiet and commonplace, unspectacular yet forcefully emblematic – the prison is located on a traffic circle in the middle of town. Subotzky describes the town as radiating from the prison, a description that could also be applied to the landscape seemingly radiating from Ponte's gauzy windows.

A few months after Subotzky's essay on Beaufort West successfully premiered at the Museum of Modern Art in late 2008, on the museum's annual New Photography showcase, the photographer once again spoke of the draw of making subtler, more nuanced work. 'Initially I thought of the work in traditional documentary terms whereby I sought to make visible that which is hidden, an aspiration that I think is particularly relevant to state institutions such as prisons,' he told Jörg Colberg, editor of the online photoblog *Conscientious*. Emboldened by his readings of South African penal history and Michel Foucault, however, he soon started experimenting visually.

'I tried out different types of images, set up workshops with prisoners, and then expanded the project in the *Umjiegwana* (2006) series to look at the lives of ex-prisoners,' Subotzky elaborated in this interview. 'At this point the work became much more personal as I established and built up relationships with a group of disparate people who inhabited the same city as me, but very different worlds. I began to see the work as my own exploration of my surroundings, a part of my attempts to make myself as conscious as possible.'

The recurrent use of the possessive adjective 'my' in the final sentence is telling. The photographer was moving beyond the constraints of mannerism, in this instance a still rather conservatively applied South African documentary style; he was shrugging off the anxiety of influence, in essence becoming more himself.

The extent to which Subotzky's work has become 'more personal' is plainly evident in the prominence he gives the high-resolution images of his left and right retinas in this book and exhibition, and in its titling too. As notionally abstract as these two photographs may appear, their factuality is incontrovertible, as is their profound subjectivity tendered as documents. This is how I see, this is why I see, they communicate. But, even here there is parity, an underlying consistency that links them to his earliest work on crime and punishment, and indeed his interest in social portraiture generally. 'It was medical anthropology,' writes art historian Christian Joschke, 'that gave the representation of the human body a decisive function in what looked increasingly like a European political project to establish an anthropological standard for the human body.' Photo-graphy became an important normative document, states Joschke, 'a stimulus to anthropological knowledge' and 'an instrument for social management'. In this latter respect, photography was key to the French criminologist Alphonse Bertillon's pioneering nineteenth-century identification system, which used ten standardized physical measurements to help police better identify criminals. It informed the system of identikits pictured in Subotzky's

Umjiegwana series, and finds a gentrified counterpoint in his granular *Who's Who* photos, a sort of history through portraiture.

Photography makes history palpable and real, more so as a photo dates. But photos also transform what was once alive and tangible into history. Subotzky's light-hearted group portrait made inside Beaufort West Prison now forms part of a historical archive of prison photographs. This substantial archive includes Bob Gosani's enquiring long-range look over the wall of Johannesburg Central Prison in 1954, as well as photos by Peter Magubane and Ernest Cole, all of whom imaged naked prisoners, something Subotzky also does in *Die Vier Hoeke*. But I want to single out an older photograph. It was made 141 years ago, when photography was more closely linked to an anthropological and political project, as Joschke puts it, when representations of the body were in other words viewed as anthropologically true, as factual embodiments of culture and difference. Part of a series of four group portraits of prisoners made by David McKenzie Selkirk and his partner William Lawrence, one of which is on display at the Apartheid Museum in Johannesburg, this particular photo shows ten San men huddled in two rows on the lunar-coloured gravel of a Cape Town jail, their shirtless backs turned to a wall made of quarried stone.

Originally published in an album of ethnological photographs – presented 'with affectionate, grateful regards and best wishes' by the German-born philologist W.H.I. Bleek to the ex-Governor of the Cape, Sir George Grey, in 1872 –

Selkirk and Lawrence's portrait was simply captioned 'Bushmen'. When it was later republished in Wilhelm Bleek and Lucy Lloyd's *Specimens of Bushman Folklore* (1911), the photograph featured a revised caption: 'Photographed at the Breakwater convict station, Cape Town, about 1871.' All of the men are identified. There is an unseen context to this photo. 'In 1870–71,' writes Karel Schoeman in *The Face of the Country* (1996), a study of 273 photographs in the collection of the South African Library, 'a number of individuals from among the Bushmen prisoners working at the Breakwater convict station in Cape Town were allowed to live at Bleek's Mowbray home in order that he might learn their language.' (19)

This dubious arrangement, between Bleek, his sister-in-law Lloyd and a group of San men, enabled these scholars to record the stories, poems and myths of an endangered people. Language, as Bleek and Lloyd knew, is the repository of culture. This is true of prisons too, which, in their reflection and distortion of the larger world they mirror, have developed their own cultural systems, a coherent 'language' included. Subotzky's early essays were guided by the nuances of the fantastical prison language used in South African penal complexes, a language that traces its origins back to two nineteenth-century bandits, Nongoloza and Kilikijan, who were eventually captured and imprisoned.

'Being men of the caves and the hills, their prison language bore their fantasies of the outdoors,' writes Jonny Steinberg in an unpublished text accompanying Subotzky's *Umjiegwana* series. 'Every-thing expanded. A day was called a year. An overcrowded cell became a vast highveld plain. But to prevent themselves from being carried away into madness, they reminded themselves every day that they were in fact *binne die vier hoeke* [inside the four corners], and not *umjiegwana* – outside. These two concepts became the touchstones of their language.' Which endures to this day. Subotzky's early work, from *Die Vier Hoeke* through to *Beaufort West*, meticulously describes the erosion of this time-honoured distinction between outside and inside. 'The new Numbers are going into prison and robbing and stealing like on the outside,' says Vallen, a sergeant in the 28s prison gang whom Subotzky photographed sleeping in a cramped family bed. The photo has a Weegee-like grace and affection. 'They didn't do that in my time. And on the outside they are speaking Sabela [prison language] on the streets. You are not allowed to do that. *Die vier hoeke* is becoming like *umjiegwana*. And *umjiegwana* is becoming like *die vier hoeke*.' (Subotzky: personal communication) Dovlatov, in a moment of unflinching candour, puts it more bluntly: 'One single soulless world extended on either side of the restricted areas.' (46)

Returning to the group portrait with which I began: the men inside Beaufort West Prison do not smile. Perhaps they, like Vallen, have recognized what Dovlatov describes as the 'striking similarity between the camp and the outside, between the prisoners and the guards...'(46) This is mere speculation. A body purified of all expressivity prompts fabrications. This is as

true of the passive inmates and guards depicted in Subotzky's *Beaufort West* panorama as it is of the nameless, note-worthy and occasionally moustached white men in his *Who's Who* series, men who only infrequently smiled after 1951, and apparently never before. My point, though, has nothing to do with expressivity in photography; rather, it aims to highlight Subotzky's interest in the mass over the unit, in other words, man as a social being. Subotzky's vast, impressionistic portrait of the occu-pants of the 54-storey Ponte building in central Johannesburg, which in the late 1990s was briefly mooted as a pos-sible site for an urban prison, demon-strates his slow-burning and relational approach to showing how and why people live or are forced to live the way they do. Started in collaboration with Patrick Waterhouse in 2008, not long after Subotzky returned to Beaufort West Prison with two three-metre-wide prints of the inmates, one for display in the prison, the other to return a modest agency to the prisoners by having them overlay their marks on the photo, the Ponte project is unfinished. Or rather, like the uncharacteristically voyeuristic work *Don't even think of it*, a new work made from photographs shot in 2004, when Subotzky was still reconciling his roles as a documentary photographer and an artist, it awaits repurposing, to bring its discrete elements into a coher-ent finality.

The Ponte project, like the Beaufort West one, includes some complicated composite portraits. Drawing on the logic of the earlier panoramic montages, but now working within a more sub-dued frame, Subotzky and Waterhouse knocked on each door in the residential building to request a portrait; when it was refused, Subotzky photographed the closed door, or, as was often the case in this building during its awk-ward reinvention by developers in 2008, the interior of the vacant apartment. This simple and empirical strategy in turn prompted a further series of typo-logical photos, first focused on the gossamer views from the windows of the circular tower block, and then, in acknowledgement that not every vista is a vertical or horizontal landscape, on the TV screens in the rooms and the images that distract, entertain and embalm the lives of Ponte's occupants. Exhibited as three four-metre-high light-boxes, these vertical towers of differen-tiated light – which look like abstracted stained-glass windows, until you zoom in close – portray the multitude of Ponte in as complete a frame as possible, albeit less seamlessly than the earlier prison portraits. There is also a notice-able shift in orientation in this work – from looking at, to looking with. This is who lives here, we are often shown, but, and possibly more importantly, this is what they see. A Highveld expanse. The Carlton Centre. Mr Bones and Mobutu wearing a leopard-skin hat. Soap operas, commercials, biblical texts, wrestling, the etv weather lady. You are seeing through their eyes, as much as the photographer's. This is the key retinal shift.

REFERENCES

Robert Adams, 1996, *Beauty in Photography*, New York, Aperture.

Roland Barthes, 1993, Susan Sontag (ed.), *A Roland Barthes Reader*, London, Vintage.

Jörg Colberg, 'A Conversation with Mikhael Subotzky', in *Conscientious*, 18 February 2009. http://jmcolberg.com/weblog/

Sergei Dovlatov, 1985, *The Zone*, New York, Alfred A. Knopf.

Okwui Enwezor, 'Documentary/ Vérité: bio-politics, human rights, and the figure of "truth" in contemporary art', in *Australian and New Zealand Journal of Art*, 4/5 (2003/04), pp. 11–42.

David Goldblatt, 1998, *South Africa: The Structure of Things Then*, Cape Town, Oxford University Press.

Christian Joschke, forthcoming, 'The photographed body and the end of anthropometry', in *20th Century Masters: The Human Figure*, Johannesburg, Standard Bank.

Errol Morris, 2011, *Seeing is Believing*, New York, The Penguin Press.

Joyce Ozynski, 1988, 'Staffrider and Documentary Photography', in A.W. Oliphant and Ivan Vladislavić (eds), *Ten Years of Staffrider: 1978–1988*, Johannesburg, Ravan Press, pp. 163–4.

Karel Schoeman, 1996, *The Face of the Country*, Cape Town, Human & Rousseau.

Jonny Steinberg, 2006, 'Umjiegwana: The Outside', unpublished MS.

Mikhael Subotzky, 2008, *Beaufort West*, London, Chris Boot Ltd.

John Tusa, Interview with David Hockney, BBC Radio 3, 30 July 2004.

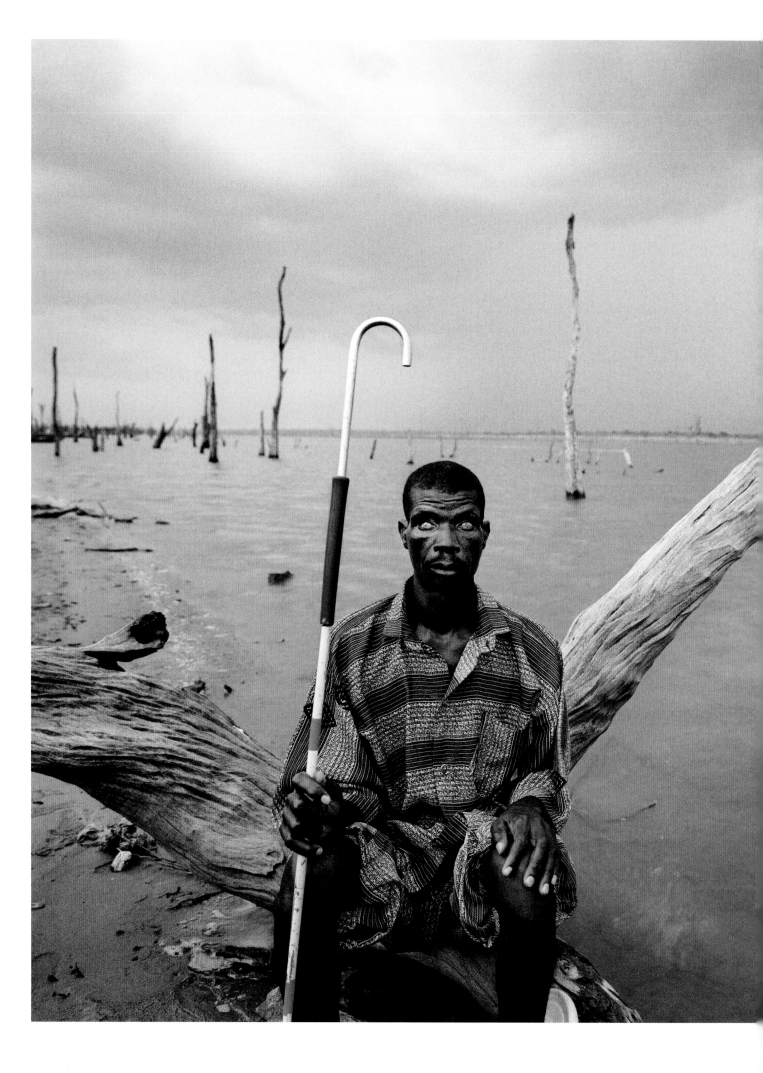

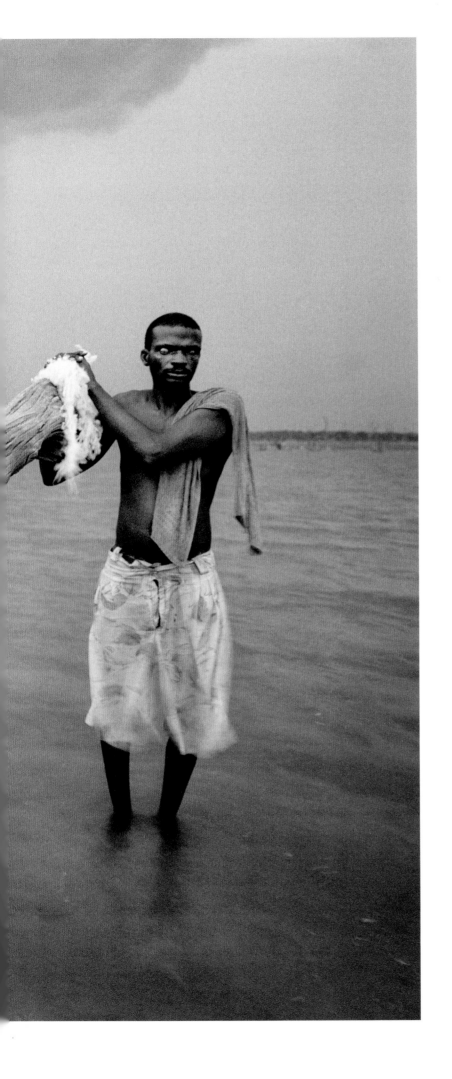

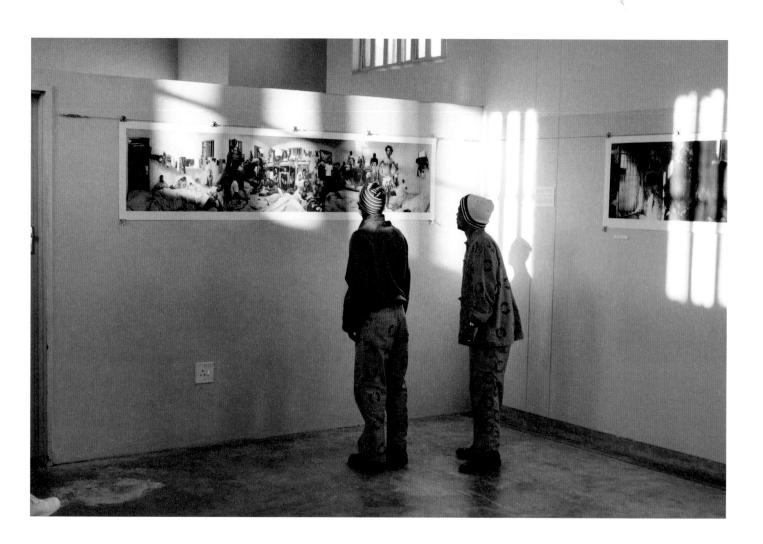

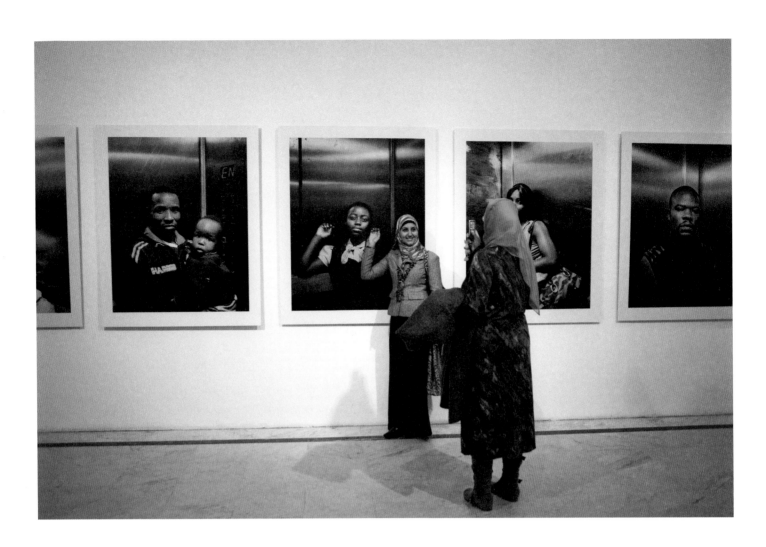

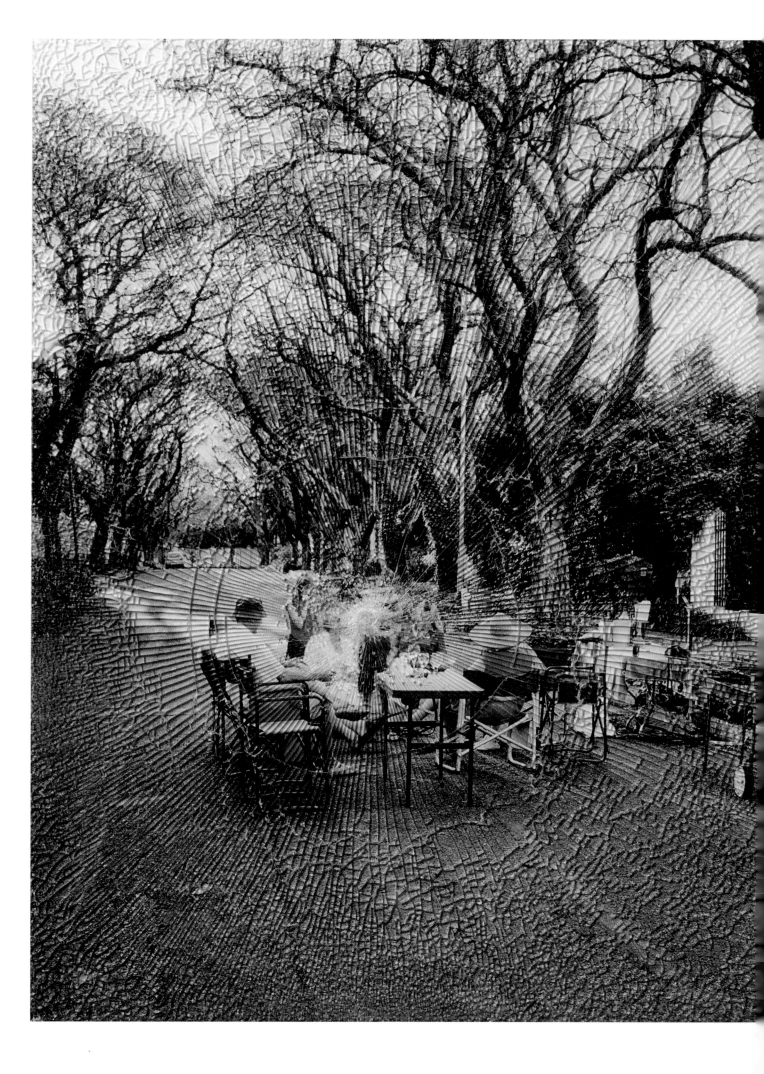

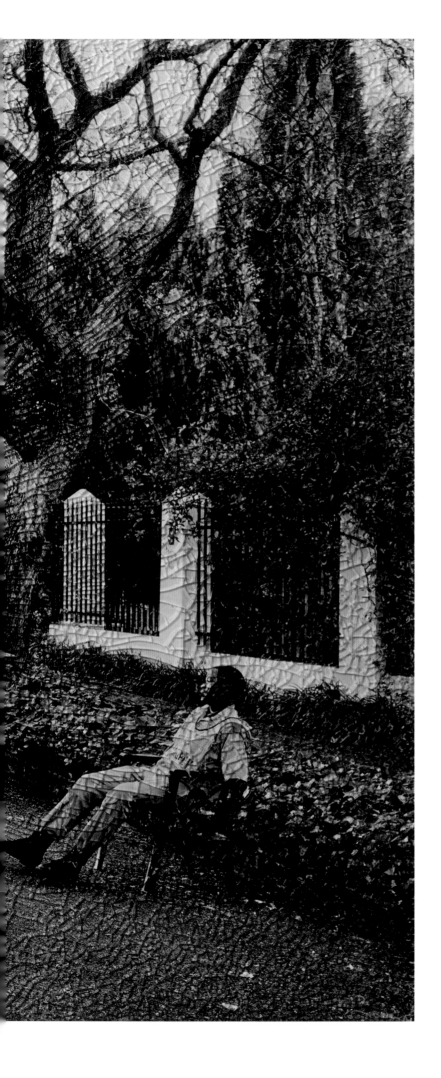

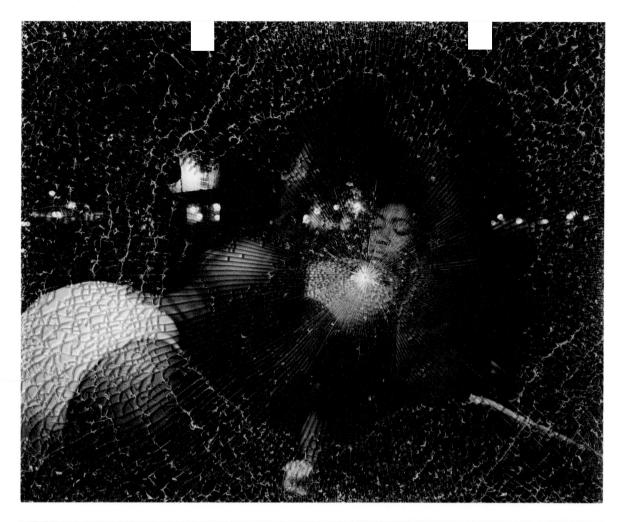

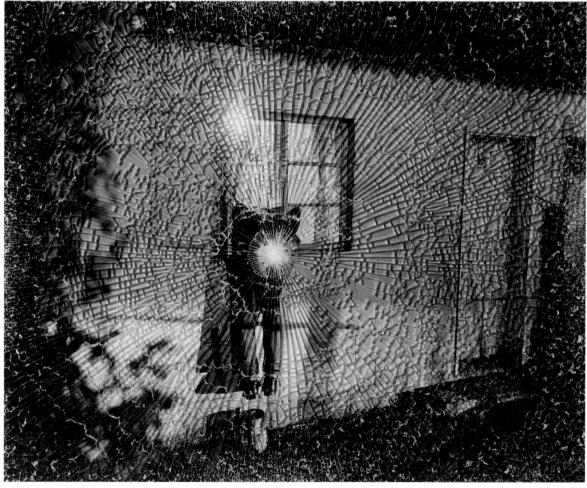

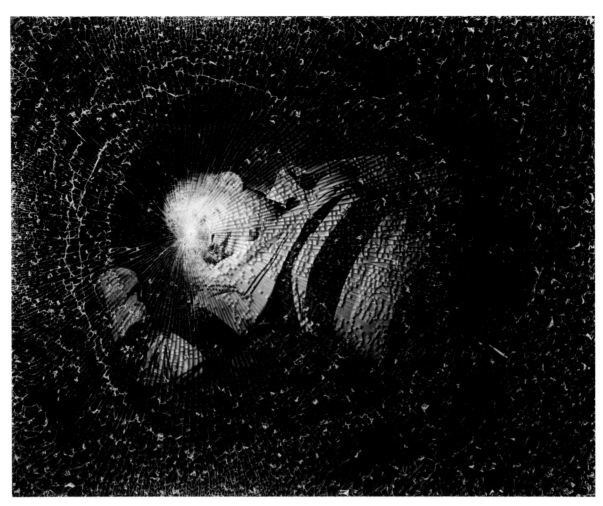

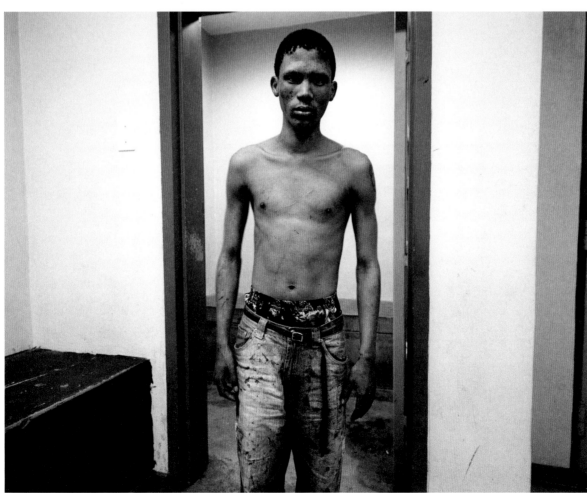

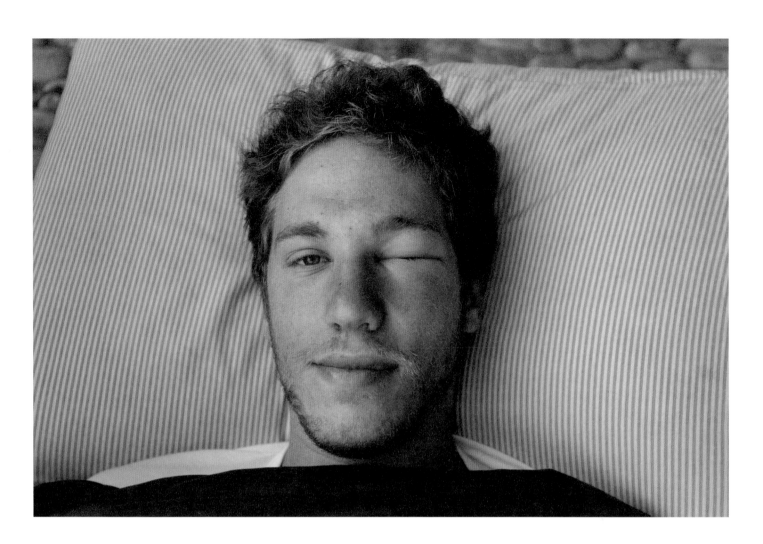

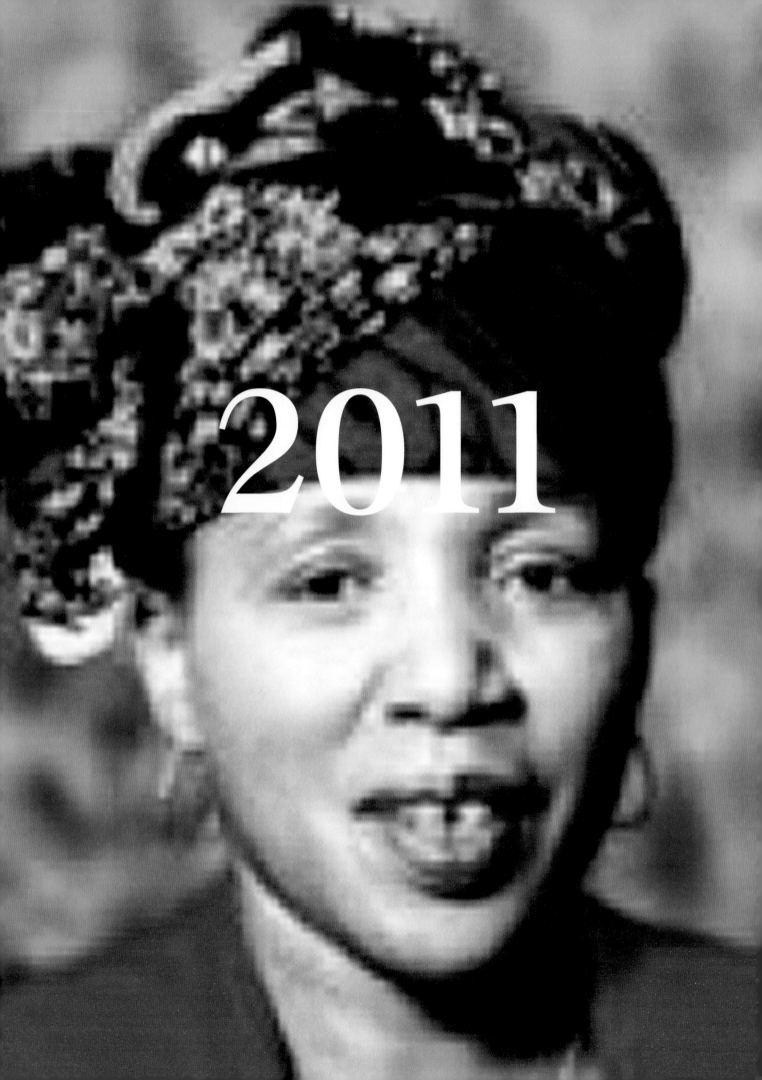

2011

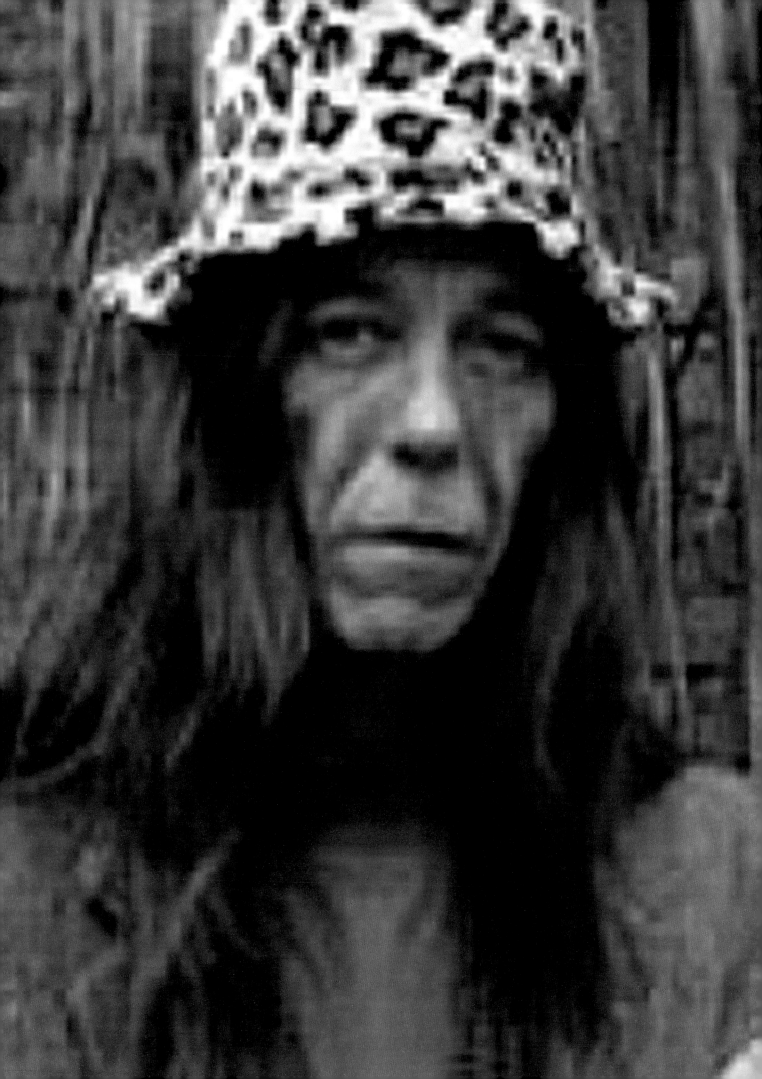

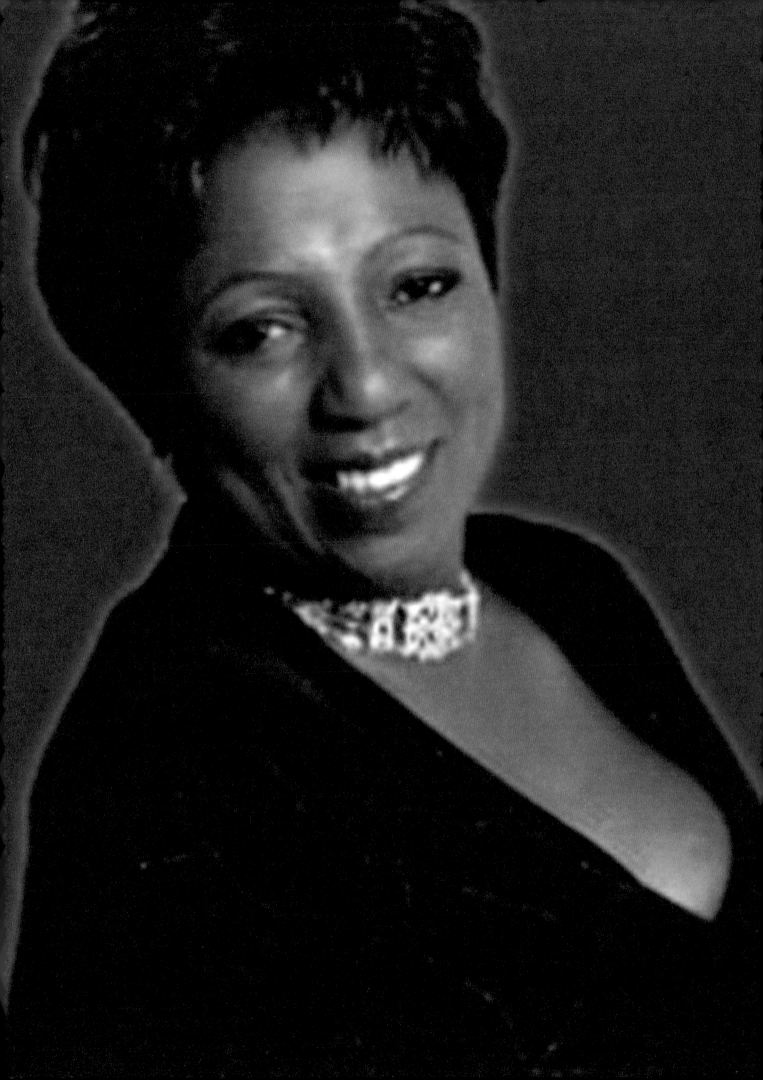

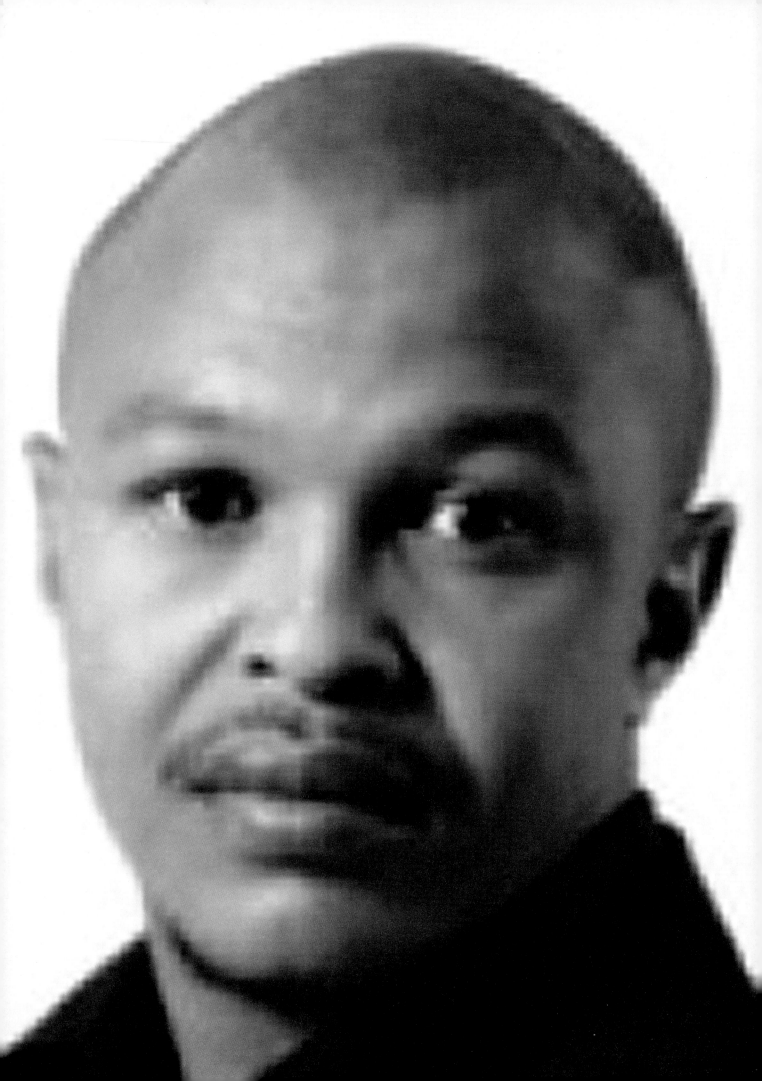

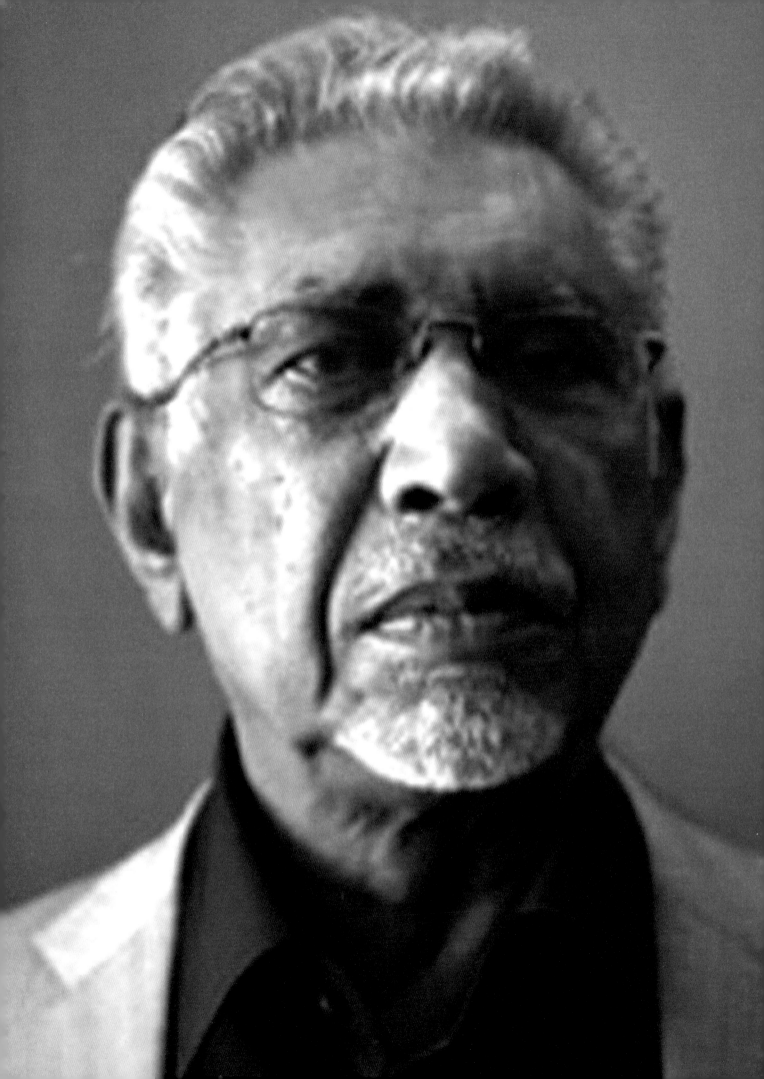